# Moments of Vision

*Kenneth Clark*

# MOMENTS OF VISION

# & OTHER ESSAYS

**HARPER & ROW, PUBLISHERS, New York**

Cambridge, Philadelphia, San Francisco,

1817   London, Mexico City, São Paulo, Sydney

MOMENTS OF VISION & OTHER ESSAYS.

Copyright © 1981 by Kenneth Clark.

All rights reserved. Printed in Great Britain. No part of this book may be
used or reproduced in any manner whatsoever without written permission
except in the case of brief quotations embodied in critical articles and
reviews. For information address Harper & Row, Publishers, Inc., 10 East
53rd Street, New York, N.Y. 10022.

FIRST U.S. EDITION

ISBN: 0-06-014885-3
LIBRARY OF CONGRESS CATALOG CARD NUMBER: 81-47225

81 82 83 84 10 9 8 7 6 5 4 3 2 1

*For NOLWEN*

# Contents

# Preface

This volume contains such of my writing on general topics connected with the arts as seems to me to be worth printing. They are chiefly the scripts of lectures, and some have already been printed.

For over fifty years I have foolishly accepted invitations to perform, and as I am incapable of improvisation all these talks had to be written out *in extenso*, and they occupy a disproportionate place in my files. Although they are obviously *pièces d'occasion* they sometimes contain observations and ideas that might interest the general reader, and I have included a few of them in this volume.

The titles of these addresses were, for the most part, chosen by my sponsors. Left to myself I would not have had the affrontery to write on such a subject as Art and Society. But I recognise that the necessity of considering such grandiose themes forced me to stretch my mind. One should not spend one's life in writing about art without having some vague idea of what the word means. So that, although I have not ventured to construct a system, I have attempted a certain amount of what might be called 'applied aesthetics'. What does the average man have at the back of his mind when he uses the word 'art'? Some of the papers in this volume may help towards an answer.

# ONE

## Moments of Vision

The apprehension which anyone must feel in delivering this famous lecture* must be greatly increased for the lecturer who is accustomed to keep his audience in the dark. It is a comfort to have a large luminous image over one's shoulder, distracting attention from what one says; and a magic lantern, as they used to be called, still allows some of the liberties of a conjurer. But there is a more serious reason for embarrassment than mere exposure. I am by profession a writer on the visual arts, and I am in the habit of illustrating my points by visual examples. Without them I feel myself condemned to vague theorising and to the vacuity of description. Our ancestors believed that the merits of a painting consisted in that part of its content which could be described in words, and confidently wrote books on antique painting when only a single specimen had been discovered. Now although the understanding of our responses to works of art has advanced little enough, heaven knows, in the last 150 years, it has advanced beyond the doctrine of *ut pictura poesis*. I cannot substitute descriptions for lantern slides, as Richardson or even Ruskin would have done. Nevertheless I must somehow use the arts to illustrate one another; and I believe that there is one element of human experience which remains almost identical, in origin and effect, whether it is turned into poetry or into painting. It is the experience which I have called a moment of vision.

A more explicit title would have been the moment of intensified physical perception. I emphasise the word physical because I am not going to talk about vision in the metaphorical sense — the sense in which the word is used by preachers, public speakers, and far-sighted men of action. Nor am I concerned with what are called visions; for these, in so far as we can trace them to their sources, are not derived from immediate visual experience but from reading and the memory of art. The authors of prophetic books have usually felt that things which a man can see with his own eyes were not suffi-ciently awe-inspiring to be communications of the divine. It is

* The Romanes Lecture, Oxford, 1954.

1

difficult to imagine supernatural events except in the quasi-symbolic forms which have already been conferred on them by art; hence the long life of iconographical traditions, and the fact that prophets and visionaries so often have recourse to imagery borrowed from a cult of which they disapprove. The author of the Apocalypse seems to have had a confused memory of Babylonian symbols, and his extravagant monsters have been a source of embarrassment to illustrators from the twelfth century onwards. Blake saw his visions so clearly that he could fix them with 'the firm and wiry line of rectitude'; but in fact they too were all memories of art, of prints after Michelangelo and Tibaldi, of Gothic effigies and antique sarcophagi, and even of Babylonian reliefs. He felt a kind of loyalty to these images which unfortunately prevented him from trusting his direct perceptions, so that only a few small and humble works, for example his illustrations to Thornton's *Pastorals*, are derived from moments of vision in the sense that I am using the term today.

We can all remember those flashes when the object at which we are gazing seems to detach itself from the habitual flux of impressions and becomes intensely clear and important to us. We may not experience these illuminations very often in our busy adult lives, but they are common in our childhood, and given half a chance we could achieve them still. Such moments are the nearest many of us will ever come to the divine agitation of the creative artist. We feel them so strongly that we can communicate them to our friends, as Dorothy Wordsworth did to Coleridge, and it is therefore not surprising that we can recognise them in painting and literature, even when they appear in a subsidiary or almost accidental manner. As an example let me quote a passage of English prose which no member of an Oxford audience is likely to have forgotten, John Henry Newman's account of his last day in the University. He describes how he calls on his old tutor, and continues: 'In him I took leave of my first College, Trinity, which was so dear to me, and which held on its foundation so many who have been kind to me, both when I was a boy and all through my Oxford life. Trinity had never been unkind to me. There used to be much Snap-dragon growing on the walls opposite my freshman's rooms there, and I had for years taken it as the emblem of my own perpetual residence, even unto death, in my University'.

Now, memorable as this passage would always have been as the

account of a turning-point in Newman's life, it would not, I think, have remained so vividly in our minds without the snapdragon. There is no reason why it should be there; and this is what gives so magical a quality to its sudden appearance. We feel the intensity with which Newman's eye must have rested on it, and like him we come to accept it as a symbol. This is an example of a moment of vision that comes from saturation: the brooding troubled mind and the eye perpetually dwelling on an irrelevant object, till unconsciously thought and perception are merged. Now let me quote an example of a moment of vision that comes in a flash. In Keats's *Eve of St Agnes* are some of the richest lines in English poetry. We turn them over and stroke them as we would a piece of ancient velvet. But which of them do we remember? Not, I think, the Pre-Raphaelite descriptions of revellers (literally pre-Raphaelite, because they were drawn from the same engravings of frescoes in the Campo Santo which inspired Rossetti and his brotherhood); not even the high latticed window which Keats had really seen in the Vicars Hall in Chichester. The line that comes first to my memory (and to the memory of almost everybody else whom I have asked) is 'And the long carpets rose along the gusty floor'. Compared to many of the splendid passages which precede it, it lacks both colour and euphony; but it has the unforgettable vividness of heightened perception.

In both these examples the moment of vision appears incidentally, as a detail, and apparently without consciousness of its impact. Let me therefore give one more instance where a moment of vision is recognised and exploited with conscious art. It is to be found in a familiar short poem of W.B. Yeats. He begins by evoking the shadowy decorative figures which hung like a tapestry in the background of his imagination. 'Many a king's daughter alights at the comely trees and the lawn'; and then suddenly an actual object, insiginificant but strange, detains his eye.

> I would find by the edge of that water
> The collar bone of a hare
> Worn thin by the lapping of water
> And pierce it through with a gimlet, and stare
> At the old bitter world where they marry in churches.

The collar-bone of the hare has made the poem; Yeats, given his

myth-creating, or myth-hungry, turn of mind, has at once recognised that an object so vividly perceived must be a symbol; and he has even tried to use his moment of vision to create others, by the fairy-tale device of boring a hole in it and looking through.

Now, poetry and painting can get on very well without these flashes of magical perception. Poetry can be made entirely out of words and concepts; painting out of the architecture of shapes and colours. Moments of vision, as I have defined them, are a sort of windfall, or legacy from an unknown relative. But we can all think of one poet who, although in fact he was a formidable technician, claimed to live almost entirely on such legacies, William Wordsworth; and as he is the human being who received these benefits with the greatest frequency, and did most to develop and define them, I must quote at least one passage in which he described his experiences. He speaks in the third book of *The Prelude* of his 'bodily eye',

> Which, from a tree, a stone, a withered leaf
> To the broad ocean and the azure heavens
> Spangled with kindred multitudes of stars
> Could find no surface where its power might sleep;

> \*     \*     \*

> And by an unrelenting agency
> Did bind my feelings even as in a chain.

And a hundred passages in *The Prelude* illustrate this visual obsession, ranging from the distant mountain which suddenly appeared over the horizon and frightened him when he was rowing in someone else's boat, to the reflection of a star in the ice, which so enchanted him that he left his boisterous companions to cut across it with his skates.

Wordsworth's bodily eye was unusually excitable. For most of us the objects of intensified vision are more restricted and, as Wordsworth's lines suggest, they are either very near or very far. Of course it is possible to see human beings in this way, as Hardy saw the man harrowing clods, or Millet saw the figures in the *Angelus*, but, on the whole, moments of vision do not come to us so fre-

quently when we are in what I may call the humanist scale of proportion. Perhaps the great intellectual achievement known as perspective, by which figures of a human size could be related to each other in some plausible and measurable system, tended to paralyse the intuitive faculty by which objects are seen with immediate vividness; for Chinese painting, lacking this form of spatial organisation, has for eight hundred years depended almost entirely on what we may call Wordsworthian subjects — birds, flowers, twigs, or distant lakes and mountain peaks. The humanist and the heroically minded may sometimes feel impatient, or slightly incredulous, when a Chinese connoisseur claims that a drawing of a sparrow or a bamboo shoot can be made the focus of a great spiritual experience; yet the English accept equally humble material, as the subject of the finest lyric poetry.

These small or distant objects must be familiar to us, and yet must suddenly appear in a new light. Sometimes it seems as if familiarity alone can do the trick. We know the agonies of boredom which Leopardi suffered as he gazed out of his window into the familiar square at Recanati. Yet the drips of experience which filled his unconscious mind overflowed into notes as vivid as a poem by Po-Chui, and these notes in turn were transformed into the indestructible perfection of *Sabato nel Villagio*. But often surprise is necessary too. The Wordsworths had seen daffodils many times before, but they had not expected to find them, on such a windy day, in the woods beyond Gowbarrow Park. 'We fancied', said Dorothy, 'that the lake had floated the seeds ashore, and that the little colony had so sprung up. But as we went along there were more and yet more; and at last, under the boughs of the trees there was a long belt of them beside the lake . . . about the breadth of a country turnpike road. I never saw daffodils so beautiful.' When, some time later, her brother made this moment of vision into a poem, he remembered first of all the surprise, the sudden change of mood.

The Ruskin family was strolling placidly after dinner in Schaffhausen 'gazing into the blue', he tells us, 'as at one of our own distances from Malvern or Dorking, when suddenly — behold — beyond! There was no thought in any of us for a moment of their being clouds. They were clear as crystal, sharp on the pure horizon sky and already tinged with rose by the sinking sun . . . the seen walls of lost Eden!' Yes, it had been a surprise; but

although Ruskin had never seen the Alps before, the last sentence shows that they were the confirmation of a long imaginative familiarity.

We must admit that our moments of vision are usually unpredictable. Mr Graham Sutherland has described how on his country walks objects which he has passed a hundred times — a root, a thorn bush, a dead tree — will suddenly detach themselves and demand a separate existence; but why or when this should happen he cannot tell us, any more than a rider can tell us why his pony shies on a familiar road. His imitators think that they can achieve the same effect by going straight to the thorn bush and painting its portrait. But it remains inert and confused, like any casual sitter.

But occasionally we can fix the moment when the familiar has become surprising. Rembrandt must have seen a flayed ox hanging in a butcher's shop almost every day of his life; so have we all and felt no more than various degrees of revulsion. But one day Rembrandt saw it differently. A drawing in Berlin tells us that he was passing an open door at night and saw, lit by a torch, the pitiful carcass splayed out, with ghoulish figures huddled at its base. The dramatic intensity of this drawing suggests that he had half-recognised an analogy with one of the greatest themes of art; but he repudiated it, or rather buried it, and when he came to execute the painting in the Louvre he seemed intent only on the truthful realisation of every detail. Yet the intensity of this first vision remained, so that the picture, far from being a masterpiece of 'pure painting', is one of the most disturbingly tragic of his works.

Perhaps only Rembrandt, with his unequalled gift of turning human experiences directly into graphic symbols, could have given a moment of vision quite this size and fullness; for in general such experiences taper to a fine point. A true instinct led Thomas Bewick to compress into wood engravings as delicate as the skeleton of a leaf the impressions which had filled his eye during his daily twelve-mile walk from Newcastle to Cherryburn. We are reminded of the burning glass, casting its ray brighter and deadlier as its focus grows sharper, till suddenly a feather of smoke warns us that it has achieved, through intensity, a transformation of matter.

For this reason heightened perception is often to be found in the details of great works of art, lighting up a dull corner with inexplicable clarity. Writers on aesthetics tell us that the parts must be

subordinate to the whole: an admirable theory, but if we examine sincerely our own responses, how often from a long poem or a large painting we carry away nothing but the memory of a detail. One flash of intensified vision, expressed, it may be in no more than three or four words, has outweighed in our memories pages of rhymed philosophy and square feet of correct design. Even in Dante we remember most easily those similes which derive from a burning-glass perception — the drenched flowers, the storks *in lunga riga*, and the countless other birds which he saw with so sharp an eye. The Pre-Raphaelites were tempted to believe that a very detailed representation of natural objects was a guarantee of vividness; and it is true that long, hard looking does involve an effort of will which can scarcely be distinguished from heightened perception. Nobody scrutinised more tenaciously than Albert Dürer; but personally, I do not find that his drawings of plants and animals convey a tremor of excitement; they are simply the result of an unusually close co-operation between his faculties. Perhaps Dürer's ideal of craftsmanship was so exacting that all but the strongest feelings were smothered by technique, yet it is hard to believe that the irises and violets so marvellously described in his water-colours ever came alive to him. But there was one visible object which obsessed him: the human hand; and to turn from his drawings of plants to his drawings of hands is, for me, at least, to experience quite a different kind of communication.

Ultimately the question of detail is irrelevant; and in fact the nineteenth-century painter who saw common things with most intensity was not at all a Pre-Raphaelite: it was Van Gogh. A rush-bottomed kitchen chair is a commonplace object, and lacks those elements of growth and secret movement which often stimulate heightened perception. Yet so irascible was Van Gogh's eye that it 'could find no surface where its power might sleep', and his familiar chair becomes like the cult-symbol of some rustic faith, vital, awkward, and uncontradictable.

Van Gogh is essentially a northern artist, just as Cézanne is essentially mediterranean. We no more expect to receive mysterious messages from the indiviual objects in Cézanne's pictures of still-life than we do from the frescoes of Giotto. He may contrive to make a pear as grand as a Romanesque capital, but it does not speak to us with a secret urgent voice. In painting, at any rate, the moment of

# Moments of Vision

vision is predominantly a gift of the north. In the open squares of
Latin civilisation, with their resistant masonry echoing the shouts of
uninhibited extroversion, such moments are rare. There are too
many people about. Vision is the illumination of solitude: 'What
spells seemed on me when I was alone'; and northern man peering
through the tanglewood, or surprised by shapes emerging from the
mist, has a full reservoir of uncommunicated emotions to pour into
the narrow funnel of his perceptions. Thus Samuel Palmer, shut
away from his century in the solitude of Shoreham, saw enormous
moons hanging like ripe fruit in the branches of the apple trees, and
Caspar David Friedrich read strange messages in the ragged calligra-
phy of tree trunks or the rigging of ships. Yet we must admit that one
of the most necromantic of all pictures is by an Italian, Giorgione's
*Tempesta*. Here we reach the point when our moments of vision are
scarcely distinguishable from the imaginative faculty in general.
Certainly the woman seated on the ground, naked but for a white
cloak, suckling her baby, has the vividness of an actual experience
which has become symbolic\*. We feel that Giorgione must have seen
her, lit perhaps by a flash of lightning; and thereafter improvised the
whole picture to go round her. In fact we know from x-rays that on
the left hand side he originally painted another woman, also naked,
seated with her feet in a stream. But symmetry reduces an individual
experience to the level of decoration; and Giorgione had a second
inspiration of a different order when he transformed the bathing
woman into a young man, whose strange detachment in no way
compromises the vision, for he is like an imaginative projection of
the artist himself, both inside and outside the scene. Thus, from what
Paul Valéry called a *vers donné*, Giorgione has developed a complete
work of the imagination; and yet its virtue still derives from the first
flash of lightning. This is what separates it so decisively from such a
work as Michelangelo's Creation of Adam, an Alpine summit of the
imagination, but one seen in the clear and steady light of intellectual
day. All the vital observation which Michelangelo has put into the
drawing of Adam's body is controlled by knowledge. The details of
perception are like a garment clothing an ideal construction which
goes back in human experience to the Ilissus of the Parthenon. The
Adam is a triumph of that generalising faculty which, since Plato, has

\* Or should we say a symbolic experience that has become actual, because
she is the accepted symbol of *caritas* revived by observation.

been reckoned the best achievement of the human mind, and which dominates the theory of art till the time of Ruskin. Ironically enough it was Blake who first showed the inadequacy of the classical theory of art, in his notes to Sir Joshua Reynolds's *Discourses*. 'To Generalise is to be an Idiot. To Particularise is the Alone Distinction of Merit. All Sublimity is founded on Minute Discrimination.' And yet, as I have said, Blake's own perceptions had all been generalised for him, by Michelangelo and the Bolognese, precisely those academic painters from whom Reynolds's theories were derived. The fact that Blake took the memories of their works to be visions must lead us to enquire how far the moments of heightened perception which we are considering are influenced by existing works of art.

The visual experiences of original artists control, to a large extent, not only our imaginations but also our direct perceptions. Bernard Berenson has described how, on one snowy afternoon spent in the Boston museum looking at Chinese painting, he pointed to the wall and said: 'Look, there is the most beautiful of all.' A second later he realised that it was the window. Even those least responsive to art have at the backs of their minds a large untidy store of pictorial images, and three-quarters of what they call beautiful in nature appeals to them because it is the reflection of some forgotten painting. It is therefore tempting to suppose that moments of vision are sometimes precipitated by a coincidence which awakens such sleeping memories; that, for example, a pollarded willow suddenly becomes more vivid because we remember a painting by Van Gogh, or a knotted hand because we have seen reproductions of a drawing by Dürer. But although this convenient explanation may sometimes be true, I believe that as a rule the visual experiences which I am trying to define are more urgent — I may even say more physiological — in their impact than anything aroused by a second-hand aesthetic emotion. There is, however, something limiting in an already realised image. We hunger for the visible definition of our concepts, and turn avidly (and rather shamefacedly) to the illustrations of a book. Yet we know that the more convincing they are — Alice in Wonderland or Sherlock Holmes — the more closely they confine us. This is borne out by poetry. When Coleridge's imagination was fed by the words of Bartram's *Voyages*, or Keats's by Burton's *Anatomy*, they developed visions of an almost physical vividness; but when the poet draws his scene from a picture,

it is usually flat and artificial. The difference between the bright transparencies of *l'Allegro* and the congested descriptions in the later books of *Paradise Lost* may well be due to the fact that when Milton lost his sight his imagery was supplied by the memory of paintings he had seen in Italy, in particular the frescoes by Giulio Romano in the Palazzo del Te.

There is an even more conclusive reason why the memory of art has practically no connections with our moments of heightened perception: they come to us most vividly and most frequently at an age when there is nothing more in the lumber room of our aesthetic impressions than a few Christmas cards, date-boxes, and other equally exotic images; and we must therefore consider some other answers to our question. One, which has often been put forward, is that moments of vision are aroused by a sudden awareness of the inexplicable. The flow of accepted associations in which the mind, like a manatee, maintains a healthy torpor — what we gratuitously term the law of nature — is sometimes interrupted, and we are shocked to recognise, for a second, how odd things really are. This explanation may account for Keats's carpets; the ground is supposed to be solid and suddenly to see it undulating shocks us into heightened perception. The collar-bone of a hare probably owed some of its magic to mystified hesitation — too fine for a stone, too purposeful for a twig — what can it be? A school of modern art based its whole programme on the assumption that surprising conjunctions of opposites or reversals of habitual association will automatically produce a moment of vision. But, as we remember from the Surrealist exhibition, they do not. A moment of vision cannot be forced or concocted; and, in any case, we know that the objects which evoke it most often are not at all strange and shocking, but the trusted companions of our youth. It is true, as the Surrealists insist, that we often see them in a new and disquieting way, as when the grasses become huge as a jungle or the roots of trees the sinews of Beelzebub. But there are moments of heightened perception, the most numerous and most blissful when the familiar tree is still itself, only for some reason we are able to possess it.

Possession: here is a word which in most of its varying senses, seems to throw some light on our problem. In a moment of vision we possess, and we are possessed. It is rare to feel that anything is really ours except (as Samuel Butler said) when we eat it; and we

naturally value the half-second when for some mysterious reason we can do so. The element of possession is confirmed, I think, by the fact that objects which excite us in this way are so often small and apprehensible. Very few of us, like Traherne, can feel that we possess the whole world: 'the streets were mine, the temple was mine, the people were mine, their clothes and gold and silver were mine, as much as their sparkling eyes, fair skins and ruddy faces'. Our emotions of possessiveness are usually limited to things that we can hold in our hands or put our arms round — a tree trunk, a sea-shell, or 'the hedgehog furtively crossing the lawn'. But this idea of possession only defers our problem, for it leads us to ask why, at certain times, the feeling of personal ownership comes over us. What, after all, does this imaginative possession mean?

Once more we turn to Coleridge, who in any study of the imagination will be always at our elbow, and find a clue in a note published by Gilman, and quoted by Walter Pater.* 'In looking at objects of nature . . . as at yonder moon dim glimmering through the dewy window pane, I seem rather to be seeking, as it were asking, a symbolical language for something within me that forever and already exists, than observing anything new. Even when that latter is the case yet still I have always an obscure feeling, as if that new phenomenon were a dim awakening of a forgotten or hidden truth of my inner nature.' Self-discovery, self-identification: here, it seems to me, is the chief reason for the compulsive, all-absorbing nature of moments of vision. For an immediate and unconscious self-identification does indeed 'bind our feelings even as in a chain'. One of our first aims in life is to eat our cake and have it and although in the material sphere this is unfortunately very difficult, in the realm of the spirit it can be managed quite satisfactorily. In a moment of vision we are both participating with our whole being and at the same time contemplating our externalised selves with possessive delight. This is to some extent the state of mind which students of aesthetics have called 'empathy'. But it goes far deeper. It is not simply a life-enhancing participation in the activities of another creature, as when Keats entered into the life of the sparrow picking in

* In his essay on Coleridge reprinted in *Appreciations*; but Pater has not been able to resist some small changes which improve the rhythm of the first sentence, and adds the curious comment 'What a distemper of the eye and mind! What an almost bodily distemper there is in that!'

the gravel, but is related, as Coleridge says, 'to something within us that already and forever exists'. The very example he quotes proves the truth of his contention, for every reader of Coleridge has noticed the extent to which the moon, dim-glimmering or veiled in mist, is the master symbol of his own spirit, appearing at all beneficent crises of his finest poetry — in the *Ancient Mariner, Christabel, Dejection,* and *Frost at Midnight.* Yet this fact, so obvious to us, was evidently unknown to Coleridge himself; and precisely because it remained screwed down in the unconscious, never lost its potency. Let me give another example of a moment of vision which crystallises self-identification. It is the concluding paragraph of Ruskin's *Praeterita,* and the fact that this inexhaustible self-communicator was content for this to be his last message to humanity proves how important the vision had been to him. 'Fonte Branda I last saw with Charles Norton under the same arches where Dante saw it. We drank of it together, and walked together that evening on the hills above, where the fireflies among the scented thickets shone fitfully in the still undarkened air. *How* they shone! Moving like fine broken starlight through the purple leaves. How they shone! Through the sunset that faded into thunderous night . . . the fireflies everywhere in sky and cloud, rising and falling, mixed with the lightning and more intense than the clouds.' Anyone who has read with sympathy Ruskin's later works, and tried to follow the points of light which rise up and vanish into thunderous inconsequence, 'mixed with the lightning and more intense than the clouds' will recognise in the fireflies of Fonte Branda an allegory of his own creative faculties, made more vivid perhaps because he believed himself to be, as he put it, a mere slide-rule, an instrument of passionless measurement.

I emphasise this element of unconsciousness, because when self-identification becomes conscious it loses its peculiar power. At best it produces heraldry, at worst a kind of fatuous symbolism. We may occasionally contrive to know ourselves, but not on those terms. Similarly, moments of vision should not be exploited for moral ends. If transplanted from the field of purposeless contemplation to that of virtuous action, they lose their independent life. No painter of the nineteenth century had more commanding moments of vision than Jean François Millet. His figures take root in our imagination, so that a delver into the sub-soil like Salvador Dali cannot keep his hands off them. Yet the *Angelus* and the *Sower* have become

cheapened because Millet has made their moral-symbolical intention too obvious. Having strayed thus far into the world of action they have become subject to its laws and have renounced a part of their immortality; and Millet's powerful images might have been lost to this generation, had they not been re-interpreted in the free copies of Van Gogh. Van Gogh himself, although his gaze was intense to the limits of sanity, sometimes allowed his revivalist enthusiasm to guide his hand; and I find his picture of old boots less moving than his picture of an artichoke precisely because while painting it he became conscious of the boots as symbols of a hard road, a life of poverty and other well-worn concepts; whereas the artichoke suddenly burned with his own flaming inner life because he saw it only as an artichoke. Of course the temptation to interpret any intense experience according to our notions of morality is irresistible, and since, on the whole, words are more convenient than pictures as a means of expounding ethical doctrines, the poet may sometimes relate a moment of vision to his philosophy in a way that would be fatal to a painter.

This, perhaps, is a point at which slightly to modify the statement made at the beginning of the lecture: that moments of vision are almost identical in the two arts. The poet must translate his heightened perception into words and audible rhythms and so from the very first he is influenced by verbal and rhythmic necessities. However moving the sight of the daffodils at Ullswater, Wordsworth could not have written his poem if they had been called by a less agreeable name, if, for example, they had borne, as they do in Italian, the name of little trumpets —*tromboncini*. So instantaneous and involved are the movements of the imagination, that for a poet a visual experience may well be precipitated by the sound of a word. And perhaps even Newman's snapdragon found its way into his thoughts (for no thought lies too deep for words) partly through the associations which cluster round the word 'dragon', the conquered dragon of St George, the repentant dragon of St Sylvester, or the dragon cup which on ceremonial occasions stands on the high table at Trinity. If a foxglove had been growing opposite his window he might never have mentioned it.

Painting, on the other hand, begins and ends in the visible; and the intensity of a self-confirming perception may be so closely bound up with aesthetic perception in general that we can hardly distinguish

one from the other. Constable, the most Wordsworthian of painters, was certainly moved by 'willows, old rotten planks, slimy posts and brickwork' in the same all-absorbing manner as the poet. His letters, no less than his sketches, leave us in no doubt of that. But the emotions they aroused in him became a part of his visual appetite for everything in nature, and in his greatest paintings the impulse of the first vision is sustained throughout the whole. Even when certain features in a painter's work stand out and present themselves to us as records of heightened intensity, they have not been seen by chance, the eye wandering where it will, as a poet's may, but have been selected in conformity with what we can only call the artist's whole rhythmic organisation.

Leonardo da Vinci looked at swirling water with the same half-hypnotised intensity that Coleridge looked at the shrouded moon. His many drawings of cascades and currents, although done, as his notes tell us, with a practical intention, are certainly the record of heightened perception. But we can see from his studies of grasses and of plaited hair that their vital interlacings were all part of the pattern of his being and that the intensity with which he gazed at whirlpools was the result, rather than the cause of this pattern.

This confirms Coleridge's theory of self-identification. No man ever peered more penetratingly into nature than Leonardo, and yet even he was 'seeking a symbolic language for something within him that already existed'. What gives such disturbing power to his drawings is that the 'something within him', call it rhythmic organisation or what one will, was analogous to an objective truth of nature, the continuum of energy and growth as photography has revealed it to us. His moments of vision are not only emotionally true, as Samuel Palmer's are, but scientifically true as well.

It is often misleading to relate too closely the peculiar equipment of an artist with the accidents of his ordinary life. But the examples of vision I have quoted do seem, in most cases, to project a central truth of experience. That Dürer should have looked with heightened perception at the human hand is exactly what his whole work and character would lead us to expect. He was brought up in a family and a society of craftsmen; his earliest vivid memories must have been strong, disciplined hands wielding a graver, or knobbly hands grasping an adze; and all his life he saw humanity through the deeds of its hands, whether carving or arguing or praying. Leonardo also looked

14

attentively at hands, as the means by which the silent figures of a picture might speak. But this image was not at the centre of his thoughts. To him they were feeble and finite compared to the forces of nature, whereas to Dürer they were the first thing that a Christian needed for the glorification of his Maker. So Dürer's hands, like Leonardo's whirlpools, are not only moments of vision, but key-stones of autobiography as well. A similar interpretation of Van Gogh's sunflowers is too well known to be worth repeating.

How are these central obsessive images of the great artist related to the moments of vision which we all share? The question leads us to consider, what perhaps has been too long deferred, the visionary powers of childhood. The child, the ordinary man, and the creative artist are all moved by a flash of self-identification in the same way, but there is no doubt that the child is moved more often and that these flashes illuminate his whole being with a more penetrating light. It was this fact which led Wordsworth to evolve what I suppose we must call his mystique of childhood. 'Thou best Philosopher . . . thou Eye among the blind . . . Mighty Prophet! Seer blest!' It goes rather far, as a poet should. Still, we must admit that the heightened perceptions of children are within the experience of us all; and we can hardly help agreeing with Wordsworth when he says that they

> . . . surely must belong
> To those first born affinities that fit
> Our new existence to existing things.

There is really no rational explanation why certain natural objects — flowers, springs and streams, clouds, birds'-nests, trees — seemed so magical to us in our infancy; or why we still attach so much value to them when they are seen afresh for us by poets and artists. Now, although theories of a collective unconscious come dangerously close to crystal-gazing and the planchette, there is a quantity of evidence for believing that man has always instinctively needed certain images to nourish his spirit, just as he has needed certain foods to nourish his body; and amongst such evidence are those indestructible records of our mental and spiritual needs, the Greek myths.

The Greeks, believing as they did that man was uniquely impor-

tant, could not account for the urgent personal emotion inspired by certain natural objects except by the supposition that these had once been human beings. They recognised (and we may remember it from our youth) that the moments in which these objects reveal themselves to us arouse a feeling of ecstasy, almost akin to physical passion; and for this reason it is at the crises of amorous pursuit that almost all the metamorphoses take place. And what were the phenomena which demanded this kind of mythical explanation? The very same spring flowers, trees and pools, laurels and clouds which have enraptured every child long before he has been forced to construe Ovid. Nor are these presences confined to the fables of pantheism. Think of the ancient emblems of Christianity: the lamb, the spring of water, the lily, the rose, the crescent moon, the gold-finch, the pomegranate; do they not, when we discover them in the mosaics of the early church or the metaphysical paintings of the sixteenth century, touch immediately memories of our childhood. Who has seen a burning bush without feeling that some god will speak from it? And of all the objects of nature which, in our youth, filled us with awe and self-confirming joy, one was far more potent than the rest: the tree. I need not remind an audience brought up on *The Golden Bough* of the place of trees in myth and primitive religion. The ancient Hittite tree of life, the tree which the Lord God planted in the garden, the oak of Dodona, the olive of Athena, the Terebinth of the Teachers, the sacred trees of northern mythology: the list can be multiplied indefinitely.*

The moment of vision, although it is a fresh individual experience for all of us, gains its power because it is a morsel of collective experience as well. The poet and artist, born as we all are with a capacity for delighted self-discovery in certain symbols, finds amongst them a few which outlive his childhood because they nourish the centre of his creative being. So Ruskin discovered his responsiveness to sparkle and filigree — to fireflies and twig tracery; and Coleridge surrendered himself to the pale translucency of the moon. So Leonardo secreted memories of the mountain streams at Vinci; of 'the lizards and other strange small creatures which haunt an Italian vineyard'; and so Dürer was obsessed by the hands which had chiselled gigantically above and around his infant head. Indeed it

---

* According to Darwin the Gaucho Indians venerated trees so much that they offered them cigars.

16

is questionable if there is any central image in an artist's work which did not come to him as a moment of vision in childhood; and even the poet, whose references to things seen are inevitably more incidental — the seasoning rather than the substance of his work — constantly draws his images from a single type of visual experience. These flashes, which seemed at first to be no more than short — though mysteriously important — accidents in a work of art, turn out to be like sparks shot up from the molten centre of the imagination.

I have now reached the frontiers of my subject, given the limited form in which I had conceived it. I set out to discover why in literature and painting, certain things seen emerge with unpredictable vividness and dominate a whole work. By collecting instances it has been possible to show fairly precisely what these moments of heightened perception are like, and which objects most often arouse them. But when I have tried to say what gives them their peculiar power, I have been driven deeper and deeper into the dark forest of ancient memory and myth. One step more and I shall be with Yeats in the *spiritus mundi*. It is time for the student of art-history to withdraw.

# TWO

## The Blot and the Diagram

A few days ago I received a card of invitation which made me pause in the reprehensible, but almost mechanical, action of throwing such things into the waste-paper basket. It was to an exhibition of photographs of stains on walls, not, as one might suppose, organised by some enterprising manufacturer of paint or plaster, in order to show the bad results of ignoring his product, but by an art gallery which was exhibiting these results of damp and decomposition as works of art.

I wonder if that invitation has made you think, as it did me, of Leonardo da Vinci. As you all know, Leonardo was not only a great painter but one of the most powerful minds which have ever been applied to the theory of art. He was the initiator of the High Renaissance. He introduced the idea that form should be revealed by a contrast of light and shade, rather than by line. He created the first unified, heroic composition. And he was the first artist to break with the old workshop tradition, and become a world famous individual. His contemporaries no longer thought of him as a master craftsman, but as a creator with almost magical powers — a status to which artists have aspired ever since.

The first artist, in the modern sense, was by inclination a scientist. He wanted to find out how things worked. He loved to collect data, and filled many thousands of slips of paper with his observations. He loved to draw diagrams. Many of the diagrams were concerned with what we would call mechanical subjects — the action of levers, or the movement of water. But many were concerned with what we call art; the way light strikes a sphere, the way in which an image is conveyed to the eye. And he made no distinction between the various forms of knowledge. He believed that what we call science and what we call art are one. Art was a branch of knowledge, in which a permanent record of natural appearances was valuable, both for its own sake, and because it would furnish man's imagination with credible images of important things.

How far that seems from my invitation card! And yet Leonardo

was too much an artist in our modern sense not to notice that the imagination could operate in a different manner. Many of you will remember the passage in his *Treatise on Painting* in which he describes this contrary mode of operation:

> I shall not refrain [he says] from including among these precepts a new and speculative idea, which although it may seem trivial and almost laughable, is none the less of great value in quickening the spirit of invention. It is this: that you should look at certain walls stained with damp or at stones of uneven colour. If you have to invent some setting you will be able to see in these the likeness of divine landscapes, adorned with mountains, ruins, rocks, woods, great plains, hills and valleys in great variety; and then again you will see there battles and strange figures in violent action, expressions of faces and clothes and an infinity of things which you will be able to reduce to their complete and proper forms. In such walls the same thing happens as in the sound of bells, in whose strokes you may find every named word which you can imagine.

Later he repeats this suggestion in a slightly different form, advising the painter to study not only marks on walls, but also 'the embers of the fire, or clouds or mud, or other similar objects from which you will find most admirable ideas . . . because from a confusion of shapes the spirit is quickened to new inventions'. 'But', he adds, 'first be sure you know all the members of all the things you wish to depict, both the members of animals and the members of landscape, that is to say, rocks, plants and so forth.'

The Blot and the Diagram: these may be taken to express the opposite poles of our faculties and it is arguable that the connection between the two has produced what we call art. Perhaps I should be a little more precise about the word diagram. I mean by it a rational statement in a visible form involving measurements and done with an ulterior motive. The theorem of Pythagoras is proved by a diagram. Leonardo's drawings of light striking a sphere are diagrams, but the works of Mondrian, although made up of straight lines, are not diagrams because they are not done in order to prove or measure some experience, but to please the eye. They are crypto-blots, or blots masquerading as diagrams.

Now let me try to apply my title to modern art. Modern art is not a subject on which one can hope for a large measure of agreement, but I hope I may be allowed two assumptions. The first is that the kind of

art which we call, with varying inflections of the voice, 'modern' is a true and vital expression of our own day; and the second assumption is that it differs radically from any art which has preceded it. Both these assumptions have been questioned. It has been said that modern art is a racket engineered by art dealers, who have exploited the incompetence of artists and the gullibility of patrons; that the whole thing is a kind of vast and very expensive practical joke. Well, sixty years is a long time to keep up a hoax of this kind, and during these years modern art has spread all over the free world and created a complete international style. I don't think that any honest-minded historian, whether he liked it or not, could pretend that modern art was the result of an accident or a conspiracy. The only doubt he could have would be whether it is, so to say, a long term or a short term movement. You know that in the history of art there are stylistic changes which appear to develop from purely internal causes, and seem almost accidental in relation to the other circumstances of life and society. Such, for example, was the state of art in Italy (outside Venice) from about 1530 to 1600. When all is said about the religious disturbances of the time, the real cause of the mannerist style was the irresistible infection of Michelangelo. It needed the almost equally powerful pictorial imagination of Caravaggio to produce a counter-infection, which could liberate the artists of Spain and the Netherlands. I can see nothing in the history of man's spirit to account for this episode. It seems to me to be due to an internal and specifically artistic chain of events which are easily related to one another, comprehensible within the general framework of European art.

On the other hand there are events in the history of art which go far beyond the interaction of styles and which evidently reflect a change in the whole condition of the human spirit. Such an event took place towards the end of the fifth century, when the Hellenistic-Roman style gradually became what we call Byzantine; and again in the early thirteenth century, when the Gothic cathedrals shot up out of the ground. In each case the historian might produce a series of examples to prove that the change was inevitable. But actually it was nothing of the sort; it was wholly unpredictable and was part of a complete spiritual revolution.

Whether we think that modern art represents a transformation of style or a change of spirit depends to some extent on my second

assumption, that it differs radically from anything which has preceded it. This too has been questioned; it has been said that Leger is only a logical development of Poussin, or Mondrian of Vermeer. And it is true that certain elements of design in each have something in common. If we pare a Poussin down to its bare bones, there are combinations of curves and cubes which are the foundations of much classical painting, and Leger had the good sense and scholarship to make use of them. Similarly, in Vermeer there is a use of rectangles, large areas contrasted with very narrow ones, and a feeling for shallow recessions, which became the preferred theme of Mondrian. But such analogies are trifling compared with the differences. Poussin was a man of powerful mind who thought deeply about his art, and if anyone had suggested to him that his pictures were praiseworthy solely on account of their construction, he would have been incredulous and affronted. Still less do I trust those who compare the geometric art of the present with Celtic illumination, Cycladic vases and the warlike implements of Polynesia. Non-figurative art has been used in decoration at all epochs, and in some remote outposts of culture such as the Trobriand Islands or the scriptorium of Lindisfarne, it has been brought to an admirable point of perfection. But it has never been the central art of Europe, or India, or China. I believe that Ruskin was right in that excellent book *The Two Paths*, when he said that the perfection of decorative art was really a kind of death. And whatever else may be said about modern non-figurative art, it is not dead.

No: modern art had been 'something other' long before it called itself self-consciously *l'autre art*; ever since the first cubist pictures of 1909. And although people like myself with a taste for traditional art have gone on looking hopefully for a return to more familiar forms, in fact the living art of the time has become progressively more different from anything which has preceded it. It is depressing to feel cut off from the art of one's own time, as I am afraid many elderly people must always do: but ever since 1918 this feeling of baffled incomprehension has not been confined to the old and there has grown up in the minds of ordinary people a dangerous feeling of frustration. Can the historian do anything to relieve this situation by making it more comprehensible?

It is a truism that ideas which gain acceptance in philosophy, however harmless they sound when first enunciated, often have

drastic consequences in the world of action. Rulers who wish to maintain the *status quo* are well advised to chop off the heads of all philosophers. Belloc's 'remote and ineffectual don' is more dangerous than the busy columnist with his eye on the day's news. In this case I am thinking, of course, of the aesthetic ideas which were expressed in the writings of Benedetto Croce, and in particular of the belief that art is connected not with our rational, but our intuitive faculties. It was, in fact, the reversion to a very old idea. Long before Leonardo had advised the artist to draw inspiration from the stains on walls, men had admitted the Dionysiac nature of art. But they had also recognised that the frenzy of inspiration must be controlled by law and by the intellectual power of putting things into harmonious order. And this general philosophic concept of art as a combination of intuition and intellect was supported by technical necessities. It was necessary to master certain laws and to use the intellect in order to build the Gothic cathedrals, or set up the stained glass windows of Chartres or cast the bronze doors of the Florence Baptistry. When this bracing element of craftsmanship ceased to dominate the artist's outlook, as happened during the lifetime of Leonardo, new scientific disciplines had to be invented to maintain the intellectual element in art. Such were perspective and anatomy. From the purely artistic point of view they were unnecessary. The Chinese produced some of the finest landscapes ever painted, without any systematic knowledge of perspective. Greek figure sculpture reached its highest point before the analytic study of anatomy. But from the Renaissance onwards painters felt that these two sciences made their art intellectually respectable.

In the nineteenth century, belief in art as a scientific activity declined for a quantity of reasons. Science and technology withdrew into specialisation. Voltaire's efforts to investigate the nature of heat seem to us ludicrous; Goethe's studies of botany and physics a waste of a great poet's time. In spite of their belief in inspiration, the great romantics were aware of the impoverishment of the imagination which would take place when science had drifted out of reach, and as you know, both Shelley and Coleridge spent much time in chemical experiments. Even Turner, whose letters reveal a singular lack of analytic faculty, annotated Goethe's theories of colour, and painted two pictures to demonstrate it. No good. The laws which govern the movement of the human spirit are inexorable. The enveloping

assumption, within which the artist has to function, was that science was no longer approachable by any but the specialist. And gradually there grew up the idea that *all* intellectual activities were hostile to art.

I have mentioned the philosophic statement of this view by Croce. Let me give an example of its quiet acceptance by the official mind. The British Council sends all over the world, even to Florence and Rome, exhibitions of children's art — the point of these children's pictures being that they have had no instruction of any kind, and do not attempt the troublesome task of painting what they see. Well, why not, after all? The results are quite agreeable — sometimes strangely beautiful; and the therapeutic effect on the children is said to be excellent. It is like one of those small harmless heresies which we are shocked to find were the object of persecution by the mediaeval church. When, however, we hear admired modern paint-ers saying that they draw their inspiration from the drawings of children and lunatics, as well as from stains on walls, we recognise that we have been accomplices in a revolution.

The lawless and intuitive character of modern art is a familiar theme and certain historians have thought that it is symptomatic of a decline in European civilisation. This is one of those statements that sound well today and nonsense tomorrow. Far from our civilisation being in decline, the development of physical science in the last hundred years has been one of the most colossal efforts that human intellect has ever made. But I think it is also true that human beings can produce, in a given epoch, only a certain amount of creative energy, and that this is directed to different ends and different times — music in the eighteenth century is the obvious example; and I believe that the dazzling achievements of science during the last seventy years have deflected far more of those skills and endow-ments which go to the making of a work of art than is usually realised. To begin with there is the sheer energy. In every moulding of a Renaissance palace we are conscious of an immense intellectual energy, and it is the absence of this energy in the nineteenth-century copies of Renaissance buildings which makes them seem so dead. To find a form with the same vitality as the window mouldings of the Palazzo Farnese I must wait till I get back into an aeroplane, and look at the relation of the wing to the fuselage. That form is alive, not (as used to be said) because it is functional — many functional shapes

are entirely uninteresting — but because it is animated by the breath of modern science.

The deflections from art to science are the more serious because these are not, as used to be supposed, two contrary activities, but in fact draw on many of the same capacities of the human mind. In the last resort each depends on the imagination. Artist and scientist alike are both trying to give concrete form to dimly apprehended ideas. Dr. Bronowski, who did so much to make science comprehensible to the average man, once said: 'All science is the search for unity in hidden likenesses, and the starting point is an image, because then the unity is before our mind's eye.' He gives the example of how Copernicus's notion of the solar system was inspired by the old astrological image of man with the signs of the Zodiac distributed about his body, and notices how Copernicus uses warm-blooded expressions to describe the chilly operations of outer space. 'The earth conceives from the sun' or 'The sun rules a family of stars'. Well, our scientists are no longer as anthropomorphic as that; but they still depend on humanly comprehensible images, and it is striking that the valid symbols of our time, invented to embody some scientific truth, have taken root in the popular imagination. Do those red and blue balls connected by rods really resemble a type of atomic structure?

I am too ignorant to say, but I accept the symbol just as an early Christian accepted the Fish or the Lamb, and I find it echoed or even (it would seem) anticipated in the work of modern artists like Kandinsky and Miro.

Finally there is the question of popular interest and approval. We have grown accustomed to the idea that great artists can work in solitude and incomprehension; but that was not the way things happened in the Renaissance or the seventeenth century, still less in ancient Greece. The pictures carried through the streets by cheering crowds, the Te Deum sung on the completion of a public building — all this indicated a state of opinion in which men could undertake works of art with a confidence quite impossible today. The research scientist, on the other hand, not only has millions of pounds worth of plant and equipment for the asking; he has principalities and powers waiting for his conclusions. He goes to work confident that he will succeed because the strong tide of popular admiration is flowing with him.

# The Blot and the Diagram

But although science has absorbed so many of the functions of art and deflected (I believe) so many potential artists, it obviously cannot be a *substitute* for art. Its mental processes may be similar but its ends are different. There have been three views about the purpose of art. First that it aims simply at imitation; secondly that it should influence human conduct; and thirdly that it should produce a kind of exalted happiness. The first view, which was developed in ancient Greece, must be reckoned one of the outstanding failures of Greek thought. It is simply contrary to experience, because if the visual arts aimed solely at imitating things they would be of very little importance; whereas the Greeks above all people knew that they were important, and treated them as such. Yet such was the prestige of Greek thought that this theory of art was revived in the Renaissance without much conviction and had a deplorable recrudescence in the late nineteenth century. The second view, that art should influence conduct and opinions, is more respectable, and held the field throughout the Middle Ages; indeed the more we learn about the art of the past and motives of those who commissioned it, the more important this particular aim appears to be; and it still dominated art theory in the time of Diderot. The third view, that art should produce a kind of exalted happiness, was invented by the romantics at the beginning of the nineteenth century, and gradually gained ground until by the end of the century it was believed in by almost all educated people, and it has held the field in Western Europe till the present day. Leaving aside the question which of these theories is correct, let me ask which of them is most likely to be a helpful background to art (for that is all that a theory of aesthetics can be) in an age when science has such an overwhelming domination over the human mind. The first aim must be reckoned *by itself* to be pointless, since science has now discovered so many ways of imitating appearances which are incomparably more accurate and convincing than even the most realistic picture. Painting might defend itself against the daguerreotype, but not against Cinerama.

The popular application of science has also, it seems to me, invalidated the second aim of art, because it is quite obvious that no picture can influence human conduct as effectively as a television advertisement. It is quite true that in totalitarian countries artists are still instructed to influence conduct. But that is either due to technical deficiencies, as in China, where in default of T.V., broadsheets and

25

# The Blot and the Diagram

posters are an important way of communicating with an illiterate population; or, as in Russia, to a philosophic time-lag. The fact is that very few countries have had the courage to take Plato's advice and exclude works of art altogether. They have therefore had to invent some excuse for keeping them on, and the Russians are still using the pretext that paintings and sculpture can influence people in favour of socialist and national policies, although it must have dawned on them that these results can be obtained far more effectively by the cinema and television. This is a somewhat shallow line of thought. The truth is that art, in the usual meaning of the term, embodies beliefs that are part of the whole philosophy of a culture and it must not therefore admit an interpretation that would be damaging to the dominant idea.

Can we then say that art must be confined solely to producing a peculiar kind of pleasure, which we receive almost entirely through our intuitive faculties. Looking around for some parallel to guide me, as historians must, it occurs to me that the two ways in which art has reacted to the dominance of science may be loosely compared to the ways in which the Church reacted to Darwin and historical criticism of the Bible. On the one hand there was an attempt to rationalise religion till the supernatural element practically ceased to exist; on the other hand there was a defiant withdrawal into that *hortus conclusus* of the spirit, which rationalism and science could not touch; the movement represented in England by Cardinal Newman and the Tractarians. The broad church believed in diagrams, the high church in stains on walls. In the end I think it is fair to say that neither extreme has proved a satisfactory answer, because human beings wish to believe in something they cannot explain, but also wish to relate their beliefs to the quasi-logical processes which govern their actions. And something of the same need to bind together the two opposite poles of our experience seems to me to operate in art.

The impure nature of art, the unnatural marriage of truth and beauty, has been the despair of metaphysicians, and has only ceased to worry philosophers since they have agreed that both words are meaningless. But it was the illogical totality, the mystic union of the blot and the diagram, which gave art its value. Can it be re-established?

Now although, as I have said, the hiving-off of science, and with it about 80% of the creative will, has been a disaster for art, I do not

believe that artists should make a conscious attempt to re-absorb the discoveries of modern science. No doubt we should all know more about science than we do, but there is a vast difference between a little knowledge and real absorption; and I am afraid that a science-conscious art would be little more than a high-class form of science-fiction. There is also the absence of an acceptable imagery. In the middle ages artists often had to give visible form to the theological concepts which in their abstruse elaboration were in some ways similar to the intellectual constructions of modern physicists; and Renaissance artists seem to have illustrated the ideas of neo-Platonist philosophers. The aesthetic theories of Alberti and Piero della Francesca show a remarkable understanding of neo-Platonist philosophy. But in both these cases there was an inconography available — a set of accepted symbols or personifications — which made them possible subjects for painting; although, even so, certain subjects were always unsatisfactory, and (for example) our concept of the Trinity has been permanently weakened by the fact that art never evolved an adequate symbol for the Holy Ghost.

An iconography is like a language. It grows slowly as a result of internal pressure. Christianity, as we all know, started by using the imagery of paganism, and took almost four centuries before producing an acceptable image of the Crucifixion. We are involved in an extension of our faculties and a change in our basic assumptions as great as that which mankind went through in the first centuries of our era, and the historian must doubt whether art will find a means of expressing the new intellectual conviction for a very long time. So, as our relationship with the outside world becomes more doubtful and incomprehensible we are driven in on ourselves.

We are propelled in the same direction by another achievement of modern science, the study of psychology. That peeling away of the psyche, which was formerly confined to spiritual instructors, or the great novelists, has become a commonplace of conversation. When a good solid word like Duty is habitually transmogrified into Guilt, one cannot expect artists to accept good, solid externalisations of their feelings. The artist has always been involved in the painful process of turning himself inside out, but in the past, his inner convictions have been of such a kind that they can, so to say, reform themselves round an object. But, as we have seen, even in Leonardo's time, there were certain obscure needs and patterns of the spirit

which could discover themselves only through less precise analogies — the analogies provided by stains on walls or the embers of a fire. Now, I think that in this inward-looking age when we have become so much more aware of the vagaries of the spirit, and so respectful of the working of the unconscious, the artist is more likely to find his point of departure in analogies of this kind. Whether Jung is right in believing that this free, undirected, illogical form of mental activity will pick up, like a magic radio station, some deep memories of our race which can be of universal interest, I do know know. There is, and perhaps always will be, something mysterious about the satisfaction we receive from certain combinations of shape and colour.

For all these reasons, therefore, I believe that art will continue for some time to follow the course that it is following today. It will be intuitive, subjective and arcane — an art of accident rather than rule, of stains on walls (or on the unconscious mind) rather than of calculation, of inscape rather than landscape. This seems to me the first inevitable result of the triumph of science. But I do not think this will last forever. For one thing, the unconscious is easily exhausted. Dreams, as we all know, are not at all what the poets pretend — they are repetitive, banal and usually boring. The trouble with an art of stains and blots, as one can see by going to any international exhibition of tachiste painting, is its monotony.

And another reason why I think that painting will change its course is that art — it is the first meaning of the word — implies a certain skill and discipline; and the disciplines open to the tachiste painter are too easily exhausted. You will remember that Leonardo ended his enumeration of episodes to be found in the walls or embers with the words: 'and an infinity of things which you will be able to reduce to their complete and proper forms'. Although imitation is neither the beginning nor the end of art, it is a means, perhaps the only reliable means of uniting the diagram and the blot.

It is also a way in which the painter can develop and nourish his intuitive faculties; and it is a way in which the spectator can, so to say, make the reverse journey, back to the painter's first intuition. I do not myself believe that the new skills and disciplines of art will involve direct imitation; on the other hand, I do not think they can be divorced from our perception of the physical world, and will there-fore involve a complete knowledge of the forms and structures of the

natural objects which impress us most powerfully. As Leonardo said: 'first be sure that you know all the members of all things you wish to depict, both the members of the animals and the members of landscapes, that is to say of rocks, plants and so forth': advice which might have been given by Ruskin. It is because one feels in his work this knowledge of the members of animals and plants — of bones and roots — that his drawings make an impression on us different from that of his imitators.

Finally the intuitive blot will suffer in so far as it is an end in itself. The greatest art has always been about something, the means of communicating some truth which is assumed to be more important than the art itself. The truths which art has been able to communicate have been of a kind which could not be put in any other way. They have been ultimate truths, stated symbolically. Science has achieved its triumph precisely by disregarding such truths, by not asking unanswerable questions, but sticking to the question 'how'. I fancy that we shall have to wait a long time before there is some new belief which requires expression through art rather than through statistics or equations.

However, I am an historian, not a prophet, and may already have gone too far in simplifying a complex situation. The one point I would like to leave in your minds is this: that the development of science, with all that has accompanied it, has touched that part of the human spirit from which art springs, and has drained away a great deal of what once contributed to art. To expect that works of art will take the same form as they did before these momentous changes is unhistorical and unintelligent. We may not like the present condition of art and we may be sickened by the cant and half-baked philosophy that accompanies it. But we must recognise it as a natural consequence, the cost even, of a glorious episode in the history of man, and wait patiently for our faculties to be reunited.

# THREE

## *Iconophobia*

'Thou shalt not make to thyself any graven image, nor the likeness of anything that is in heaven above, or in the earth beneath, or in the water under the earth.'

At least twice a year, for centuries, this clear unequivocal commandment fell on the ears of Christian congregations, and in the Church of England appeared on the two Tables of the Law that were placed over the altar in every parish church: the second commandment. Nobody paid the faintest attention to it. People continued to indulge the human instinct — and instinct going back to paleolithic times — of making images of living things. Well, the ten commandments have long been removed from the east end of churches. They can sometimes be found in the vestry; but on the whole they have been put out of sight. As Bertrand Russell once said, they are like the questions in an old-fashioned examination paper — 'Not more than six to be attempted' — and in the last few years the number has dropped to three. But during the same period one of the commandments has been reaffirmed with a violence and a feeling of virtue comparable to that of the most austere religious sects: 'Thou shalt not make to thyself any graven image. . . .'

We must not deceive ourselves, as elderly people are often tempted to do, that this is a passing phase or the self-gratifying dogma of a small coterie. Let me give you an example of how powerful it is. When I was in New York a few years ago, not only were three of the chief public galleries — the Guggenheim, the Museum of Modern Art and the Whitney — almost exclusively devoted to non-representational art; but in the Metropolitan Museum, which was instituted for a very different purpose, the whole main floor had been emptied – Titian, Rembrandt, Rubens, Tiepolo, Degas, Cézanne — all banished, and in their places hung pictures that contained no image of anything on the earth or in the waters. This display represented the judgement of a director who was not only exceptionally intelligent, but had his ear to the ground, and I think it should persuade us that our contemporary rejection of represent-

ational images must be taken seriously by historians and still more by artists, who have no hope of winning a competition or being chosen for an international exhibition unless they conform to it. They have not even much hope of earning a living. A painter whose work I have long admired cannot get a teaching job at even the most humble provincial Art school because his work is naturalistic. It may seem hard to imagine a work of art in which all reference to natural objects has been completely suppressed, but they occupy the place of honour in most collections of contemporary art. If this is true of pictures, it is even truer of architecture, where there is an economic as well as an aesthetic motive for omitting all figurative ornament.

This is far from being the first epoch in which representational images have fallen into disrepute, and aroused positive hostility. Iconophobia, if I may be allowed a convenient word, is a very ancient attitude and has reappeared in the history of art a number of times: in Judiac culture, in Islam, in Constantinople, in twelfth-century France, all over Northern Europe in the sixteenth century, in England in the seventeenth century, and in certain eastern religions. No doubt it represents some deep-seated human necessity, and it seems to me worthwhile trying to discover some of the conditions which lead to its periodical revival. Before doing so I must clear up one point. The great image-hating cultures I have mentioned have never ruled out the worship of material objects. The Jews held sacred the Ark of the Covenant, which was presumably a plain wooden box; the Moslems worship the Black Stone in Mecca. What they objected to was not fetishes but images — the painted or sculptured imitation of living things. So in spite of the jungle of theological argument that has overgrown the various iconoclastic movements, the deepest motive seems to me to have been always the same; the fear and hatred of images that represented living things.

Let me return to the second commandment. It seems to be the oldest condemnation of images, although exactly how old we cannot say. It occurs twice in the Old Testament, once in Exodus, once in Deuteronomy. Both these books are accepted by biblical scholars as compilations, put together after the Babylonian captivity in order to give the Jewish people a written, as opposed to an oral, tradition of history and law. The date of the compilation is probably the fourth century BC; but the traditions they represent must be much older. Many incidents in the books of Moses are tolerable only if we think

of them as dating back to a very crude tribal society, and several episodes clearly belong to a time before the laws and rituals of the Jewish people had taken a consistent form. Amongst these are a certain number of references to images — the terrapin put into David's bed which was sufficiently life-like to have deceived Michal; the serpent that Moses raised up in the wilderness, which for a reason which will become clear was considered less idolatrous than the golden calf of Aaron or the seraphim on the corner of the Temple. These have worried biblical commentators and strict protestants. But what an astonishingly short list it is; and this scarcity of recorded images is confirmed by the evidence of archaeology. In a country where almost every inch of ground has been dug, not one single image of any significance has emerged. There is no doubt that this people who produced one of the three or four greatest bodies of literature in the world, a literature, moreover, full of imagination, imagery and even the observation of nature, felt no impulse to make these experiences visible in painting or sculpture. And as so often happens in life, they turned their limitation into a moral and religious principle.

What do we know about the early history of this people so devoid of the plastic gift as to make the hatred of images into a corner stone of their religion? Very little. But historians allow us a few conjectures. They were a break-away Syrian tribe who rebelled against the settled life of the great river civilisations. They were, if you like, Luddites who rejected the Neolithic revolution. They were wanderers, living in tents, chiefly in the hills. The cities of the plain were an abomination. They must have carried with them in their first flight from the north-east the memory of a great plastic tradition, the art of Mesopotamia. These quasi-nomads were frontiersmen between two empires, the settled communities of Syria and Egypt, and in the course of the interminable wars between them a section of the southern border fell under Egyptian domination, and its inhabitants were used as cheap labour.

Once more they were surrounded by plastic art. The Temple of Karnak is a magnificent ruin, but when every one of its reliefs was coloured, it must have been terribly oppressive, and the Egyptian deities standing in solemn rows seem, even today, more like idols than works of art. Under an inspired leader, the frontiersmen turned their backs on the fleshpots of Egypt — on all that goes with a

32

settled civilisation — and once more became wanderers in particularly tough country, the mountains of Sinai. It may well be that during this period they formed themselves into a unified clan, and in doing so established some of the prohibitions and rituals that were transmitted orally for five hundred years. When they had savagely fought their way to some kind of settlement they seem to have had the notion of a god, and they wished to build him a temple. They were not capable of doing it themselves, but had to get their architects and craftsmen from the sea-coast towns, which were no doubt as corrupt as Naples, Palermo or Marseilles. The Phoenicians had no authentic art of their own and their version of the current mediterranean style shows no comprehension of the Greek sense of beauty. If our scanty evidence is any guide, the ornament that they applied to the Temple of Jerusalem was secondhand and perfunctory. To the people of Judah it would be associated with an idol worship even more degraded than that of Egypt and Syria. It must have strengthened them in their fear and hatred of images.

So much for what I may call the external factors in Jewish iconophobia: a wandering people for whom visual art is no more than the stitched border of a tent or a prayer mat; the reaction of such a people against the images that were associated with an oppressive regime; the sense of primitive virtue that poor communities develop as compensation for the more agreeable way of life of their powerful neighbours. All this has continued to be a factor in the fear and hatred of images. But beyond this was what one can properly call a philosophic factor. I call it philosophic rather than religious, because the notion that it is not only impossible but blasphemous to depict the Absolute occurs in both Judaic and Hellenistic thought, and at about the same period.

The voice that spoke to Moses out of the burning bush, or the single almighty being who spoke through the prophets, was infinite, and to give him finite shape in visible form was blasphemy. Antisthenes, a pupil of Socrates, said 'although there are supposed to be many gods, there is in reality (kata phusein) only one. God is not like any body; no one can learn from an image what he is.' Now if we consider a period in art when practically all representations were of divine or semi-divine beings — and this included likenesses of a king or pharoah — it will be seen that monotheism, in a pure form, is inevitably hostile to images. To represent minor gods is to encour-

age idol-worship, to represent the true god is to limit and debase him. 'God is a spirit, and they that worship him must worship him in spirit.' Those words would have been equally acceptable in the Greek and the Judiac world. The difference was that the Greeks had inherited a matchless tradition of image-making, whereas the Jews had, at best, the traditional crafts of nomadic peoples.

The combination of external and philosophic forces pushed the iconophobia of the Jews to lengths unequalled even by the Quakers. It was a sin not only to make or to worship, but to set eyes on any image. Josephus himself, an intelligent and conscientious man, when he had command in Galilee, urged the local council to pull down the palace of Herod Antipas because it contained representations of living creatures: a remarkable anticipation of the most enthusiastic reformers of the seventeenth century. A troublesome problem was presented by coinage, which normally bore the likeness of a reigning emperor. One Rabbi, named Nahum ben Sinai, achieved the feat of never in his whole life looking at a heathen coin, for which he received the title 'the all holiest'. One up on our Reformers, but only just ahead of our contemporary iconophobes, because when the Mint Committee was considering the decimal coinage, we received many letters and memoranda urging us to put an abstract design instead of an image of the sovereign. I often thought of Rabbi Nahum.

Given the overwhelming Judaic element in Christianity, it is really very extraordinary that a Christian art came into existence; in fact the early Christian fathers were strongly opposed to it. Quite apart from the argument that God is a spirit, they were engaged in a struggle with a culture that had produced a crop of visible gods and goddesses so large, so diverse and so shameless that compared to them even the hybrid Egyptian pantheon was restricted and respectable. The Church fathers had no doubt at all that these images were idols, and to pay them respect was devil-worship. Nor were these holy men likely to be deterred by the notion that images were 'works of art'. Artists did not enjoy the privileged position that they do today. In the pseudo-Clementine Church Order a painter is put in the same list as a harlot, a brothel-keeper, a drunkard, an actor and an athlete. And yet, as we all know, a Christian art gradually came into existence both in the west and, even more surprisingly, in the east.

There are few more moving examples of the necessity of the

image to mediterranean man than the classic Christian art that grew up in Italy in the fourth century, chiefly I believe in the Milan of St Ambrose, but also in the uneasy society of Rome. Let me take as examples two ivories, clearly by the same artist, who may well have been working in Milan. They are both concerned with the Resurrection. They show a balance of truth and decoration that has never been surpassed. They have a perfect mastery of low relief and a classic largeness of form. The Angel — if indeed it be an angel and not the risen Christ — has been evolved from an antique philosopher, but the two women show real Christian feeling. This is even more evident in the group of the three Maries in the other ivory. This angel is more classical (still without a nimbus) but the figures of the sleeping guards, and the apostle who witnesses the Ascension of Christ have a humanity almost unknown in the Hellenistic world. It is quite clear that artists of the time had no hesitation at all in representing Christ. Another example is the famous silver casket in S Nazaro e Celso, which seems to have been made about the year 382, and contains one of the earliest dateable representations of the Virgin and Child. The quality of the low relief suggests that it was inspired by a painting in the atmospheric style of late Hellenistic wall-painting. The Virgin is frontal, but human; the Child has no trace of the frontal, hieratic pose, which probably already existed in the east. We can see no trace of dogmatic pressure or even of an iconographic tradition. The most extraordinary instance is an ivory casket at Brescia, in which scenes from the Old and New Testament are treated with perfect confidence and a classic sense of economy. The artist even shows the head of the Almighty speaking to Moses. The second commandment and the Judaic hatred of images is completely forgotten and the classical figures of late antique art have been, so to say, baptised.

In eastern Christianity the status of the image was a good deal less secure. There were, of course, doctrinal reasons for this. The original objections of the early fathers were maintained by many individual theologians, such as Eusebius. But the real reason why the image declined in the east was not theological, but stylistic. The great change in what German art historians call 'the form-will' which for six hundred years destroyed the human norm of Hellenistic art was ultimately an eastern movement. I shall not try to describe in a few sentences what was undoubtedly the most far-reaching and complex

revolution in the whole history of art before 1910; but broadly speaking, it was a movement away from a plastic, naturalistic style to a decorative and increasingly abstract style.

A familiar example of the approaching flight from the image is one of the earliest surviving fragments of Byzantine illustration, the Rossano Codex. In it an actual head can be painted with a Hellenistic sense of tone, but the general disposition of the page is entirely decorative and symbolic.

To realise how the heart had gone out of representation in the fifth century, one must visit the Coptic Museum in Cairo. The figurative representations, although sometimes what is known as amusing, are crude and incompetent, both in vision and execution; the purely decorative carving is masterly and shows in every curve the energy of conviction. And this contrast between figurative and abstract art ante-dates by a hundred years the Islamic prohibition.

The grandest specimens of non-representational art are to be found in the churches built in Constantinople in the sixth century. These churches seem to have been entirely devoid of representational sculpture or painting; and what sublimely beautiful works of abstract art they produced. But there are two capitals from the Church of St Sergius and St Bacchus (527), and a capital in the Church of Holy Wisdom of a few years later, which comes near to breaking the second commandment, as the underlying motive is some kind of acanthus, but so transformed by geometrical skill as to have taken the essential step from imitation to intellectual construction. Not that the senses were denied in S.ta Sophia: the use of colour and materials has a refined spiritualised sensuality unequalled in the post-Byzantine world. But this too is divorced from the likeness of anything on earth.

Given this magnificent rejection of the image in the most sophisticated capital in the world, except Ch'ang an, it would not have been surprising if an almost illiterate tribesman from Mecca should have condemned all representational art. As a matter of fact there is no condemnation of images in the Qur'an, any more than there is in the works of Luther. There is a tradition that on his return to Mecca from Medina, the prophet ordered the destruction of the idols that surrounded the Kaaba — the black stone that is the fetish of Islam. Only a tradition, but quite early, and I think credible because the prophet was a passionate monotheist. The will of Allah, reiterated on

every page of the Qur'an, could not have tolerated the existence of a secondary pantheon.

No one who is not an Arabic scholar should express an opinion — but the Qur'an makes on me the impression that it records the living voice of the prophet. On the other hand the Hadith, which takes an expressly hostile attitude to images, seems to me a later compilation. Such hostility is completely understandable. Islam was not only monotheistic, but in its origins, puritanical. It was, as you know, basically Judaic. Mahomet considered the founder of his religion to have been Abraham, and its first great exponent Moses. He took the commandments literally, and he continued the democratic primitivism of early Jewish society. For example, Moses, in the same chapter of Exodus in which he delivers the second commandment, says 'an altar of earth shalt thou make unto me . . . and if thou build me an altar of stone, thou shalt not build it of hewn stone'. In the same spirit the early Caliphs pulled down pulpits, because they lifted the preacher above the people, and destroyed the *mihrabs* in mosques, because people might be tempted to ornament them too richly. They were what the seventeenth century called Levellers. Mahomet's own objection to representational art was really an objection to all art. He had no time for it. However his immediate followers concentrated their objection on imitation (that false basis of Aristotelian aesthetics). They said that representational art was wicked, not simply because it led to idol-worship, but because it was a lie. You can paint a picture of a fish, but you cannot make a real fish. It is rather the same objection that God-fearing puritans used to make against novels.

'I am come to bring not peace but a sword'; Mahomet, the last of the great prophets, fulfilled that prophecy. But inevitably his puritanical ignorance of art could not survive the conquest of the ancient centres of artistic culture. And yet, as we all know, this puritanism did not last. It was defeated by the love of grandeur; and so strong was the pull of style that the second major mosque, the great Mosque of Damascus, built in 715, has mosaics of trees and a house with drawn curtains in a late antique style. As you all know, the architectural form of the mosque was derived from the great churches of Byzantine Christianity — SS Sergius and Bacchus, and of course S.ta Sophia. It is a curious paradox that these Christian churches were probably far more aniconic than the first great mosque of

# *Iconophobia*

Islam, the Dome of the Rock (691), which contains decorative motifs derived from the Hellenistic repertory. Still one must admit that the rich decorative abstract style that one sees foreshadowed in the rather crude Coptic carvings of the fifth century reaches a point of absolute mastery in the palace of M'shatta — an Umayad hunting-lodge given to the Kaiser by the Sultan of Turkey, and now in East Berlin. It is really superb, and shows that by the eighth century a new element had entered the formation of Islamic art: Persia.

The Persians were always bad Moslems. They were deviationists, called Shiites, and their style had never been completely cut off from the glories of the Sassanian empire. Human figures are relatively rare, and are subordinate to decoration. Only a few stylised animals and magnificent birds continue to appear. Islam continued to be based on the word (and the chant), not the image; and when the impulse to embellish man-made objects became too strong to be resisted, it was the word made visible that provided the subject matter of painting and sculpture. Whatever its origins, Cufic lettering became a great art form, less personally revealing than Chinese calligraphy, but more architectural. Islamic ornament based on Cufic lettering is perhaps the most beautiful in the world because its content is both significant and almost infinitely adaptable. It can cover a dome or constitute a frieze; and it can dance in a nonchalant manner over the surface of a mosque lamp.

By a curious accident, the earliest examples of the abstract style that we associate with Islam were produced and preserved in the west. Just as the bronze sculpture of late T'ang China was melted down by the Tartar invaders and is preserved only in Japanese temples (where it is called Japanese), so the marvellous designs of Syrian and Egyptian craftsmen of the seventh century are first reflected in the illuminated pages of Celtic manuscripts. The Lindisfarne gospels contains both the flowing style and the carpet style — rightly so-called because it is no doubt inspired by Syrian carpets. As always, a wandering style is ultimately a weaving style.

There is nothing at all mysterious in how this style got to Ireland. The Christian monks, who, in the first half-century of Islam, fled from the eastern Mediterranean, made their way to the Western Isles, and no doubt took with them as many of their treasures as they could. Pieces of Sassanian silver have been found in dykes in Ireland. Their rugs formed the basis of their style when they began to

illuminate gospel books. What is remarkable is how they have used a strange deformation of the Roman alphabet with almost the same effect as the Cufic lettering in Islamic decoration. It seems to me almost inconceivable that this use of lettering as decoration could have come into existence without the example of Cufic. Let me add, in order not to inflame nationalist feelings, that although the general lay-out and most of the ornament on these pages is unquestionably eastern, all of them contain decorative motives that might properly be called Celtic, that is to say related to such decorative objects, and others show grotesque birds and animals round the edges of the kind that one associates with the Norsemen.

The style of these pages is so evolved and assured that I think one must presume that it existed before the time of Islam. After all, the Lindisfarne gospels can only be about fifty years later than Mahomet's flight to Medina — 622. Personally I am convinced that this had been the current style in Syria and Egypt for some time before that date and that Islam adopted and continued the style because it was free from imagery. But owing to the destruction of war and bigotry, the only surviving examples of the style are to be found in these manuscripts.

This eastern style produced imageless works of art of great beauty for over seven hundred years. Of course, images slipped in, especially among the heretical Persians. But it remains the greatest body of abstract art the world has ever known, and until the present day had had no parallel in either the west or the far east. I derive deep satisfaction from it, but I think it has one drawback — that it had so little power of growth or development. Every now and then one is aware of a new invention; but on the whole the lack of development is almost incredible. An example is a fourteenth-century book-binding, which has changed very little in the seven hundred years since the pages of the Lindisfarne gospels: a period of stasis almost as long as one of those in Egyptian art. One could find dozens of *Mihrab* which tell the same story. As far as I know it was Ruskin, in a book called *The Two Paths*, who first observed the unevolving character of near eastern art (he did not associate it with abstract design, but with Islamic art as a whole): and he made the point that however crudely and painfully an artist tries to convey those impressions of human life that his eye reports to him, it stretches his power of skill and sympathy in a way that the repetition of perfected formulae does not.

# Iconophobia

I don't think we need follow Ruskin when he says that abstract art, if long pursued, leads to the destruction both of intellectual powers and moral principle, but I do think that the finality of Islamic art, even the best of it, was bound to lead to sterility.

Meanwhile in western Christianity imagery continued; and in about the year 600 it received a sanction which should be regarded as one of the crucial events in the history of art: the letter that Pope Gregory the Great wrote to the Bishop of Marseilles: 'It has come to our ears' he said, 'that, fired with inconsiderate zeal, you have broken up pictures or images of the saints, on the ground that they ought not to be worshipped. That you forbade them to be worshipped we altogether approve; but that you broke them up we pronounce to have been wrong. For the unlettered, the heathen especially, a picture takes the place of a book. So if anyone desires to make images, do not forbid him.' In the west this pronouncement held good till the Reformation, and to it we owe the thread of continuity that runs through western art.

In the eastern church things did not go as smoothly. The spirit of Judaic puritanism had never died out, and in 716 the corrupt Byzantine empire fell under the rule of a great puritan leader, known to history as Leo the Isaurian. Like the original people of Israel, he came from the Syrian highlands, and like them he saw the profusion of images as a symptom of corruption. He saw the importance, both religious and political, of monotheism. I think there is no doubt that he was influenced by Islam, and his chief lieutenant, named Beser, had in fact been a Moslem. Thus began that extraordinary episode in history known as the iconoclastic movement which in so many ways — its destructive impulses, its mixture of politics and theology — anticipates our own Reformation. The comparison of Leo the Isaurian with Henry VIII, like so many historical *jeux d'esprit*, is incomplete. Henry was a better theologian and a less admirable character. And the loss to art was greater in Byzantium. The tradition of painting, mosaics and sculpture that had grown up in Constantinople between the fourth and the eighth century must have been one of the most refined and elevated expressions of the image-making faculty in the whole history of art, but so thorough were the iconoclasts that no trace of it remains, except in later versions.

Amongst the thousands of images that were destroyed, one was

40

supposed to have been saved, the Virgin Mary showing the Christ Child as the Giver of the Word: the so-called *Virgin Hodegetrias*. This famous image, traditionally ascribed to St Luke himself, and certainly dating back to the early days of Christianity, has come down to us in numerous replicas, said to be derived from the original, although all of a post-iconoclastic date. The fact that it remained a source of inspiration till the time of Raphael shows the power of images, and could be taken as a justification of the iconoclastic movement. That it represents Christ showing the Word is ironically appropriate, because as the iconoclastic controversy developed it became a war of words and generated arguments that went far beyond the quasi-political puritanism of Leo and Beser.

In their desperate attempts to refute the iconoclasts, the defenders of images developed two or three arguments that have had a considerable bearing on all aesthetic thought to the present day. The first and simplest is the classic text of St Basil, 'The honour paid to the image passes to the proto-type'. This is the basis of Ruskin's theory of art, and of social realism in general. The second is the neo-Platonic notion that the value of an image resides not in imitation, but in form and idea. Of course, this doctrine, which finally overthrows the old Greek theory of imitation, could have been deduced from Plotinus; but it was the defence of images in the eighth century which, so to say, brought it into action. This is the basis of most modern thinking on aesthetics, including my own. The third argument of the iconophiles was that God made man in his own image. We would not express it quite like that today; but we might still allow that man had what our grandfathers called a divine spark. At least he remains the most interesting object in the world, and to cut ourselves off from representing him in art is a serious deprivation.

But important as the philosophical issues were (and are) the image controversy in the eastern Church has less relevance to my subject than one would expect, because after the first wave of puritanism, only *holy* images were destroyed: even in court circles no one seems to have objected to the representation of profane personages who could not be worshipped: and eighth-century Byzantium produced a number of spirited, but somewhat confused, reminiscences of antique mythology which have survived chiefly on ivory boxes. When finally the iconophiles won the day there were still a number of artists trained in image-making who could recreate (we shall never

know with what differences) the first great imagery of Christianity.

In the West the image revived as the quality of human life revived; and indeed was partly instrumental in its revival. Pope Gregory's far-seeing pronouncement became more relevant when, after the seventh century, literacy had declined, and even kings and emperors were unable to read. Who can doubt that such works as the doors of Hildesheim or the font at Huy extended, through imagery, the human understanding of unlettered man. In general it was, as Gregory had foreseen, the straightforward narratives of the Gospels and legends of the saints that occupied artists and instructed the simple. But through symbolism and the juxtaposition of images the most abstruse questions of theology could be given expression. And we must allow that by the middle of the twelfth century the image making faculty had, so to say, become autonomous. It took full advantage of its freedom; some of the images produced by the school of Cluny are surely the result of a self-delighting exuberance. In contrast to the capitals of Toulouse or Autun, where the sculptor is still presenting a clear and credible representation of the sacred legend, a work like the *trumeau* of Souillac does look like the overspill of an overcharged imagination. Perhaps this instance is unfair, as the sculptor, whom we may call the Moissac master, was evidently an eccentric — one of those artists who, throughout the ages remind us that the haunted neurotic was not an invention of the nineteenth century. But in general, Cluny encouraged an abundance of imagery, just as she encouraged a profusion of ritual; and this inevitably led to a reaction.

This time the protestant was not a semi-literate camel driver, nor an ambitious politician, but a man of the highest culture and intelligence, St Bernard. He was the greatest of all puritans. It is true that like Mahomet and Leo the Isaurian, he associated purity with unity — in his case the unity of Christendom. But fundamentally his objection to images was the same that we have met before in St Augustine and shall meet again in Tolstoy; that inevitably they tend to debase the quality of spiritual life by offering diversions and distractions. We must add that although St Bernard saw the danger of images, and banished them, as far as possible, from the churches of his order, he was no iconoclast; and in fact it is in a manuscript in the library of Citeaux that we find one of the earliest western reproductions of the icon *par excellence*, St Luke's *Virgin Hodegetrias*.

# Iconophobia

St Bernard's feelings that images might mislead or corrupt represents the highest point of my subject. It expressed a powerful moral conviction and led to the creation of an imageless style purer than anything in Islamic art. The next chapter in the history of iconophobia is, on the whole, the most disreputable: I refer, of course, to the Reformation.

Please do not think that I am denying the value, or indeed the necessity, of the Reformation in theological and institutional matters, or questioning the spiritual greatness of the leading reformers. But the curious thing is that the destruction of images seems to have played no part in their doctrines. The Reformation was a very complex incident, in which the symptoms of spiritual hunger and discontent took many forms. There may have been sects (although I can find no account of them) which objected to images on the same grounds as earlier iconoclasts. In a muddled way the veneration of images was confused with the veneration of relics which had been the object of reforming zeal from Erasmus onwards. And funeral monuments were thought to imply belief in the doctrine of Purgatory. But neither Luther nor Zwingli were opposed to images, and Calvin, who is usually cast as the villain of the piece, was a typical austere Frenchman of high culture, who would never have given his authority to wholesale destruction. At most he would have said, like the early Christians, and, for that matter, the early Buddhists, that representations of the deity were apt to be misleading because they gave finite form to the infinite. In any case Calvin belongs to the second wave of the Reformation, and much of the harm had been done (especially in Germany) by 1525.

That damage was also done in England and France our cathedrals and parish churches bear witness; and in default of other evidence, I believe that this was chiefly due to a kind of popular frenzy. Images were rightly recognised as symbols of an existing order that had to be overthrown and humilated; and just as the Spanish revolutionaries in 1937 shot the Duke of Alba's horse, so the mass of people who for the first time were feeling their power, turned on these symbols of hierarchy.

In support of this theory, one may notice that an even more ferocious destruction of images took place during the French Revolution, although this was no part of the Jacobin programme. The destruction of images was chiefly an inarticulate social protest.

43

# Iconophobia

However, I think it would be optimistic to push this theory too far. I believe that a great many people, perhaps a majority, really hate art as such, not because it is a symbol of a dominant class, but because it represents a scale of values that they do not understand. They would be glad of any excuse to attack it, and we are really very lucky that some mysterious feeling of awe usually prevents them from doing so.

That there was also a kind of sporting instinct involved is shown by many accounts of destruction: for example the story of how a certain Mr Ford cut the bases of all the sculpture in Winchester College Chapel, linked them to a single cord and on the stroke of midnight pulled it so that 'at one moment all the golden gods came down. It awakened all men with a rush; they were amazed at the terrible noise'. But by the time they came to the Chapel, Mr Ford, whose rooms were near by, was in bed, feigning sleep.

This episode seems to have taken place as late as 1554, and a print exists showing a similar technique in a church in the Low Countries, where a well-organised destruction of images took place under Calvinist influence in 1566. There is no doubt that the fear of images, and their destruction, continued throughout the whole sixteenth century in an unco-ordinated way. Under the Puritans of the mid-seventeenth century it became a much more serious affair, because once more there was behind it a body of doctrine. As far as I know no one has ever tried statistically to work out the relative achievements of Henry VIII's reformers and the Puritan levellers as image smashers, but I incline to think that the latter had much the bigger bag to their credit. Certain great works, like the Chapter Houses at Salisbury and Ely, were undoubtedly left for the second wave of iconoclasts to destroy. The journal of the arch-destroyer, Dowsing, who was in charge of East Anglia, is a painfully Sovietic document. On the other hand, we must admit that the more godly members of the Long Parliament really wanted to purify worship; and out of their intentions came what is surely the purest form of worship ever put into practice: the Quakers. There is something noble about this attempt to eliminate everything which could appeal to the senses, either directly, or through the imagination. A curious and moving example of the revulsion from images is evident in the poetry of Milton. *Paradise Lost* is still the work of a man deeply influenced by the Italian Renaissance, and Milton takes every opportunity to

44

# Iconophobia

ornament his poem with imagery as rich as the cortile of the Palazzo
Spada. He delights in sonorous roll-calls of heathen idols. By the
time of *Paradise Regained* he has become the complete Puritan. No
more splendid imagery, no more processions of heathen gods.

This short survey of the history of iconophobia in Europe (and I
believe that a similar survey of the subject in Asia would produce
much the same results) suggests that it has several causes and symp-
toms, which can be distinguished from one another, although they
overlap. First of all there is a philosophic cause, the argument that
influenced the early Fathers, the more thoughtful disputants in the
iconoclastic controversy, St Bernard and the Quakers. The unques-
tionable truth that God is a spirit, beyond our comprehension, who
cannot be given visible shape without limiting or degrading him, is
extended to all forms of spiritual activity, which must therefore be
kept free from physical associations. Closely connected with this is
the moral objection that to represent a thing is a lie. This is the
puritan aspect of iconophobia, and has always been carried out in the
name of *purity*.

Secondly there is what I may call a stylistic cause. More than once
in history the arts that represent living things have been threatened
by the concept of art as a form of vitalised ornament, more or less
free from imitation, and when a representational style has grown
monotonous and effete, an injection of vital abstraction has put new
life into it. Here we come back to the conflict between the serpent
that Moses lifted up in the wilderness and Aaron's golden calf,
because the writhing monster was the accepted symbol of a folk-
wandering people, down to the time of the Vikings, whereas the cow
was the symbol of the settled agrarian people — Egypt, India,
Mesopotamia, etc.

All this leads me to what I may call the social cause of iconophobia.
It is the rejection by an unsettled society — a people wandering in
the desert and anxious to preserve the unity of the tribe — of the
idols of an established society. I think it fair to say that long estab-
lished cultures — Egypt, the Graeco-Roman Mediterranean,
nineteenth-century France and England — tended to produce rather
too many images. From our point of view we can sympathise with a
visitor to the Great Exhibitions of London or Paris who felt the need
for what the Fascists used to call a *purificazione generale*. The trouble is
that this feeling, like many virtuous impulses, gains the support of

some very questionable allies. Several times in its history iconophobia has been associated with revolution, and has switched from purification to mere vandalism. There are always plenty of people with undirected instincts of aggression. It is, after all, much easier to destroy an image than to make one. Arnold Bennett, in one of his novels, describes how, at a fair in the great pottery producing Five Towns, the chief attraction was a booth where, for the payment of sixpence, one could smash as much pottery as one liked. One could vent one's destructive energies on symbols of the tyranny by which one was enslaved.

Side by side with these destructive and negative impulses was the belief that a religion must aim at absolute purity. Curiously enough the two were often combined. In the second phase of reforming zeal in England, who shall say which was most responsible for the destruction of images — high-minded puritan country gentlemen, who destroyed chantry chapels because they denoted a belief in purgatory; professional purifiers like Dowsing, hired to do the job at a penny a head; or mere hooligans, who would do the same today if there were enough images left. So the iconophobia of the west represents a curious alliance of spiritual purity and animal aggression. But the great aniconic art of the east, which became the predominant art of Islam, was created by the mysterious forces of style, and is something positive, not negative.

I now return to the point at which I began: the art and architecture of the present day. It may have seemed to you that when I associated the second commandment with Malevich, Kandinsky and Mondrian I was indulging in a fanciful analogy: that the earlier hostility to images was religious and theological, and the later purely aesthetic. I believe that the analogy is correct. The words 'purely aesthetic' will not stand up to analysis. Works of art do not merely arouse physical sensations, but involve memories, associations, self-identification and the unconscious recognition of symbols. They are created out of the same imaginative conviction that created objects of devotion. One need think only of the failure of nineteenth-century painters — even as great a painter as Ingres — to represent Christian subjects, to realise that works of art are not created by will, but from some far deeper condition of spirit, that is really very close to the impulses which propelled the various movements in religion.

The founders of pure abstraction were, in fact, conscious of a

# Iconophobia

semi-religious vocation. Kandinsky's *The Spiritual in Art* is a kind of theosophy, and Mondrian's statement of belief, although it is entitled *General Principles of Plastic Equivalence* is written in metaphysical terms almost indistinguishable from those used in theological controversy.

If you compare the symptoms of ancient iconophobia to modern art and architecture, you will find that nearly all of them hold good. The secondary causes are obvious. The rejection of all imagery and ornament from modern architecture is clearly part of a reaction against the proliferation of meaningless images that one can find on practically every building down to 1920. And this revulsion was equally part of an unconscious feeling that all these images and ornaments were the expression of a worn-out hierarchy; not so much a religious hierarchy as a hierarchy of social concepts that had long been recognised as no more than a cloak for exploitation. No one felt strongly enough to knock them off existing buildings (except for Epstein's reliefs on the British Medical building, and that was because they were good works of art, not because they were symbols), but I remember that when I sat on the Royal Fine Arts Commission almost the only thing we ever did was to tell architects to remove the ornaments and images from their designs.

This imageless architecture — the first that the world has ever seen — has produced works of great merit, but like all aniconic art, it runs the risk of monotony, and it is, alas, easily degraded in the interests of materialism.

When we turn from architecture to painting, we come to what I have identified as the first and deepest cause of iconophobia, the desire for purity. Let me make it clear that I do not consider cubism as an imageless art. Picasso and Braque went a long way from naturalistic representation — in fact Braque was a determining influence on Mondrian — but they never abandoned all reference to things seen and remembered. Indeed few painters have had less desire for purity, in any sense of the word, than Picasso. Matisse, in his late collages, is aiming at this quality, and yet we feel that these beautiful blue silhouettes are the purified daughters of his earlier odalisques.

These great painters were all part of the Mediterranean tradition. The determination to create a pure art arose from artists outside this Mediterranean world. It is interesting that at least five of

47

them — Malevich, Kandinsky, Gabo, Rothko and Polia-
kof — came from Russia, a country where representational art
had never flourished; but perhaps one should not make too much of
this fact, as the other founder of pure abstraction, Mondrian, was
Dutch. Now all these painters took as their point of departure the
word 'pure'. Kandinsky, who perhaps may be said to have painted
the first completely abstract picture in 1911, believed that he was
achieving an ultimate similar to that which was being discovered by
physicists when they split the atom. Kandinsky fulfils almost too
neatly all that I have said about the history of aniconic art. In 1918 he
founded the Museum of Pictorial Culture in Moscow, and was one
of a three-man commission on the People's Education in Art. It was
no doubt Kandinsky, who believed himself to be descended from
Genghis Khan, who gave pure abstraction its will to conquer and
even to persecute. His biographers have gone so far as to say that he
represents a conquest of the west by the east, and although I rather
mistrust this kind of statement, I must say that it fits in remarkably
well with my thesis. The gentle Malevich was no less determined on
the subject of purity. In 1913, as you will remember, he produced his
famous picture of a white square on a white ground, and defended it
with the words, 'by suprematism I understand the supremacy of
pure feeling in creative art', adding, 'everything that determines the
objective ideal structure of life and of art — ideas, concepts and
images — all this the artist has to cast aside in order to heed pure
feeling'. A few years later Mondrian extended this approach to a
more intellectual idea of art which he called 'the mutual interaction
of constructive elements and their internal relations'. 'This process',
he says, 'consists in mutual purification; purified constructive ele-
ments set up pure relationships, and these in their turn demand pure
constructive elements.' Mondrian was, to my mind, far the greatest
artist of the early abstractionists. He was a genuine mystic and
moralist, who said that he wished his pictures to express not purity
of sensation, but purity of being. The leading Dutch critics have
compared him to Spinoza — fair enough. They have also seen him as
the heir to Dutch Calvinism. 'Against outward appearance', says one
of them, 'the zeal of the Dutch Calvinist iconoclasts was directed as
early as 1566; for them the purity of the Gospels was hidden and
distorted by statues, sacred images and the representation of sacred
events.' That is a quotation from the introduction to the Mondrian

# *Iconophobia*

exhibition at the Whitechapel Gallery in 1955, and I hope it will persuade you that my linking of iconophobia and contemporary art is not a personal fad.

Kandinsky 1911, Malevich 1913, Mondrian 1913 to 1920, when he reached the conclusion that only by confining himself to right angles could he give the sense of moral rectitude which must accompany purity in art. You see that this style was invented over fifty years ago and, to tell the truth, I don't think it has made much progress. As I implied earlier, pure abstraction can achieve a finality which is destructive. Certainly no one has painted intellectually purer works than Mondrian and Malevich. Only in the realm of pure sensation, that is to say the realm of colour, have some painters, notably Rothko, made an advance on the founders of pure abstraction; and Rothko himself, before his tragic death, felt that he had come to a dead end. Does this mean that our present bout of iconophobia is almost over? I am on record as saying that generalisations about the future are intellectually disreputable, and I shall not attempt one now. But after so long an exposé you are entitled to my guess. I think that non-representational art still has a long run ahead of it; not perhaps the five hundred years of Islamic art, but at least another fifty. It is part of the whole form-world that surrounds us — the world of computers and transistors, refrigerators and washing-machines, to say nothing of space modules. These are our symbolic shapes and provide our iconography, and even if our artists do not portray them, as the winner of a recent John Moore prize so nearly did, we cannot easily think of man-made form in other terms. However history — a very long history, going back to paleolithic times — suggests that the instinct to make likenesses of living things is extremely strong. It has survived revolutions and persecutions almost as catastrophic as those of our own time. I would suppose that in the end representational art will reappear, although I shall not be here to see it.

# Provincialism

I am going to examine what, for sake of convenience, I may call the problem of provincialism. For obvious reasons I shall confine myself to the visual arts; but I believe that some of what I say is relevant to music and literature as well. In its simplest form, provincialism is easily recognised and defined. The history of European art has been, to a large extent, the history of a series of centres, from each of which radiated a style. For a shorter or longer period that style dominated the art of the time, became in fact an international style, which was metropolitan at its centre, and became more and more provincial as it reached the periphery. A style does not grow up simultaneously over a large area. It is the creation of a centre, a single energising unit, which may be as small as fifteenth-century Florence, or as large as pre-war Paris, but has the confidence and coherency of a metropolis.

Examples are obvious enough. Fifth-century Greece: in the course of fifty years, the Athenians created a style so complete and convincing that for five hundred years its basic assumptions of imagery and techniques went unquestioned. The familiar relief of Mourning Athena in Athens and a grave relief in Silchester are basically in the same style, but we have no doubt that the Athenian relief is metropolitan, the British, provincial. A second example, Constantinople from the sixth to the twelfth centuries. Even the scanty tokens of Byzantine art which have come down to us, the ivories in the palace style, or the mosaics in the church of St George at Salonika, reveal a metropolitan art of the utmost refinement. Compared to them, the illuminations, and still more the wall paintings of Western Europe, vigorous and amiable though they may be, are provincial. A third example, the Gothic style of the Ile de France in the thirteenth and fourteenth centuries: we do not need to argue the point that the sculpture of Chartres is metropolitan and Nottingham alabasters are provincial. And so we could go on, taking numerous examples from Roman Baroque in the seventeenth century, to the School of Paris in the early twentieth.

So far all is plain sailing. In these instances it may be said that

# Provincialism

provincialism is simply a matter of distance from a centre, where standards of skill are higher and patrons more exacting. But at an early date complicating factors arise. Since a metropolis is the source of style, whether in fashion, or furniture or the major arts, the concept of style tends to become too important, and at a certain point the balance of ends and means is upset. Just as provincial art fails from its lack of style, metropolitan art fails from its excess, and there appears the familiar symptoms of over-refinement and academism. At the same time the provinces may receive an injection of energy from an unexpected quarter, as provincial Byzantinism was injected with the style of folk-wandering ornament; or they may throw up an inexplicable individual of genius; or they may wish to express certain human values, that have been neglected. Thus the provincial artist is launched on his struggle with the dominant style.

Metropolitan art is far more powerful and pervasive than the layman would suppose. It is, as I have said, a 'basic assumption', comparable to Ptolemaic geography or the theory of evolution, or any of those other beliefs which, during their periods of supremacy, are questioned only by idiots. The provincial artist who feels that he must make a personal and local contribution in his own way, has to come to terms with this monster. One thing he must not do is to try and compete with metropolitan art on its own ground. This is the most painful and, in the case of Benjamin Robert Haydon, literally, suicidal form of provincialism. But how can he escape — by impudence? By naivety? By isolation?

To see these abstract questions in concrete terms, let me take some examples from English art in the eighteenth and early nineteenth centuries. No open-minded historian of art would deny that English painting is provincial. It has produced one or two men of genius, one or two charmers, and one or two curiosities, but to enter a room of English painting in the Prado, the Uffizi or the Louvre is to feel oneself floating far away from the mainland of European art.

To begin with Hogarth. In his lifetime the metropolitan style had grown exceedingly feeble, feebler perhaps than at any time since the fourth century. The last convulsions of Roman Baroque, the style which his father-in-law, Sir James Thornhill, had practised in a straightforward provincial fashion, were still regarded as the proper means of covering a large area. Incidentally, the only major artist of the period, his exact contemporary, Giambattista Tiepolo, had

found a means of illuminating this style, but probably Hogarth had never heard of him. Somewhere in the background there was always perceptible the relentless accompaniment of an earlier international style, Raphaelesque classicism, the style taught in academies and still given top marks in manuals of painting. Both these styles were equally foreign to Hogarth; and being a man of spirit he attacked them, and the connoisseurs who preferred them to the truth and nature of his own work. At the end of the catalogue of his exhibition in 1761, he put an engraving of a monkey, dressed as a connoisseur just back from the Grand Tour, with a magnifying glass in his hand, watering three dead stumps, which are called *Exoticks*. So much for the roots of the European tradition. In the same year he did a print to express his opinion that the pictures admired by connoisseurs gained their prestige from dirt and discoloured varnish. Father Time is seated in front of a canvas on an easel, puffing smoke from a clay pipe at its surface. Beneath are the words 'To nature and yourself appeal, nor learn from others what to feel'.

Truth to nature and individual judgement: these are the recurrent catchwords of provincial art in its struggle to free itself from the dominating style. And no one has repeated them with more wit and persistence than Hogarth. There is an irresistible self-portrait in the National Portrait Gallery, which shows him, seated before his easel, at work on a large canvas, accompanied by a tough little terrier, the very image of truculence. But what is on his canvas? — the first outline of a perfectly conventional figure in a feeble Bolognese style. Even *Time smoking a Picture* was a lottery ticket for his commonplace imitation of Carlo Maratta, called Sigismunda. His most ambitious work, the enormous altarpiece of St Mary's, Radcliffe, was in the international style of late Baroque, and the one of his pictures by which he set most store, the *Paul before Felix*, is based on Raphael's cartoons. It must be one of the most ridiculous travesties of the classical style ever exhibited. So this cocksure rebel, this plain man of the people, when he wished to be taken seriously, could not escape the dominance of the most moribund of metropolitan style, in spite of the fact that he had achieved his own lively and circumstantial manner of telling stories, through which he added something small but positive to European painting.

This story demonstrates the formidable power of a central tradition — formidable and destructive. It also points to the first means

of escape: anecdote. When there is a story to tell, the pressure of style can be relaxed. Of course, the great classic artists can tell stories, as Giotto and Raphael do; but on the whole metropolitan art, in its struggle for formal perfection, prefers to repeat the same subject, and even the same pattern, again and again.

We are often told that this anecdotal art is peculiarly English, but it has flourished equally in all countries of the perimeter. The leading painters of the nineteenth century in Germany and America, Menzel and Winslow Homer, were almost as gifted as their French contemporaries. But they remained illustrators. The case of Adolf Menzel is particularly revealing. The very mention of his name made Degas feel uncomfortable. He recognised in Menzel a skill similar to his own, and almost as great, and knew how easily he himself might grow fat in the pleasant pastures of illustration. His severe concentration on a few subjects — dancers, race-horses, *modistes* — which he strove with a fanatical zeal to bring to perfection, was, so to say, an assertion of his own metropolitan status. But only an artist brought up in the tradition of Ingres and the great Italians could afford this austerity.

The artist of the perimeter who empties his work of its element of illustration is almost certainly condemned to high-minded vacuity. Still worse if he empties it of fact. Provincial art is surest of success when it is concrete. At times when the artist of the centre has grown too intent on the abstract achievements of style, the provincial recalls him to the respectable theory that art is, after all, concerned with what we see, and what interests us in life. Of course not all returns to naturalism have originated outside the centre. Two of the most influential, those of Caravaggio and Courbet, were entirely metropolitan. But on the whole it has been the strength of provincial artists to cut through the sophistries which protect a self-perpetuating art. This sudden application of common sense to a situation which has become over-elaborate, has been recognised since classical antiquity as the great provincial achievement. The plain man, usually from a northern province, appears in the earliest literature. I am bound to say that he does not usually make much of a show in painting. When Horace Walpole, the incarnation of urbanity, went to call on the ageing Hogarth, Hogarth said to him, 'I think it is owing to the good sense of the English that they have not painted better'. (Walpole adds that he thought Hogarth had gone mad, and

was going to bite him.) As a matter of fact it was not good sense, but the lack of it, which led Hogarth to paint his history pictures; but in at least one of his contemporaries, curiosity about facts, and a desire for clear communication was combined with pictorial gifts of a high order: George Stubbs. Unlike Hogarth, who was essentially a Londoner, Stubbs was a provincial in the fullest sense of the word. He was born in Liverpool in 1724, worked in York, and did not come to London till 1759. Like all the great 'plain men' of history, Stubbs was not at all a simpleton. He knew precisely what he was doing, and had, as one can see from his anatomical engravings, the highest technical skill. Moreover he recognised that mastery did not reside solely in the hand, but in the mind. Hogarth would not go to Rome. He said he would prove that the English could produce a great school of historical painting without an expensive journey. Stubbs went to Rome in 1754, almost the year in which Hogarth painted his *Paul before Felix*. Ozias Humphrey, who records this journey, says that it was undertaken 'to convince himself that nature was, and is always, superior to art, whether Greek or Roman; and having received this impression he immediately resolved on returning home'. This sentence is often quoted, but it may not be true, because it is a regular feature of the provincial artist myth, and appears in almost as many lives of the painters as the legend of the jealous master.

At all events, his later work suggests that he had paused on his journey to look at paintings of the *quattrocento*. If I were asked to describe the work of Stubbs to a Continental art historian, who would certainly never have heard of him, I should begin by mentioning Carpaccio, in whom apparent naivety half conceals a similar understanding of form. Whether Stubbs derived his large frontal dispositions and firm bounding line from the sight of Italian frescoes, or whether (and such parthenogenesis is extremely rare) he came to it independently, he was able to do so because he believed in what I may call a pre-Mannerist theory of art. He believed that art was a branch of knowledge and a way of perpetuating information; and the description of his labours on the anatomy of the horse might have come straight out of the earlier lives of Vasari. His certainty of knowledge gives his forms an air of finality which optical impression alone cannot achieve. His finest work has some of the dignity and timelessness of classic Renaissance painting. It would be hard to imagine a more complete antithesis of the current metropolitan

# Provincialism

styles, degraded Baroque and Roccoco, than his gaunt, noble picture of a groom rubbing down a horse named *Hambletonian*. Now I suppose that in the eighteenth century only a painter well away from the centre could have achieved this independence. But the freedom of provincial art from the time-spirit of style is always accompanied by certain other limitations, and for this reason each escape tends to be an episode complete in itself. The limitation of Stubbs is expressed simply in the fact that he painted animals, and although he could bring the same clarity and character to the delineation of human beings, he did not quite know what to do with them — unless they had a horse's bridle to hold. Twenty years after Stubbs was in Rome, another independent character reacted against the fashionable mannerisms, and tried to achieve the monumentality of an earlier style, Jacques Louis David. But he was the conscious heir and master of a central tradition. His *Oath of the Horatii* is as revolutionary as a Stubbs, and, in detail, as realistic; but it is completely metropolitan, because the facts are used in conformity with the main intellectual current of the time, and the archaic parallelism of the design is due to conscious direction and not to a kind of insular primitivism.

The plain man, and lover of fact, is not the only type of artist who flourishes in isolation and gains by remoteness. There is also the poet. Provincial painting is at its best when it is poetical painting; or perhaps I should say, for the great epics of Michelangelo are also poetic, lyrical painting. The word lyrical has been devalued by publishers' blurbs and hack criticism generally, but I think one can still attach two meanings to it. First it can be applied to a work which expresses a single mood or emotion, complete in itself, lasting only as long as the emotion lasts. And secondly it implies that the work, like a song, does not aspire to pure form, but is a blending of two elements: or in other words that the associations which give the work its poignancy are not hidden within the form, but openly confessed. The most strange — perhaps unique — example of lyrical painting is in fact the work of a great poet, William Blake. Blake desired as ardently as Haydon to be a metropolitan painter; and like Hogarth he was confident that he had succeeded, although he too had never been to Italy, and knew metropolitan art only at third hand, through prints and copies. His visual stock-in-trade was taken from prints of the Roman mannerists, and his style of drawing represents a fashionable revival of interest in Tibaldi, which is also

perceptible in the drawings of Mortimer, Fuseli, Romney, Serghel and many others. For this reason Continental critics cannot distinguish Blake from contemporary mannerists, and have a low opinion of him. I remember how, during the Fuseli exhibition, my French friends qualified their disapproval by saying 'Il est pourtant mieux que Black'. I think this denoted a failure of perception, but it is understandable because Blake's theory of inspiration makes it extremely difficult to distinguish between designs which are heaven-sent and those which are contrived. As everyone knows, he maintained that his visible ideas came to him, clear and complete, out of the inexhaustible reservoir of his imagination. In fact nearly all of them are memories of figures that he had seen in engravings during the years that he had worked in a print-seller's shop. Graphic images made so strong an impression on him that years afterwards he could recall them from his unconscious memory and genuinely believe that they had come to him as visions. When Samuel Palmer pointed to the similarity between his colour print of Nebuchadnezzar and a woodcut by Cranach, from which in fact it is obviously derived, Blake denied ever having seen the Cranach, and said that the resemblance simply proved the reality of inspiration. Need I say that he was completely sincere, and that this strange procedure does not detract from the beauty and energy and almost hypnotic power of Blake's best designs. By long secretion, his memories of old engravings had become as much part of himself as Chagall's memories of his childhood in Vitebsk. The trouble is that he himself does not seem to have known whether they came recharged from the depth of his being, or whether they were useful memories. At their best they are like sparks thrown off from the bonfire of his poetry, and when the fire is smokiest and most disorderly, the sparks are particularly bright. The illustrations to the *Songs of Innocence* and to the *Songs of Experience* are far less vivid and compelling than those of the Prophetic Books; and the image accompanying the Tyger is the feeblest of them all. The most moving accompany the almost unreadable *Urizen*.

I have mentioned the curious fluctuations in Blake's visionary powers because they illustrate how, in the art of the perimeter, poetical painting leads a precarious existence. It is, in the main, visionary painting, and when vision loses its compulsive intensity, there is no orderly contact with the outer world to sustain it.

Samuel Palmer is a pathetic example. In him, remoteness from the

mainstream of contemporary style was sought by physical means. Hogarth was surrounded by dealers and *cognoscenti*; Blake used Roman sources; Stubbs went to Rome. But Palmer escaped to the Shoreham Valley, then as remote as Kashmir, and cultivated his vision in studious isolation. The first result was beautifully successful, although it took almost a hundred years for the world to realise this. The nearest equivalent in English painting to the lyrics of Keats and Coleridge is to be found in certain small pictures in ink and body colour which Palmer produced in Shoreham between 1824 to 1834. They are so pure and self-sufficient that one cannot think of them as provincial, and some years ago I invented, to describe them, the word 'micropolitan', which still seems to me worth retaining.

At the end of ten years Palmer was defeated, and relapsed into a conventional style which was well liked, and allowed him to live to a comfortable old age. This may have been to some extent the inevitable result of escapism. Even Gauguin, ten times tougher than Palmer, found his self-imposed isolation intolerable. But it also reflects the fact that visionary powers, like all forms of lyrical inspiration, are short-lived. Palmer kept his fires alight at least as long as Wordsworth, longer than Coleridge, and far longer than Rimbaud or Mallarmé. The difference is that the false poetry which he produced when his vision faded, lacks the technical authority and the sense of superintending mind, which makes the later Wordsworth respectable. Dull Wordsworth is still written in the great tradition of Chaucer, Spenser and Milton, and technically aspires to their standards; Palmer could paint only to the standards of the old Water-Colour Society. It is revealing that after his loss of vision, he went for his subjects to Italy; he thus ceased to be a micropolitan, and became a provincial.

As with anecdote, this visionary, poetic art is often claimed as being peculiarly English; but in fact it appears in the best painters of all schools of the perimeter. Ryder is reckoned among the first two or three painters of America; Carl Frederick Hill is probably the most admired of all Swedish artists. Both were micropolitans in the romantic Palmer manner. Ryder, curiously enough, was discovered, fifty years ago, by Roger Fry who, although at the peak of his classical-formalist enthusiasm, yet had the insight to recognise the talent of this painter-poet. Ryder was then still alive, and leading a life of complete isolation in the provincial welter of New York. No

doubt at that peak period of materialism, such solitude was the only condition of imaginative sight. A recent American isolationist of equal talent, Maurice Graves, had to take refuge, like Thoreau, in the woods. Carl Frederick Hill achieved his solitude by an even more drastic means. He went mad. In Paris in the early seventies he had become a follower of the Impressionists, so gifted that his signature has often been removed or painted over in favour of a more lucrative inscription. In 1876 he lost his reason, and was taken back to his family in the small university town of Lund in South Sweden. He was put into a darkened room and given a child's box of chalks. He did four drawings a day, till the day of his death in 1911. As with Hölderlin, visitors used to suggest subjects to him, and like Hölderlin, he had a craving for the Mediterranean: but his finest drawings are memories of his own country, and given, with nightmare vividness, the cold, crazy breath of the North. Perhaps they are almost too simple. They anticipate a fallacy of modern art, that the artist should discover the main cause of his emotion and communicate it immediately, without any accompanying explanations. But if ever this emotional economy is justifiable, it is in setting down a vision, and it is related to economy of a more material kind.

The most successful micropolitan painting is on a small scale. A vision gains in intensity when it is concentrated, like the ray of a burning glass. Moreover, a small scale does not require that mastery of the science of picture making which is acquired only in the centre. Need I add that this proposition is not true in reverse: I mean that some of the greatest artists of the centre have loved minuteness — Van Eyck, Fouquet, Dürer and Mantegna — and yet they could work on a large scale if they chose.

These, then, seem to me to be the characteristics of a positive and independent provincial art: it tells a story; it takes pleasure in the facts; it is lyrical, and it achieves a visionary intensity. These characteristics are often, but not necessarily, combined, producing that type of provincial art which we in England call Pre-Raphaelite. In fact its earliest and most distinguished exponent was a German, Caspar David Friedrich, whose clear, sharp visions of the Northern scene, hills and harbours and desolate moors antedate our own Pre-Raphaelites by over forty years. He was a calculating visionary; that is to say he recognised the obsessive character of certain elements in his pictures, and repeated their shapes almost as cunningly

as Seurat. For this reason his visions sometimes seem to us rather cold; on the other hand they seldom lapse into banality, whereas the Pre-Raphaelites do not seem to have been aware when they were in the grip of an image, or when they were merely recording details. This at least has the advantage that when their vision failed, they remained honest recorders; whereas that arch-provincial Stanley Spencer, when his vision failed, tried to screw himself up by using, and even exaggerating, the distortions which had come to him unsought in his visionary years.

Please do not think that I am underrating the value of provincial art. Stubbs is a noble figure. Palmer and Friedrich are genuine poets. Ford Madox Brown's work, and Holman Hunt's *Hireling Shepherd*, have a fascination which does not depend entirely on their subjects. These, and others like them, have added to the wealth of our imaginations in a way that the more pretentious provincials, the Haydons and Benjamin Wests, could not do. But I think it is a mistake to claim them as great artists, and to do so is itself a mark of provincialism. Matthew Arnold, in his essay on the *Literary Influence of Academies*, speaks of what he calls the 'note of provinciality' (he says that he owes the phrase to Doctor Newman) detectable in much English criticism, and quotes as an example a passage from Ruskin. Actually Arnold's meaning of provinciality was more what I should call freakishness or extravagance — the characteristic which he belaboured in this essay on translating Homer; and his quotation from Ruskin is a typical extravaganza on Shakespeare's surnames. Let me quote another passage from Ruskin, which is more relevant to my own meaning of the word: 'The precision of his unerring hand, his inevitable eye, and his rightly judging heart, should place him in the first rank of the great artists, not of his country only, but of all the world.' Now, which artist do you suppose is the subject of that eulogy? Dürer, perhaps, or Rembrandt, or even Holbein? Not at all. It was written about Thomas Bewick. I love and admire the work of Bewick. He had, in a concentrated form, those virtues of micropolitan art which I have been extolling; sharpness of vision, acceptance of fact, not excluding the bitter facts of the North Country, and a modest acceptance of the limitations of his medium. But to 'place him in the first rank of the greatest artists . . . of all the world' is, in Matthew Arnold's words, 'to show in one's criticism, to the highest excess, the note of provinciality'.

# Provincialism

This note is struck repeatedly in English criticism of the arts. I sometimes wish I had kept an anthology of it over the last forty years. I remember, for example, how the author of a book on Mantegna named Wilenski said that if Mantegna had not sold himself to the Gonzagas, he could have been an artist of the stature of Mr Stanley Spencer — a sentiment of such exquisitely provincial flavour that it might come from Virginia Woolf's *Lives of the Obscure*. We may enjoy such pronouncements, as we do the Loyal Speech made by a colonel at a regimental dinner; they may even awaken a loud 'Hear, Hear!' from the back-benchers. But they cannot do English art any good. Because the worst and commonest feature of provincialism is complacency. Partly in self-protection, partly out of mere ignorance, provincial artists refuse to look beyond the circle of their fellow mediocrities. You may remember the story in Vasari of how, when Michelangelo's sublime *Pietà* was exhibited in St Peters, two Milanese artists passed in front of it, and one said to the other 'Our Gobbo did this' (naming some local worthy). Michelangelo, who overheard them, immediately carved his name on the Virgin's ribbon. As usual the wretched Haydon provides a classic example of insularity. In 1820 he exhibited at the Egyptian Hall his enormous canvas of *Christ's triumphant Entry into Jerusalem*, congratulating himself that Benjamin West's *Christ healing the Sick*, though still on view in Pall Mall, had lost some of its novelty. 'In colouring', said *The Times*, 'it would stand well by the best productions of Titian's pencil, while the character of the heads, the grand style of drawing in the figures, and the correctness and gusto displayed in the hands and feet would not suffer by a comparison with Raphael himself.' A few months later there was exhibited, also in the Egyptian Hall, an even larger canvas of a historical event, painted on Haydon's principles. It happened to be the masterpiece of a great artist in the main current of European art. Haydon never went to see it; at least that most communicative of men makes no mention in his Journal or in his letters of Gèricault's *Radeau de la Mèduse*.

That is pure provincialism. There is, however, a higher type of insularity, which fears that the dominant international style will corrupt the freshness of native responses. And this leads me to restate my original problem in the light of the examples I have quoted. Granted that there are certain things which the provincial artist can do, and others which he had much better leave alone, how deeply

should he study the art of the centre? How far should he attempt to master the weapons of an international style, even though he may use them for different ends? This is not an academic question, but a matter of vital importance to painters of the present day. Because since the war the most talented artists have not come from any of the old centres of European art, but from China and Japan, Australia and Indonesia, India and Mexico, and, of course, above all from the United States of America. It is an unprecedented situation, and the historian, who depends on precedents, must approach it with diffidence.

But I think some things are clear. First of all there is no hiding place. We may object in theory to an international style, although in fact the great styles of the world have all been international; but we can no longer pretend that an artist can cut himself off, as Stubbs or Palmer could do. Colour reproductions and circulating exhibitions have done for pictorial ideas what printing did for free enquiry in the sixteenth century: and remember that the germ of an idea is as infectious as smallpox; one postcard can infect a whole group. This being so, I think that the painter who tries to ignore what is vital in contemporary art will become a provincial in the worst and simplest sense of the word.

At the same time, I do not think that knowledge of the international styles, or even a short love affair with one of them, need prevent him from developing some of the provincial virtues. Some elements of metropolitan art are more easily assimilated than others; Hogarth, for example, was able to use a great many Mannerist tricks and attitudes, although the classical style was so far beyond him. In our own time Paul Klee, although near the centre of modern art, practised the small scale, the oblique narrative, the lyricism and the visual intensity of a micropolitan. Where he differed from a provincial painter was in his intelligent awareness of his own problems and of the science of picture-making in general. For these reasons, it was Klee, rather than Braque or Picasso, who had a decisive influence in India, China and Australia.

In our own case, it is clearly impossible to avoid the impact of abstract art, and particularly the recent phases of it, which can be classed under the pretentious, but fairly accurate, title of abstract expressionism. This means that one of our provincial virtues, the love of factual detail, must be abandoned for the time being. But the

# Provincialism

other virtues I have mentioned, the sense of drama, the lyricism, the intensity of vision, can all, it seems to me, be maintained, and even enhanced, by a style which works through association and analogy, rather than through direct statement. After all, the response of modern art to the objective world is often no more than an extended visual metaphor; and from Shakespeare to Hopkins, metaphor has been one of the chief endowments of the English mind.

# FIVE

# *Art and Society*

'Art and Society' is an off-putting title. So much that has been written on this topic is vague, unreal and, in the case of Marxist writers, positively misleading. This is partly because the subject has been studied on two different planes which are not brought into relation with each other. There is the high speculative plane, where philosophers like Hegel, or poetic moralists like Ruskin, examine the art of past centuries as an expression of the societies which produced them. And there is the practical plane on which those who spend their lives, as I have done, in trying to increase the availability and appreciation of art, consider ways and means. Here I shall try to construct some sort of bridge between the two. I shall begin by looking at the relationship of art and society in historical terms, and I shall then attempt to relate my findings — what nineteenth-century writers would have called laws — to the age in which we live.

Art is an extensive word. I limit it here to the branch of art that I know best, the visual arts: and I take this term to cover everything made in response to the feeling that certain events or objects of contemplation, seen or imagined, are so important that they must be enriched. These two aspects of visual art I shall refer to as image and ornament. They used to be called 'fine art' and 'applied art', and in the nineteenth century were severely distinguished from one another. Today we tend to minimise this distinction. We believe that the form-creating instinct can express itself in both ornament and image; all ornament, however abstract, suggests some visual experience; all images, however factual, reveal some sense of design. Both are forms of order. And both are sacramental. 'What is this sacrament?' As the catechism says: 'The outward and visible sign of an inward and spiritual grace'. Both image and ornament are revelations of a state of mind and social temper.

Having accepted this basic unity, however, these two branches of visual art show very great differences, especially in their relationship to society, and I shall consider them separately. I think it true to say that all image art of any value has been made by, or on behalf of, a

63

# Art and Society

small minority: not necessarily a governing class in a political sense but a governing class in an intellectual and spiritual sense. Since I shall often refer to this minority, I must decide what to call it. Plato's 'governors' is too narrow a term, Rousseau's *volonté générale* is too wide and too mysterious. For the sake of brevity I have referred to it as an *élite*; although in fact it is not elected, and may be drawn from any class of society.

Images are not made for fun. In fact it is almost true to say that all image art of value illustrates or confirms a system of belief held by an *élite* and very often is employed consciously as a means of maintaining that system. Obvious examples are the theocratic art of Egypt, the Parthenon with its Olympian embodiment of Greek philosophy, the stained glass of Chartres and Bourges illustrating not only Christian legend, but the whole superstructure of patristic theology, the temples of Angkor and Borabadur, the Basilica of Assisi and its Buddhist equivalent Ajanta, the Stanze of Raphael, and so forth, down to David's picture of the *Oath of the Horatii*. The list could be expanded till in the end it would include most of the greatest visible feats of human imagination and all of those which are in any way related to society and do not depend solely on the genius of an individual artist. It seems that an image achieves the concentration, clarity and rhythmic energy that makes it memorable only when it illustrates or confirms what a minority believes to be an important truth.

Of course the images provided for the majority by the *élite* may be more, or less, popular. Franciscan art in the thirteenth century and Baroque art in the seventeenth century were two attempts to create a new repertoire of images which should be more popular than those which preceded them. Both consciously exploited emotionalism. But the artists who gave the finest expression to those styles — let us say Cimabue and Bernini — were working for a small group of patrons, and were deeply receptive of their ideas. Bernini's *Saint Theresa* became a popular image; it revealed to the majority a hidden need. But it was Bernini's own invention and in its origin it owed nothing to popular demands.

Even the images which we at first believe to have a popular origin — for example those charming woodcuts known as *images d'Epinal* — are for the most part naive and imperfect memories of images already invented for the *élite* by such an artist as Philippe de

64

Champagne. The only exceptions I can think of are those anecdotal strips which simply tell a story, often with the help of balloons of text. Such are the illustrations of certain Indian manuscripts, such are the paintings of certain fourteenth-century Italians like Pacino di Bonaguida, and a number of Japanese scrolls, like the comic animals attributed to Toba Sojo. These, I believe, are the only forms of autochthonous popular image art before the nineteenth century, and I mention them now because they reveal a fundamental characteristic of all popular art: that it is a form of narration.

At first sight ornament would seem to be a more popular form of expression than image. Ornament has the character of a language — the old books used, quite properly, to speak of the 'grammar of ornament' — and in so far as it is a living language it is accepted almost unconsciously by the majority. However there is this difference, that whereas language seems to have evolved unconsciously from mass needs, a system of ornament has seldom been invented by the people. In fact I can think of only one exception, the pottery of the Mexican Indians which is outstandingly beautiful and does seem to be a genuine popular creation. But in Europe folk ornament turns out almost always to be — like the popular image — a cruder rendering of a minority style; and I think the same is true of China, India, Persia and the whole Moslem culture. I would even extend this to the most vital and expressive of all ornament — that produced by the so-called folk-wandering people. I believe that the finest Scythian ornaments derived from the inventions of a great artist, and that most of what has been discovered in Scandinavia or Ireland is a half-understood imitation of these aristocratic adornments.

In ornament the ulterior motive is less strong than in the image. It does not openly recommend a system. But no one maintains that it exists solely to please the eye, and lacks ulterior motive altogether. It is an assertion of status — whether in a cope or crown or crozier or *portail royale* or precious reliquary. This fact, which has been worked out in detail by Marxist historians, is taken by them as a condemnation of art; and, as everyone knows, Veblen coined for it the expression 'conspicuous waste'. I think this expression is apt, but I do not find it at all damaging. All art is waste in a material sense; and the idea that things should be made more precious-looking in accordance with the status of the user seems to me entirely fitting. I think that a

bishop should have a finer cope than a deacon and that the main portal of a cathedral should be more richly ornamented than the door of a warehouse. I would go further, and say that ornament is inseparable from hierarchy. It is not only the result, but the cause of status. The carvings on the corner capital of the Doge's Palace and the central window of the Palazzo Farnese confer a kind of kingship on those two points of the building. In a democratic building where all windows are equal, no ornament is possible, although I understand that the higher executives can have more windows.

So I would deduce from history this first law (in the Ruskinian sense) of the relationship of art and society: that visual art, whether it takes the form of images or ornament, is made by a minority for a minority; and would add this rider, that the image-making part is usually controlled in the interests of a system, and that the ornamental part is usually the index of status.

Created by a minority: yes, but accepted by the majority unquestioningly, eagerly and with a sense of participation. The degree of physical participation in the great popular works of art is hard to assess. We know that in the buildings of the Gothic cathedrals — Chartres is the most familiar example — whole villages moved to be nearer the work, and men were prepared to learn subsidiary crafts in order to help the professional masons. We can assume that the same was true of Borabadur or Ellora, although the economic status of the workers may have been different. A parallel in modern life would have been the building of a great liner in Clydebank, where the whole life of the town depends on the work. But apart from this active participation, one has only to read the accounts of how, in the great ages of artistic creation, works of art were brought into existence — the long and serious thought which preceded the commission, the public anxiety about its progress, the joy when it was at last accomplished, and the procession in which it was carried to its destination, to the sound of bells and singing of a Te Deum — one has only to come upon such documents, common enough in the Middle Ages and Renaissance, and applicable, surely to Olympia and the Acropolis of Athens, to recognise that the society of those times needed art, believed without question in the value of art, and participated imaginatively in its making. So this would be my second law: that a healthy and vital relationship between art and society exists when the majority feel that art is abso-

lutely necessary to them, to confirm their beliefs, to inform them
about matters of lasting importance, and to make the invisible vis-
ible.

Now in saying that this is the *healthiest* relationship between art
and society, I must not be understood as saying that these are the *only*
circumstances under which good works of art can be produced.
Even before 1850 great pictures were painted by individuals who had
no relationship with society at all and whose work was distasteful or
incomprehensible to the majority. Rembrandt and Turner in their
later phases are obvious examples. In the history of art, as in history
in general, nothing poses a more delicate problem of interpretation
than the relationship between individual genius and the *volonté
générale*. But even if we believe, as I am inclined to do, that inspira-
tion is more likely to illuminate an individual than a mass and that all
the memorable forms of art were originally invented by individuals
of genius, we must agree that at certain periods these individuals are
isolated, at others they enlist behind them a whole army of assent and
participation.

Nor is this direct relationship of need and unquestioning belief
certain to produce good art. Artistic faculties are somewhat
unequally — we may think unfairly — distributed among the peo-
ples of the globe; and although the relationship may be sound, not all
needs have the same validity. However, I am sufficiently a Ruskinian
to believe that when a society, over a long period, produces an art
which is lacking in vitality and imaginative power, but which
nevertheless seems to be accepted by the majority, there is some-
thing wrong with that society.

This brings me back to my opening definition, when I said that art
was a sacrament; and I must now consider how an inward and
spiritual grace can be given outward and visible form. The answer is,
through symbols. A symbol is a sort of analogy in the physical
sphere for some spiritual or intellectual experience. Usually it is the
concentration of several related experiences so complex that they
cannot be expressed in any rational form, and so intense that a
physical symbol suggests itself unconsciously. We know from the
saints of every religion that the most poignant spiritual experiences
demand expression by physical analogies, and we may infer that
spiritual experiences which remain abstract are not likely to have
been very intense. There are exceptions to this generalisation, e.g.

# Art and Society

the work of Piet Mondrian. Symbols may start as a result of private revelations, but their value in art depends on the degree to which they can be felt and accepted by others. In fact nearly all intensely felt symbols have some universal quality, which makes them comprehensible even when their maker believes them to be peculiar to himself. But it is also true that the sacramental character of art is far more easily achieved when the principal objects of belief have already been given a symbolic form which is generally recognised and accepted: in other words, when there is an established mythology and iconography.

In the relationship of art and society the importance of an accepted iconography cannot be overstated. Without it the network of beliefs and customs which hold a society together may never take shape as art. If an iconography contains a number of sufficiently powerful symbols, it can positively alter a philosophic system. The points of dogma for which no satisfactory image can be created tend to be dropped from popular religious exposition and episodes which have scarcely occupied the attention of theologians tend to grow in importance if they produce a compelling image. I would go so far as to say that the failure to discover a satisfactory symbol for the Holy Ghost has seriously impaired our concept of the Trinity. Let me give an example of iconographic triumph and disaster from one painter in one place: Titian in Venice. In the Frari is his sublime image of the Assumption of the Virgin, which was to remain a dominant influence on Baroque and Rococo painting for the next three hundred years, and was to float in the background of Catholic imagination till our own day. In the Salute is Titian's painting of Pentecost, a work over which he took great pains, but without success. It was the final blow to a subject which had never found an iconographical form and gradually faded from the consciousness of popular Catholicism. And yet I think it could be maintained that the Descent of the Holy Spirit was theologically more important than the Assumption of the Virgin. Let me take another example, from Buddhism. It had been categorically laid down that the Buddha must not be portrayed, and in the earliest scenes of his life, such as those on the Stupa at Sanchi, the central point of each episode is left a blank — an empty chair or a deserted boat. This insult to the image-making faculty was not to be borne, and a representation of the Buddha was finally accepted. But where did it come from? From the imitation, in the fringes of the

Buddhist world, of some Praxitelean Apollo. Thus the most extreme example of spirituality was embodied by the most concrete expression of physical beauty. Conversely, dogma may triumph over the popular love of imagery in a theocratic society, and produce an iconography, like that of later Buddhism, with its ten thousand Buddhas, which makes visual art almost impossible. The six arms of Siva are difficult enough.

Lest you should think that this question of iconography does not apply to modern life, let me add that it is not confined to dogmatic religion. It exists whenever people are obsessed by certain symbols which express a belief so strong as to be almost unconscious. The iconography of the Romantic Movement was almost as compulsive as that of a religion. The tiger — in Blake, Stubbs, Géricault, Delacroix, Barye, and a dozen lesser artists. The cloud — in Wordsworth and Byron, Shelley, Turner and Constable. The shipwreck — in Byron, Turner, Goya, Géricault, Delacroix and Victor Hugo. These are the symbols of romanticism, used and accepted unconsciously because they expressed the new worship of nature and power, and a new sense of destiny. I think it would be a misuse of language to call this state of mind a religion. That word should be reserved for beliefs which are based on a book of holy writ and involve certain formal observances. But at least we can say that the belief in nature, which expressed itself in the glorious landscape painting of the nineteenth century and has remained the most productive source of popular art to this day, is a non-material belief. It is something which cannot be justified by commonsense or material interest, and seems to lift the life of the senses on to a higher plane.

This suggests another 'law' in the relationship of art and society: that it is valuable only when the spiritual life is strong enough to insist on some sort of expression through symbols. No great social arts can be based on material values or physical sensations alone.

This 'law' leads me to consider the problem of luxury art. Now, it would be dishonest for me to take a puritanical or Marxist view of luxury art. Like everyone who enjoys life I derive much pleasure from luxury art. Moreover there is a point — Watteau's *Enseigne de Gersaint* is an example — at which the sensuous quality of luxury art is so fine that it offers a spiritual experience. We are playing with words and concepts which, as we breathe on them, become alive and flutter from our hands. Still, the fact remains, that in the long run

69

# Art and Society

luxury art implies the reverse of what I have called a healthy relationship between art and society, and so has a deadening effect. The most obvious example is the art of eighteenth-century France. But the predominance of luxury art in the eighteenth century is a short and harmless episode compared to that long slumber of the creative imagination which lasted from the end of the second century B.C. to the third century A.D. For almost five hundred years not a single new form of any value was invented (except perhaps in architecture). Works from the preceding centuries were reproduced interminably — made smoother and sweeter for private collectors, bigger and coarser for public commissions.

What can we say of the relations of this art to the society which produced and accepted it? That no one believed in its symbols; that no one looked to it for confirmation or enlightenment. In short that no one wanted it, except as a conventional form of display. They did not want art, they did not make it: but they collected it.

The problem of luxury art is complicated by the fact that the periods in which it predominates are usually periods when the art of the past is collected and esteemed. This was obviously the case in Hellenised Rome and in eighteenth-century England; conversely the idea of collecting and displaying works of an earlier period was hardly known in those cultures when the need for art was strong and widely diffused. One must distinguish, of course, between the fruitful use by artists of earlier works, which took place in thirteenth-century Rheims no less than in fifteenth-century Florence, and the competitive accumulation of collectors. The feeling for the art of the past in Donatello or Ghiberti is entirely different from that of the eighteenth-century connoisseurs: at once more passionate and more practical. 'How can I use these admirable inventions to give my own message?' 'How can I surpass them in truth of expressive power?' These are the questions aroused by the work of the past in the great ages of art. In periods of luxury art, on the other hand, works of the past are collected at worst for reasons of prestige and at best in order to establish a standard of taste. The concept of good taste is the virtuous profession of luxury art. But one cannot imagine it existing in the twelfth century, or even in the Renaissance; and without going into the complex question of what the words can mean, I am inclined to doubt if a completely healthy relationship between art and society is possible while the concept of good taste exists.

# Art and Society

Such, then, are the deductions that I would make from studying art history; and I have ventured, in the nineteenth-century manner, to call them laws. It is arguable that this word should never be applied to the historical process: we see too little. But at least we can say that these are strong probabilities which should be our first criteria when we come to examine the relations of art to society at the present day. In doing so I may be allowed one assumption: that fundamentally human beings have not changed. The picture of human nature which we derive from the epic of Gilgamesh or from the portrait heads of Old Kingdom Egypt is much the same as what we know today and I think we may safely assume that it will take more than television and the automobile to change us. In fact I would suppose that we have more in common with the Middle Ages than our fathers had, because to us universal destruction is an actual possibility whereas to our fathers it was only a pious fiction. However, if human nature has not changed, human society has; and changed as the result of a basic shift of mental outlook.

This change can be described in one word: materialism. The word is usually employed in a pejorative sense, but materialism has been the source of achievements which have added immeasurably to the well-being and happiness of mankind. Whether as the dialectical materialism of the East or the liberal materialism of the West, it has given to masses of men a new standard of living; a new sense of status and new hope. These benefits have been achieved because materialism has been the philosophical basis of two outstanding human activities, one in the moral and one in the intellectual sphere: humanitarianism and science. These are the integrating forces of our culture, and they are as powerful, as all pervasive, as was Christianity in the Middle Ages.

Now how does this underlying philosophy of materialism relate to art? One cannot help being aware of one very serious obstacle. Materialism and all its children are dedicated to measurement. Bentham's philosophy was based on the greatest good for the greatest *number*. Democracy depends on counting the *number* of votes. All social studies are based on statistics. Science has triumphed because it has achieved a new accuracy of measurement.

In its century of triumph, measurement has even become an article of faith. The potential of faith latent in the human mind is probably fairly constant, but it attaches itself to different ideas or manifest-

71

ations at different periods. The bones of the saints, the Rights of Man, psycho-analysis — all these have been the means of precipitating a quantity of faith which is always in solution. People probably believe as much nonsense today as they did in the Middle Ages; but we demand of the precipitant that it *looks* as if it could be proved — that it appears to be measurable. People might have believed in art during the last fifty years if its effects could have been stated in an immense table of figures or a very complicated graph: of course they would not have checked the figures or understood the graph, but the existence of these symbols of measurement would have sustained their faith.

Now even if you do not agree with all my earlier conclusions, I think you will probably agree that the values of art are not of a kind that can be measured. We cannot measure the amount of satisfaction which we derive from a song; we cannot measure the relative greatness of artists, and attempts to do so have produced results that in half a century look ridiculous. In the eighteenth century, which was very fond of that exercise, Giulio Romano always came out top of the poll, which as we all know, by some non-measurable form of knowledge, is incorrect. If you agree with my belief in the symbolic nature of art, the relations between art and materialism become even more uncomfortable, because the value of a symbol lies precisely in the fact that it cannot be analysed, that it unites an inextricable confluence of thoughts, feelings and memories.

Art cannot be measured in material terms and the more honest philosophers of materialism have recognised this. Bentham invented the unforgettable comparison between push-pin and poetry, coming down on the side of push-pin because more people wanted it. Poetry he defined as 'misrepresentation', which is the liberal counterpart to Veblen's 'conspicuous waste'. The philosophers of dialectical materialism have accepted art only in so far as its magical properties can be used for political ends. Less ruthless social philosophers have conceded the right to enjoy and even to produce art among the rights of minorities. Art is the opiate of the few.

How are the philosophic assumptions of materialism reflected in the actual status of art in modern society? It is incontrovertible that fine art, as the word is usually understood, is the preserve of a very small minority. We must not be bamboozled by the claim that more people listen to 'good' music or visit picture galleries; nor even by

the fact that a few of us have tricked the unsuspecting viewer into looking at old pictures on television. Similar claims could be made for the nineteenth century: for example, during the Manchester Art Treasures Exhibition of 1857, special trains ran from all over England, and whole factories closed down in order that the workers could enjoy the experience of art; and yet the next fifty years saw the consolidation of a philistinism unequalled since the Roman Republic.

Anyone who has been concerned with those 'arts' which really depend on the support of a majority — the cinema, television or wholesale furnishing — knows that the minority which is interested in art is so small as to be irrelevant in any serious calculation. In England the majority is not merely apathetic, but hostile to art. A recent example was the film called *The Horse's Mouth* which the exhibitors would not show (in spite of brilliant acting by Alec Guinness and hilarious comedy) simply because the leading character was an artist. If only, they said, he had been a schoolmaster or a doctor! This is perfectly understandable. The existence of these freakish members of society whose usefulness cannot be demonstrated, but who often seem to be enjoying themselves and sometimes even to be making money, is an affront to the ordinary hardworking man. It is fair to say that in spite of this feeling artists are treated tolerantly in England.

We should be grateful for this tolerance, but does it not fall far short of my second condition for a healthy relationship between art and society: that the majority feel art to be absolutely necessary to them; that they are not merely consumers, but participants; and that they receive works of art as the expression of their own deepest feelings?

Now, before admitting this, I must look back at my original definition of the word 'art'. Do the majority still feel that certain images are so important that they must be preserved? In a sense the answer is 'yes'. The majority still want ornament on their clothes, their furnishing fabrics, their wallpapers and many objects of daily use. More than this, they still mind very much how things look, independent of their utility. Whether it be dress or motor-car design, they are still in the grip of style. They and the designers are swept along by a blind destiny, a mysterious force which they cannot analyse, but of which they are acutely conscious when they look

back at the fashions of twenty years ago.

Does this mean that in ornament the relation between art and society is a healthy one? This has certainly not been the opinion of qualified judges during the past hundred years. Ruskin and William Morris supposed that quality of ornament had been destroyed by the machine. But this turns out to be applicable only to the Gothic style. In almost every other style the machine is an extended tool that can be used with confidence; and for that matter a great deal of the ornament of the past, from the Viking goldsmith work of Sutton Hoo to the inlaid panels of the Taj Mahal, is entirely devoid of manual sensibility and might just as well have been made by a machine. From a technical point of view, the premises on which ornamental art is produced have not greatly changed. When we examine it in the light of my other laws, however, the change is considerable. With a single exception, the ornament favoured by the majority is no longer made for an *élite*; it is not indicative of status; and it no longer has any underlying sense of symbolic meaning.

In one branch of art — in architecture — it has almost ceased to exist; and although we have now grown used to buildings without ornament, the historian must record that this is a unique event in the history of art, and one which would certainly have shocked those famous architects of the past who gave so much thought to the character of their ornament, and counted upon it at all points of focus and transition. The great refusal of modern architecture was perhaps a necessary purge and had certain health-giving consequences. But how often it is simply an impoverishment, an excuse for meanness and a triumph for the spirit that denies. That it is not the expression of a popular will we learn when we look down the blank face of a modern building into the shop windows at its base: and this leads me to the exception I mentioned just now: it is women's dress. There, it seems to me, the compulsion is so strong that a healthy relationship between art and society is never lost. I am not suggesting that all fashions are equally good — of course there are moments of failing invention and false direction. But they always right themselves because there is an indestructible *volonté générale* — an interaction between the *élite* and the masses, a sense of status and an unconscious feeling for symbolism.

If the position of ornament in modern society is uneasy and incomplete, the position of image art has suffered a far more drastic

change, owing to the invention of the camera. The public hunger for memorable and credible images has in no way declined, but it is satisfied every day by illustrated papers; and the love of landscape which, as I said, was one of the chief spiritual conquests of the nineteenth century, is satisfied by coloured postcards. I am not denying that there is an element of art in press photography, especially in photographs of footballers; I will also admit that I derive a pleasure from coloured postcards which must, I suppose, be called aesthetic. I prefer a good coloured postcard to a bad landscape painting. But in both these projections of the image much of what we believe gives art its value is necessarily omitted. There is selection, but no order, and no extension of the imaginative faculty. To realise how destructive has been the effect of the camera on image art, consider the art of portraiture. The desire to hand down one's likeness to posterity produced one of the chief social arts of the post-mediaeval world. It expressed the discovery of the individual, and it produced, beside much that was mediocre, individual works of art of the highest quality. It did so because the portrait painters of the time had behind them an immense weight of *volonté générale*. The sitters participated because they knew that their desire to perpetuate their likenesses could not be achieved in any other way. The excellence of early photographs has always been recognised, but even so no photograph is comparable with a Goya as a work of art, or even as a likeness. But the fact that photography exists, and can tell us far more accurately than a mediocre painting what people looked like, has knocked away the foundation upon which portraiture rested. There is no longer a feeling of participation in the sitters. The portrait painter no longer feels that he is really needed, any more than ornament is needed on a building.

The portrait is typical of the decline of confidence in art which is felt unconsciously by the mass of people as a result of the camera. There is however one form of popular imagery which was not entirely dependent on photography, and that was the poster. Here, a number of my conditions for a healthy relationship between art and society obtain. Posters are made on behalf of a minority and aim at supporting some belief; they are supposed to appeal to a majority, and millions of people derive from them what they take to be information about matters which they believe to be important. Moreover, posters achieve their effects through the use of symbols,

and it is a curious fact that the ordinary man will accept in posters a symbolic treatment, a freedom from realism, which he would not accept in a picture framed in a gallery, simply because a poster does not exist for its own sake, but is concerned with something he needs. All this is true, and yet we know that in spite of many effective and memorable posters,* advertising has not produced an art comparable to the windows of Chartres Cathedral; and never can. The reason is, of course, that it lacks what I have called the sacramental element in art. I said earlier that the nearest equivalent in modern life to the building of a mediaeval cathedral was the construction of a giant liner. But the liner was built for the convenience of passengers and the benefit of shareholders. The cathedral was built to the glory of God. One might add that advertising art is concerned with lies, of a relatively harmless and acceptable kind; but one must remember that the great art of the past was also concerned with lies, often of a much more dangerous kind. The difference is not one of truth, but of the different realms to which these two forms of art belong — the realm of matter and the realm of spirit.

I need not press any further the point that the philosophy of materialism is hostile to art. But what about its two noble kinsmen, humanitarianism and science? Although they are to a great extent committed to measurement, they are not wholly materialistic. They recognise values which we may call moral, intellectual and even aesthetic. As I have said, they seem to me the integrating forces of the last 150 years. How are they connected with art?

The more enlightened supporters of humanitarianism have often bewailed the fact that art seems to have flourished in societies which were quite the reverse of humane. Yet we feel instinctively that this is natural; that kindness, mildness, decency, are not as likely to produce art as violence, passion and ruthlessness. One of the most ancient and persistent images in art is the lion devouring a horse or deer; and it must puzzle the humanitarian mind that this bloodthirsty episode came to be a suitable decoration for pagan sarcophagi, then entered Christian iconography as a symbol of the spiritual life; and finallly became the dominating motif of the only great religious painter of the nineteenth century, Delacroix. The answer is given in Blake's

---

* Posters, which played a large part in the art of the thirties, have now been found to be commercially ineffective and are no longer of much importance in a survey of art. (1977)

## Art and Society

*Marriage of Heaven and Hell*, and I will not be so foolish as to elaborate it. But I may quote the words of Augustus John: 'It isn't enough to have the eyes of a gazelle; you also need the claws of a cat in order to capture your bird alive and play with it before you eat it and so join its life to yours.' To put it less picturesquely, art depends on a condition of spiritual energy, which must devour and transform all that is passive and phlegmatic in life, and no amount of good will can take the place of this creative hunger.

I am not saying that violence and brutality *beget* art, or that there is not still far too much violence and brutality left in the world. The bright new towns in our welfare states are an achievement of which humanity may be proud. But do not let us suppose that this peaceful, humdrum, hell-free, de-Christianised life has been achieved without the sacrifice of something vital. And apart from the unlikeliness of art being forged at such a low temperature, the doctrine of equality, or at least the drift towards equality, on which such a society depends, runs counter to one of my first laws. We have many reliable indications of what Mr and Mrs Honest Everyman really want. We don't need surveys and questionnaires — only a glance at surburban and provincial furniture stores, and television advertisements. There we see the art of a prosperous democracy — the art of least resistance. This would not matter much, were it not that Gresham's law — 'bad money drives out good' — is equally true of spiritual currency; and we are all surrounded by far more bad art than we are aware of. I fancied that during the war, when the amount of conspicuous waste was cut down in the interest of economy, and objects of daily use, like teacups, were made without even a curve, let alone a pattern, the appetite for real works of art was much keener and more discriminating than it has been since.

With science the position is rather different. It is not so much a soil in which art will not grow as a rival crop. It is obvious that the development of physical science in the last hundred years has been one of the most colossal efforts the human intellect has ever made. But I think it is also true that human beings can only produce, in a given epoch, a certain amount of creative power, and that this is directed to different ends at different times; and I believe that the dazzling achievements of science during the last seventy years have deflected far more of these skills and endowments which go to the making of a work of art than is usually realised. To begin with there

77

# Art and Society

is the sheer energy. In every moulding of a Florentine palazzo we are conscious of an immense intellectual energy, and it is the absence of this energy in the nineteenth-century copies of Renaissance buildings which makes them seem so dead. To find form with the same vitality as the window mouldings of the Palazzo Strozzi I must wait till I get back into an aeroplane, and look at the relation of the engine to the wing. That form is alive, not (as used to be said) because it is functional — many functional shapes are entirely uninteresting — but because it is animated by the breath of modern science.

The deflections from art to science are the more serious because these are not, as used to be supposed, two contrary activities, but in fact draw on many of the same capacities of the human mind. In the last resort each depends on the imagination. Artist and scientist alike are both trying to give concrete form to dimly apprehended ideas. An English scientist has said: 'All science is the search for unity in hidden likenesses, and the starting point is an image, because then the unity is before our mind's eye.' He gives the example of how Copernicus's notion of the solar system was inspired by the old astrological image of man with the signs of the Zodiac distributed about his body, and notices how Copernicus used warm-blooded expressions to describe the chilly operations of outer space. 'The earth conceives from the sun' or 'The sun rules a family of stars.' Well, our scientists are no longer as anthropomorphic as that; but they still depend on humanly comprehensible images, and it is striking that the valid symbols of our time, invented to embody some scientific truth, have taken root in the popular imagination. Do those red and blue balls connected by rods really resemble a type of atomic structure? I am too ignorant to say, but I accept the symbol just as an early Christian accepted the Fish or the Lamb, and I find it echoed or even (it would seem) anticipated in the work of modern artists like Kandinsky and Miro.

Finally there is the question of popular interest and approval. The position of science in the modern world illustrates clearly what I meant by a vital relationship with society. Science is front page news; every child has a scientific toy; small boys dream of space ships, big boys know how to make or mend a radio set. What does a compulsory visit to an art musuem mean compared to this? An opportunity to fool about and hide behind the showcases. And at the other end of

the scale, the research scientist has universities competing for his favours with millions of pounds worth of plant and equipment, while principalities and powers wait breathless for his conclusions. So he goes to work, as Titian once did, confident that he will succeed, because he knows that everybody needs him.

Such are the conclusions I would draw from examining the present relation of art and society in the light of history. They are somewhat discouraging; and it may well be asked if I have no positive and hopeful thoughts on the subject with which to fortify the last few minutes of my lecture. I think that, without false optimism, there is this to be said. The fact that art is not only tolerated, but actually supported by government and municipal funds, although it is hardly worth a single vote and practically no politician has the faintest belief or interest in it, shows that it has retained some of its magic power. The unbelieving majority still recognises that the believing minority, in picture galleries and concert halls, achieves a state of mind of peculiar value. There are very few people who have never had an aesthetic experience, either from the sound of a band or the sight of a sunset or the action of a horse. The words 'beauty' and 'beautiful' often pass the lips of those who have never looked at a work of art — oftener, perhaps, then they pass the lips of museum curators — and some meaning must be attached to them.

I believe that the majority of people really long to experience that moment of pure, disinterested, non-material satisfaction which causes them to ejaculate the word 'beautiful'; and since this experience can be obtained more reliably through works of art than through any other means, I believe that those of us who try to make works of art more accessible are not wasting our time. But how little we know of what we are doing. We are at the very bottom of the hill, and I am not even sure that we are trying to climb it by the right path. In plain language, I am not sure that museum art and a museological approach, however extended and skilfully contrived, will ever bring about a healthy relationship between art and society. It is too deeply rooted in cultural values which only a small minority can acquire. Here we reach the crux of the problem. Is it possible that anything which we call great art can be created in response to mass desires and satisfy mass emotions? In a recent television programme a Liverpool sculptor said that any healthy art of the future must appeal directly to

the working classes, of which he was proud to be a member. He did not want it to preach or influence action, as Marxists do. He wanted it simply to delight and illuminate them. He was trying to do this in his own sculpture, and as far as I could see his work had the kind of impact that might make it popular. But about half way through the programme he changed his tone. He visited the Liverpool football ground and said (I quote from memory): 'This is where the real religion of Liverpool is to be found', and he added that many Liverpudlians, when they die and are cremated, ask that their ashes should be scattered on the football ground. I found this very moving, and one of the few perfectly sincere statements about our own society that I have heard on television; but of course he was not talking about art, only about strong unified emotion, and a kind of ecstasy which was indeed an element in the creation of communal works of art like the great cathedrals, but would have been fruitless without discipline, tradition, and a superintending mind.

It was my first unwelcome conclusion that all great art was made by, or on behalf of, a small minority. Nothing in history contradicts this conclusion, and the art produced today in hopes of satisfying mass desires confirms it. But I went on to say that this small minority must inspire confidence in the majority. This is no longer as easy as it was, because although the mass of people remain infinitely gullible, they like to think that they are deciding all questions for themselves by what is called a 'democratic process'. And the situation has been made more difficult by the fact that modern art has become so hermetic, so removed from the average man's experience, as to be incomprehensible, even to a semi-professional like myself. There is something admirable in all forms of bigotry, but I do not believe that we can return to a healthy relationship between art and society over so narrow a bridge. On the contrary, I believe that our hope lies in an expanding *élite*, an *élite* drawn from every class, and with varying degrees of education, but united in a belief that non-material values can be discovered in visible things. Many obstacles will remain. There is the lack of an iconography — for our objects of belief have become as abstract as the Holy Ghost, and, what is worse, definable by analysis. There is the glut of false art which blunts our appetites. There is even the danger that true art may be degraded through the media of mass communications. But I believe that all these obstacles can be overcome if only the *need* for art, which lies dormant and

unperceived in the spirit of every man, yet is manifested by him unconsciously every day, can be united with the *will* to art which must remain the endowment, and the responsibility, of the happy few.

# SIX

# *Art History and Criticism as Literature*

How many authors who have written on the history and criticism of art can still be read with pleasure by those not already interested in the subject? Relatively few. The history of art is largely occupied with fact-finding, the criticism of art with fault-finding or the ephemeral praise of journalism. In the four hundred years since 1435 when Leon Battista Alberti finished *della Pittura*, the first, but not the most readable, work on the subject, we can scarcely name a dozen authors whose works could be considered as 'literature'. Vasari and Lomazzo in the sixteenth century, Bellori in the seventeenth, Winckelmann and Reynolds, Diderot and Lessing in the eighteenth: all these can still be read with interest, but we do not turn to them (except, of course, to Vasari) for pleasure. In the nineteenth century a romantic sensibility to impressions and a freedom of association created a new genre. Hazlitt, Ruskin and Pater in England, Baudelaire and Fromentin in France, wrote about the visual arts with an insight and an eloquence which places them amongst the masters of prose of their time, and even minor writers on the arts, like R.A.M. Stevenson or the de Goncourts are still readable.

Taking this empirical view of the subject, we may ask how the few outstanding historians and critics of art set about their aim. Broadly speaking, in four ways: biography, description, analysis and rhapsody. The earliest sustained piece of art history is biographical: Vasari's *Lives of the Most Excellent Painters and Sculptors*; and his model, reinforced by the example of Pliny, was followed till our own time. It is not always true that the story of a man's life will help us to understand his art. One of the greatest of all critics of literature, Sainte-Beuve, used this method and his influence has led to its extension into all fields of criticism; but what may be successfully applied to a seventeenth-century divine, about whom we are relatively well-informed and whose life had a direct bearing on his writings, is much less rewarding when applied to a fifteenth-century painter, of whose life we know next to nothing and whose capacity for self-expression was still bounded by traditions of craftsmanship.

# Art History and Criticism as Literature

Yet from the first the biographical approach has added greatly to our understanding of certain artists, and produced, incidentally, works of some literary value. Vasari's two masterpieces, the lives of Leonardo da Vinci and Michelangelo, have contributed so vividly to our concept of each artist that no educated person can look at their work without having his perceptions enriched by the memory of Vasari's anecdotes. Vasari never attempts what might be called a psychological interpretation of the artists' personalities. He simply tells stories about them, strung together on a thread of rather dubious facts; yet the very selection of these stories was dictated to him by his enthusiasm for his fellow artists and his desire to explain their work. Take, for example, the story of how the Pope sent him to Michelangelo to collect a drawing. 'He found the master at work upon the marble pietà which he was later to break. Recognising the knock, Michelangelo rose from his work and took a lantern. When Vasari explained his errand, he sent his servant Urbino upstairs for the drawing, and began to speak of other things. Vasari's eyes wandered to the leg of Christ, which he was trying to alter, and noticing this, Michelangelo immediately let fall the lantern, so that they were in the dark. Then he called Urbino to bring light and said, "I am so old that death often pulls at my cloak to take me with him, and one day my body will fall like this lantern." How much more this simple anecdote tells us about Michelangelo than the elaborate metaphysical interpretations to which Michelangelo literature is particularly prone.

Needless to say the biographical approach is also open to misuse. The romanticised biography of an artist is one of those literary forms that reveal a decisive breach between educated and popular taste. A historical novel is tolerable because, in the ordinary conduct of life, human feelings remain fairly constant, and we believe (sometimes mistakenly) that in the past men acted from the same motives as they do today. But the state of mind in which an artist creates his work, his relationship to his patrons, to his material, to his fellow artists, and to the ideas of his time, is so complex and mysterious, that any attempt to interpret it without concrete evidence is immediately suspect. Even when a quantity of evidence exists, as in Delacroix's *Journals* or Van Gogh's letters, we prefer it in its original form, rather than filtered and flavoured by some imaginative interpreter.

As well as telling the stories of the artists' lives, the early critics and

83

art historians made a practice of describing at length the subjects of
their pictures. This approach, too, goes against the drift of contem-
porary criticism, but, if we are tempted to under-value it, we must
remember that the great painters who have written on their art, from
Leonardo da Vinci to Delacroix, have themselves left eloquent
descriptions of possible subjects. When David and Delacroix
described an appealing expression or a dramatic gesture they cer-
tainly believed that such details were necessary to their total effect,
and would have thought little of the hasty modern critic who did not
notice them, let alone try to understand their significance. Descrip-
tion has a further value, that it makes us look at a work of art for
longer. 'We must look and look' said Mr Berenson 'till we live in a
painting and for a fleeting moment become identified with it.' True
enough, but how are we to persuade our distracted eyes to keep on
looking. The simplest way is to try to follow the subject, which
occupies our minds and leaves our eyes free to absorb, and com-
municate to the 'imaginative reason', all that can be learnt from form
and colour alone, until 'for a fleeting moment' we become identified
with the artist's whole intention. Thus in criticism merely to
describe a subject may be the prelude to total absorption and may
induce a gradual process of self-identification.

Up to a point the description of a picture's subject is similar to
other forms of descriptive writing and demands the same qualities in
the writer: an eye for significant detail, a sense of overall effect and
style both concrete and flexible. So it is not surprising that certain
passages in which Hazlitt, Ruskin and Pater describe the pictures that
have moved them are amongst the accepted masterpieces of English
prose. They may achieve their effect solely by precise observation, as
in Hazlitt's description of Poussin's landscapes; but often the descrip-
tion is really subsidiary to a critical purpose. Here, for example, is a
passage from Ruskin's *Queen of the Air* in which he contrasts a
Turner water-colour with a Persian miniature: 'Opposite me is an
early Turner drawing of the lake of Geneva, taken about two miles
from Geneva, on the Lausanne road, with Mont Blanc in the dis-
tance. The old city is seen lying beyond the waveless waters, veiled
with a sweet misty veil of Athena's weaving: a faint light of morn-
ing, peaceful exceedingly, and almost colourless, shed from behind
the Voirons, increases into soft amber along the slope of the Saleve,
and is just seen, and no more, on the fair warm fields of its summit,

between the folds of a white cloud that rests upon the grass, but rises, high and towerlike, into the zenith of dawn above.

'There is not as much colour in that low amber light upon the hill-side as there is in the palest dead leaf. The lake is not blue, but grey in mist, passing into deep shadow beneath the Voirons' pines; a few dark clusters of leaves, a single white flower — scarcely seen — are all the gladness given to the rocks of the shore. One of the ruby spots of the eastern manuscript would give colour enough for all the red that is in Turner's entire drawing. For the mere pleasure of the eye, there is not so much in all those lines of his, throughout the entire landscape, as in half an inch square of the Persian's page. What made him take pleasure in the low colour that is only like the brown of a dead leaf? in the cold grey of dawn — in the one white flower among the rocks — in these — and no more than these?'

No one, I think, will question that this is both 'literature' and 'criticism', and, as I have said, it goes beyond mere description of the subject. To begin with it passes from the subject to the means — 'not as much colour as there is in the palest dead leaf'; and then it asks questions which concern not only Turner's character, but the whole nature of art. This is true of all creative descriptions of works of art: they become evocations of the artist's attitude to the nature of aesthetic experience. But they gain most of their literary distinction, and some of their critical value, from the fact that the writer's first concern is a direct visual experience which he must put into words as vividly as if it were an impression of nature.

It often happens, however, that in attempting to convey the impression of a work of art a critic is forced beyond a straightforward description of the subject, and must have recourse to allusion, metaphor and analogy. The most famous description of a work of art in the English language, Walter Pater's evocation of the *Mona Lisa*, is of this kind, and we may argue that with an image so complex, a simple description of the subject would have been meaningless. Pater's accumulation of associative images — the rocks, the vampire, the diver in deep seas, the sound of lyres and flutes — may seem rather far-fetched; and no one supposes that they were in Leonardo's mind when he was at work; but to the nineteenth-century reader, with his rich, elaborate mental furniture, they did to an extraordinary degree convey the mysterious power of the original painting.

The description of a picture by analogy and associated images is an

essential arm of criticism if we are to go beyond the primary subject to that amalgam of subject and style from which a work of art derives its total effect. And from the literary point of view, it is a most seductive exercise. It is an extension of that faculty for seeing similars in dissimilars which Aristotle claimed to be the core of poetic endowment; and in the case of Pater's *Mona Lisa* the result is so close to poetry that Yeats put this passage, chopped up into *vers libre*, as the opening extract in his *Oxford Book of English Verse*. Yet the critic follows this line of approach at his peril. Without a high degree of insight, imagination and literary skill it degenerates into pretentious nonsense. In France and Italy two thirds of current criticism consists in extended metaphors, which evidently gave the writer satisfaction, and may be the envy of his colleagues, but obscure rather than clarify the impact of the work discussed. Perhaps modern art, which is often itself a kind of visual metaphor, cannot be criticised in any other terms. But the result is like a prose translation of a metaphysical poem.

Yet without analogy and metaphor the interpretation of works of art would have remained in a very primitive stage. Once we try to go beyond the primary subject and set about turning an aesthetic sensation into words we have no choice but to find analogies in other sensuous experiences for which words already exist, or to remember from poetry forms of words that seem to describe an analogous moment of illumination. How far we succeed will depend partly on our imaginative insight, partly on our own responsiveness to experience, and partly, of course, on our command of words.

Here I may digress to say that the critic of art, like all other writers of critical prose, must fight an unending battle against the degradation of language. No doubt this has always been true, but the threat to words, and in particular to words of praise, has become much more serious during the last twenty-five years owing to the increased literary consciousness of those who write advertising copy. Almost every word the critic would wish to use in praise of a work of art has already been applied to a face tissue or the flavour of a cigarette: and as the critic explores a more exotic vocabulary, so the copy-writer, painfully sophisticated, pads along behind him. Only words of abuse, which are excluded from advertising, remain relatively fresh. Moreover, ordinary journalists, in picking up pseudo-scientific terms like syndrome have also collected one or two critical

terms that used to be of real value to the writer on art. Such, for example, is the word symbol, which can be employed by the art historian with a precise meaning and is almost irreplaceable. Yet today we are haunted by the memory of 'status symbol' and other vulgarised derivatives, and use the word with distaste. The word image, equally necessary to the writer on art, has suffered an almost worse fate, since it has been used to cover a firm's reputation or the public estimate of a politician. Yet these damaged words should not, I think, be dismissed as incurable. The vocabulary of criticism is already very limited, and every useful word which can be given a precise meaning should be nursed back to health by careful usage.

I have distinguished between description and analysis. In practice the two are almost inseparable from each other, for how can we analyse a work of art without describing its parts; and in both the problem is the same: to find valid equivalents for visual experiences. Nevertheless we can point to passages where description is subordinate to an analytical intention; and when this procedure is directed by the penetrating eye of Ruskin, Wolfflin or Riegl, it is perhaps the most enlightening in all criticism. I cannot say that strict analysis tends to produce fine writing. There is something insistent about it, some ghost of a dialectical method, which is hostile to the sensuous directness of good prose. To analyse a work of art is to destroy precisely what gives it value, its unity; and even if this is done with love it is an anti-creative activity which is not likely to result in fresh creation. Nevertheless, the literature of art contains pages of analysis in which the writer's insight is so acute and his deductions so convincing that we derive from them a real aesthetic pleasure. Such as Wolfflin's analyses of Baroque architecture, or his comparison between Terborch and Metsu. Yet we must admit that a great part of our satisfaction is due to the clear and graphic style in which Wolfflin describes the different elements in the pictures. It is less an analysis than an orderly sequence of impressions. As for Ruskin, who prided himself on his analytical mind, long before his argument is concluded his gift of poetic eloquence has intervened and left us breathless.

This leads me to the last of the four ways in which, as I suggested earlier, writers on art can achieve literary distinction. I called it rhapsody, but perhaps this word, by implying an absence of intellectual control, is misleading; for the passages of which I am thinking,

## Art History and Criticism as Literature

in Ruskin, Baudelaire, Pater and even Fromentin, are by no means
without a background of hard thought. But I wished to suggest that
in the finest pieces of writing about art the critical historian is carried
away by the excitement aroused by his admiration of an artist or of a
work of art, and the result is a piece of impassioned rhetoric which is
not the less illuminating because it is a *feu d'artifice*. Here is Baudelaire
on the subject of his hero, Delacroix: 'His works contain nothing but
devastation, massacres and conflagrations; everything bears witness
against the eternal and incorrigible barbarity of man. . . . Burnt,
smoking cities, slaughtered victims, ravished women, the very chil-
dren cast beneath the hooves of horses or menaced by the dagger of a
distracted mother — the whole body of this painter's work is like a
terrible hymn composed in honour of destiny and irremediable
anguish.' And here is Ruskin's famous comparison between Salis-
bury Cathedral and his favourite building, the Campanile of Flor-
ence: 'The contrast is indeed strange, if it could be quickly felt,
between the rising of those grey walls out of their quiet swarded
space, like dark and barren rocks out of a green lake, with their rude,
mouldering, rough-grained shafts, and triple lights, without tracery
or other ornament than the martins' nests in the height of them, and
that bright, smooth, sunny surface of glowing jasper, those spiral
shafts and fairy traceries, so white, so faint, so crystalline, that their
slight shapes are hardly traced in darkness on the pallor of the Eastern
sky, that serene height of mountain alabaster, coloured like a morn-
ing cloud, and chased like a sea shell.' The reader will observe that in
both the quotations the effect is still obtained by the two factors I
mentioned earlier, description and analogy; but the pressure of
enthusiasm has given them a rhythmic unity that transcends the sum
of the parts. Cézanne defined art as a harmony parallel with nature;
the best criticism is a creation parallel with art, and Baudelaire was
right in objecting to the distinction between creative and critical
writing, on the condition (as he said) that it is impossible for a poet
not to contain within himself a critic, although unthinkable that a
mere critic should become a poet.

What are the special qualities required by the historian and critic of
art? To begin with he must not only be responsive to works of art; he
must have an appetite for them. The dyspeptic critic, though he may
score some small successes, is not of lasting value. Desmond Mac-
Carthy, one of the best of recent dramatic critics, used to say that

every time the curtain went up he was as excited as a small boy at his first pantomime. And this eager responsiveness is also necessary to the art historian, for if he does not respond to works of art he cannot 'read' them intelligently as documents. But although I would place this first among the critic's endowments, delight alone is not enough. Mere hedonism is aimless and enervating. In all the great critics aesthetic responses are related to a central core of philosophy with which they form a complex web of cause and effect. We do not ask that this philosophy should be entirely consistent or proof against the examination of a trained logician. But it must be firm enough to allow the critic to recognise the nature of his perceptions, and relate them to one another. Pater, although he claimed that the effect of painting was no more than 'a space of fallen light, caught as in the colours of an Eastern carpet', yet found it necessary to deduce from the reality of these responses a sort of existentialist philosophy which, in the conclusion of the *Renaissance*, are put forward as the basis of a way of life. Baudelaire absorbed, through Edgar Allan Poe, the philosophic assumptions of Coleridge. Berenson was undisguisedly a pupil of William James. Unfortunately the philosophers themselves (with the possible exception of Hegel) have seldom been responsive to works of art, perhaps because the capacity to form abstract propositions cannot survive bombardment by a succession of aesthetic experiences. The value-judgements of writers on aesthetic philosophy are, for the most part, so naively academic that when, in the course of their arguments, they quote concrete examples, we tend to lose confidence in their theories.

I began by saying that the history and criticism of art must go beyond the accumulation of facts; but this does not mean that the critic, still less the historian, can ignore or distort them. The moment we feel that an historian is twisting the facts to suit himself, or to support some doctrine, we become suspicious of his whole tone and can no longer take him seriously as a writer. Amongst these facts is truth to his own responses. Baudelaire frequently claimed that the first qualification of the critic was *naïveté*, by which he meant a sincere and modest acceptance of his feelings; not, one would have supposed, a very difficult achievement, but how often interrupted by loyalty to some abstract concept — academism, Marxism, or the desire to be 'in the movement'.

How far does the value of a critic, including his literary value,

# Art History and Criticism as Literature

depend on his judgement being confirmed by posterity? We may agree that the term posterity is a somewhat dubious concept and often implies no more than the taste of the time at which it is being used. What did 'posterity' say of Piero della Francesca in 1870; or of El Greco? But it is not completely meaningless, because we expect a fine critic to see beyond the prejudices of his time, and we could argue that 'the judgement of posterity' really consists in the sum of these keener insights. To 'spot winners' is not the certain mark of a great critic. Ruskin and Baudelaire, who were often 'wrong', are greater critics than their contemporary, Thoré, who was nearly always 'right'. And yet we can say that for a critic to be consistently and obstinately wrong, as so many nineteenth-century critics were, is a serious defect, because most errors of judgement arise from an absence of love, a lack of fine perception and an inability to withstand the pressure and prejudices of the time. These defects destroy the value of criticism as literature, for it is precisely by the qualities of spontaneity and passionate conviction that criticism transcends its negative function. The great critics have been hero-worshippers and have written best in praise of their heroes: Vasari on Michelangelo, Ruskin on Turner, Baudelaire on Delacroix, Fromentin on Rubens. In each case we feel that the critic is giving imaginative release to the kind of work of art he would have wished to create himself.

For some years past literary critics have maintained that their duty is not appreciation but evaluation, and this intellectual fashion has revealed the hollowness of much well-meaning enthusiasm in earlier criticism. But it seems to me doubtful if the literature of evaluation will continue to interest readers once its work of re-assessment has been done. Criticism, to survive as a form of literature, must change sides and become a form of creation, and this it can do only when it is the result of the same passions and energies, the same controlled delight and the same total immersion that go to the making of a work of art.

# SEVEN

# The Concept of Universal Man

Among the Founding Fathers of the American Republic, two derive much of their eminence from the fact that they were what we call universal men: I refer, of course, to Benjamin Franklin and Thomas Jefferson. It might be interesting to compare these great Americans with other so-called universal men, to see what this concept involves, under what circumstances it develops, and whether it has any value for us today.

What meaning can one attach to the words 'universal man'? I propose one that might have been acceptable to Franklin and Jefferson. Universal man is one whose interest extends from every branch of human activity to the observation of nature. He is a man who, when he observes a human institution — the paving of a road, or the irrigation of a field — wishes to improve it; and, when he observes a natural phenomenon, wants to know how it works. Can it be measured, does it conform to certain laws, can it be made of use to man? In order to answer these questions he collects evidence. Universal man, on my present definition, is essentially a believer in the inductive method.

But he regards all these branches of knowledge as arts. There is in England an institution which still perpetuates the earlier meaning of that elusive word: The Royal Society of Arts, founded in 1754. From the first it devoted most of its time to agriculture and afforestation, and other useful arts. This year it has had lectures on Agriculture and the Engineer, on the Changing Design of Ports, on Structural Engineering, and on Afforestation. Franklin, who was one of its early members, would still feel at home there, although he might have shirked the occasional lecture on art in our contemporary sense of the word.

Universal man was not a concept of antiquity. It could, I suppose, be claimed that some of the pre-Socratic philosophers, in particular Empedocles, were universal men. They certainly asked questions about the nature of matter. But they were inhibited by the profoundly theoretical, or non-inductive, character of the Greek mind,

91

# The Concept of Universal Man

and when we come to Plato the questions are not about observable facts, but about certain aims — wisdom or happiness — into which material considerations were supposed not to enter. One might have supposed that Aristotle, with his encyclopaedic interests, would have drawn the portrait of the universal man, but quite the contrary. His ideal was the *magnanimous* man, who would have lost some of his magnanimity if he asked the kind of questions asked by Alberti and Leonardo, Franklin and Jefferson. There was no 'do-it-yourself' in ancient Greece. Aristotle would have recoiled from the very thought. And one result of this society based on slavery was the division between liberal and mechanical arts which was supposed to go back to Aristotle, although its classification took place only in Roman times, in the encyclopaedia of Varro. The mechanical or illiberal arts include science, mathematics other than geometry, painting, sculpture, architecture (off and on), agriculture and, of course, all forms of craftsmanship.

It is true that Plato, in the *Republic*, admits that the four mathematical sciences might be admitted into the education of a statesman as tending to draw the soul towards truth. Aristotle also allows that science could be studied, but only if this is done for its own sake, without any view to results. The last word on the subject is in Xenophon, who considers the illiberal arts (i.e. science) so degrading that he commends those countries where they are made unlawful.

If the concept of universal man, as I am trying to define it, found no favour in antiquity, still less was it valid in the Middle Ages, which based its philosophical structure on Plato, Aristotle and Boethius, and assumed that all intellectual activities were ultimately directed towards the knowledge and love of God. In a sense Dante was a universal man — scholar, jurist, soldier, active politician, philosopher, astronomer, supreme poet. But Dante was separated from the men I am discussing today in that all his experience of life was ultimately directed towards the knowledge of Divine Truth, whereas Franklin and Jefferson wanted to observe nature and master every branch of human experience in such a way as to be of use to man. This concept was an invention of the early Italian Renaissance, and depended on the assumption that natural causes and human arts could be combined.

In Jacob Burckhardt's immortal essay, the central section is called 'The Discovery of Man and The Discovery of the World'. The

# The Concept of Universal Man

combination of these two discoveries created universal man. It had what I have called a Robinson Crusoe side, because the first universal men, Leon Battista Alberti and Leonardo da Vinci, had to ask absolutely new questions — questions that a man might ask if put down on a desert island — and find not only new answers but new means of answering them.

Alberti is Burckhardt's hero. In fact most people know him only through the moving passages in the *Civilisation of the Renaissance* that are devoted to him. Burckhardt speaks of Alberti's athletic prowess, of his mastery of horses, of his love of music, and adds 'All the while he acquired every sort of accomplishment and dexterity, cross-examining artists, scholars and artisans of all description about the secrets of their craft (Franklin did the same). That which others created he welcomed joyfully, and held every human achievement that followed the laws of beauty as something divine.' Burckhardt goes on to describe his skill as a painter, and his literary works, and ends with the following unforgettable passage: 'At the sight of noble trees and waving fields of corn he shed tears: handsome and dignified old men he honoured as "delights of nature" and could never look at them enough — and more than once, when he was ill, the sight of a beautiful landscape cured him.' It is as a result of this paragraph alone that Alberti has entered the general historical consciousness, and has even been made the hero of an article in *Life* magazine. I rather doubt if many readers of that article carried their researches further. Alberti's works are rare and inaccessible, and his autobiography, from which Burckhardt made this rather free translation, is extremely obscure. However, I hope you will allow me to say a little more about Alberti, as he seems to have established a sort of prototype of universal man which was to re-emerge in the first days of the American Republic. It is possible to know a lot about him because, in addition to this autobiography (the first since St Augustine), he left over a dozen dialogues on morals and society in which he and his family are the chief speakers, he left a book on the theory of painting (the first ever written), a great book on architecture (the first since Vitruvius), a book on sculpture, on the moving weights, on mathematics and on the excavation of a Roman galley. The first, the first, the first: you see why I stress this point, that universal men grow most vigorously in untilled soil.

Alberti was born in the year 1404. He learned Greek and Latin at

the University of Padua, and throughout his life had a remarkable facility in languages. He then moved to Bologna, where he studied law. Evidently he overworked, and suffered some kind of breakdown. Letters, he tells us, which had once seemed to him like vigorous and sweet-smelling buds, now swarmed beneath his eyes like scorpions. But he conquered this breakdown, as he conquered all physical weakness, for as he said 'A man can do all things with himself if he will'. And he developed an almost morbid industry. 'Although at no hour of the day could you see him idle, yet that he might win for himself still more of the fruits of life and time, every evening before going to bed he would set beside himself a wax candle of a certain measure and, sitting half undressed, he would read history or poetry until the candle was burnt up. The followers of Pythagoras used, before they slept, to compose their minds with some harmonious music. Now our friend finds his reading no less soothing than was the sound of music to them; but it is more useful. They fall into a profound sleep in which the mind is motionless; but he, even when asleep, has noble and life-giving thoughts revolving in his mind; and often things of great worth become clear to him, which when awake, he had sought with unavailing effort.'

After the law he turned to mathematics, and received instruction from the leading mathematician of his day. But as a typical humanist, Alberti did not practise mathematics for its own sake, but in order to secure control over the forces of nature, in particular how to use the powers of wind and water. He invented a means of measuring the depths of the sea, an igrometre for measuring damp, various devices for raising weights, and a *camera obscura*, which he described as a *miracolo della pittura*. He was interested only in the practical application of his studies for, as he said, 'Man is born to be of use to man. What is the point of all human arts? Simply to benefit humanity. So the wise will blame those who studiously devote themselves to complicated and unimportant enquiries.'

We are a long way from Aristotle and Xenophon, and remarkably close to Franklin and Jefferson. The description of Alberti sitting up in his nightshirt reading till his candle had burnt out is pure Franklin; but on the whole the resemblance to Jefferson is closer, and is confirmed by a comparison of their proud, wilful heads: also by the fact that both of them put their theories into practice through the medium of architecture. Architecture would seem to be the ideal

means of expression for the universal man, combining as it does knowledge of mathematics, and what Alberti called 'the movement of weights and conjunction of bodies' with a wide appreciation of human needs.

Unfortunately architecture is a good deal more difficult than it seems, and those who have learnt the art in a library rather than a stonemason's yard usually reveal a certain amateurishness. This charge, which has been brought against Alberti (in my view wrongly), can I think be sustained in the case of Jefferson. In his buildings nothing clicks. And yet there is something lovable in the way one can follow the workings of his mind, and what professional architect could have conceived the overall plan of the University of Virginia? Perhaps only the great universal man of seventeenth-century England, Sir Christopher Wren, whose early buildings are as amateurish as Jefferson's, but who, by turning from universalism to concentration, became a professional architect of the first order.

The other great universal man of the Renaissance, Leonardo da Vinci, escapes all generalisations. He has no resemblance to a Virginia country gentleman or a Philadelphia printer. And yet if we compare him to the great minds of antiquity or the Middle Ages, we find how much closer to the age of the enlightenment he is. His aim is knowledge. He believes that nature will act consistently in all its operations and thus that all natural phenomena must somehow be related to one another. The scaffolding in which his observations must be fitted is mathematical. 'In mathematics', he says 'One does not argue if twice three makes more or less than six: all argument is reduced to eternal silence, and propositions can be enjoyed in a peace that the lying sciences of the mind cannot attain.' But this mathematical peace of mind was continually disturbed by his insatiable curiosity. Everything he saw suggested a question — the sight of a shell on a high mountain, the shape of a leaf, the formation of clouds, the forces of wind and water, the way that a feather in the flame of a candle burns to a point — a question also asked by Franklin. Endless questions about the forces of wind and water.

The thousands of notes in which he recorded his observations are not lively reading. We must accept the fact, confirmed by such of his successors as Franklin, Jefferson and Sir Joseph Banks, that a universal man is not afraid of being a bore. What makes Leonardo's observations tolerable is that they are related to the art in which he

was supreme, the art of drawing. 'If you despise painting', he says, 'which is the sole means of reproducing all the known works of nature, you despise an invention which, with subtle and philosophic speculation, considers all the qualities of forms: seas, plants, animals, grasses, flowers, all of which are encircled in light and shadow.' So the relegation of painting to the mechanical arts becomes all the more absurd.

Leonardo, in this list, does not include the human body. Yet it was to the human body that he first applied his scientific attention, and it remained the subject of his last dateable drawings. Once more, he was 'the first': although there had been a school of anatomy in Padua, and the subject made rapid strides during Leonardo's lifetime, producing the first anatomist of known eminence, Marcantonio della Torre, with whom Leonardo became friendly. But Leonardo raised the subject on to an entirely new plane, partly because he asked questions which no one had dared to ask, particularly on the subject of conception and birth, and partly because he could record his findings in accurate and beautiful drawings. Interest in our own bodies would seem to be a proper occupation for universal man; but this has not been the case. Is the subject too depressing? Or does it mean that the universal man is, as a rule, an extrovert? Or is it simply that the study of human anatomy is too exacting?

The strange thing is that Leonardo did not go further. Why, for example, when he made such a thorough and on the whole accurate investigation of the action of the heart, did he not anticipate Harvey's discovery of the circulation of the blood? The answer is that he distrusted all forms of hypotheses: an answer that may have some bearing on my subject, because hypothesis, without which scientific advance cannot take place, is the product of the imagination, charged with its subject and concentrating on a single problem; something which the universal man is unlikely to achieve.

Universalists have usually been more interested in what we call nature — in botany, geology, astronomy — than in our own bodies. I suppose that the study of anatomy was distasteful and soon became too specialised, although famous anatomy schools remained places of resort throughout the seventeenth century. But to Leonardo the human body was the type of all life. Its growth and change could by analogy be extended to nature as a whole. 'Nothing originates', he says 'in a spot where there is no sentient, vegetable,

and rational life; feathers grow upon birds and are changed every year; hairs grow upon animals and are changed every year. . . . The grass grows in the fields, and the leaves on the trees, and every year they are, in great part, renewed. So that we might say that the earth has a spirit of growth; that its flesh is the soil, its bones the arrangement and connection of the rocks of which the mountains are composed, its cartilage the tufa, and its blood the springs of water. The pool of blood which lies round the heart is the ocean, and its breathing, and the increase and decrease of the blood in the pulses, is represented in the earth by the flow and ebb of the sea.' In such a passage as this humanism takes on an imaginative power very different from the commonsense of Alberti or the homespun empiricism of Franklin.

And yet Leonardo had his Robinson Crusoe side. Next to the movement of water, I suppose that the greatest part of his notes is concerned with machines, many of them so elaborate and fanciful as to remind us of another Robinson. (Perhaps Heath Robinson, the humorist of modern technology, is now forgotten. His drawings are worth publishing.) How far these are Leonardo's own inventions, and how far the records of things he had seen and had struck him as ingenious we shall never know. Very elaborate machinery must have been used in the building of Beauvais Cathedral, but the craft rules of the Middle Ages prevented it from being recorded. From the point of view of my subject the important thing is that the greatest of universal men was not content with either theory of fact finding, but wanted to put his ideas of cause and effect into practice.

But at this point there emerges a curious difference between Leonardo and what I may call the standard universal man. Alberti says repeatedly that he accumulated knowledge in order to be of service to men. This was a mainstay of the humanist creed. Franklin and Jefferson would have said the same. They were propelled by some kind of moral necessity, and believed that the more you know the better equipped you are to make humane and reasonable judgements. This point of view had no appeal to Leonardo da Vinci. The vast accumulation of words in his notebooks contains hardly a single moral judgement except in some proverbs copied from sources like the *Acerba*. In his early notes he sometimes implies that knowledge would give man power over the forces of nature. But as he grew older he abandoned this position, partly because he had come to have

so low an opinion of the human race that he was quite prepared to see the forces of nature wipe it out; and partly because he came more and more to the conclusion that nature was not only indifferent, but beyond the powers of reasonable analysis. He had started with a mathematical framework in which observations could be measured and arranged. In the end these observations, not only by their bulk, but by the contrary nature of their evidence, had passed tragically out of his control. *Di mi se mai fu fatto alcuna cosa* — tell me if anything was ever done: this was Leonardo's doodle, the words that came automatically from his pen in a vacant moment. Before the infinite complexity of space and organism the greatest of universal men foreshadowed the eventual inadequacy of universal man.

\*　　　\*　　　\*

The Renaissance reached England almost a hundred years late, and it is appropriate that the last great universal man of the Renaissance should be an Englishman: Francis Bacon. 'The Discovery of Man and The Discovery of the World': We think of Burckhardt's chapter when we look at the superb frontispiece of the *Instauratio Magna*, with its galleons sailing away between the pillars of *Fortitudo* into the unknown, while in the foreground is the knowable world of plants and shells. Like Alberti, Bacon frequently declared a practical intention. 'I thought myself born to be of advantage to mankind.' And like Leonardo he maintained that he had taken all knowledge for his province. 'Knowledge', he said, would 'restore the original commerce between man and nature and recover the *imperium hominis*, the grand object of all science.' However, his opinion of *homo sapiens* was no higher than that of Leonardo before him or Voltaire after him, and the section of the *Novum Organum* entitled 'Idola' is an anatomy of human prejudice, in which he specifically renounces the notion that man is the measure of the universe. He accepts the conclusion that so much distressed Leonardo, that 'Man, the servant and interpreter of nature can do and understand so much, and so much only; as he has observed in fact or in thought of the course of nature; beyond this he neither knows anything, nor can do anything', and makes it the basis of his system. Because, unlike Leonardo, Bacon tried to make his observations into a system, and, in spite of his prodigious intelligence, he failed for the same reason that prevented

# The Concept of Universal Man

Leonardo from even attempting such a task: his mistrust of hypotheses. It is for this reason that he omits some of the chief scentific discoveries of his age, including those of Copernicus and Kepler. He does not even mention Harvey, although Harvey was his own doctor. Harvey, in return, said 'He writes philosophy like a Lord Chancellor'. That is unfair. The scope and universality of Bacon's mind is unquestionable, and the *Novum Organum* is entirely uninfluenced (except in its most brilliant chapter, the 'Idola') by his experience of public life. But on those words we may ask if Bacon should be described not as a universal man, but as a universal intelligence. There have been few men of his eminence of whom the good old Victorian epithet 'manly' is less applicable. His life was spent in lobbying, intriguing, and weighing the chances of legal and political preferment. Even in that age of sycophancy no one wrote more abjectly grovelling letters to those in power. He not only abandoned his friend and patron (that, under the circumstances, was understandable) but used all his skill to ensure that he was beheaded. In order to secure Royal favour he used the rack to question a harmless old silly called Peachum. For a Lord Chancellor to take bribes may have been customary at the time, but it cannot be considered admirable.

The concept of universal man should ideally involve a balance of human faculties and, if I may be permitted two expressions which are out of favour with modern writers, Bacon was unusually deficient in warmth of heart and moral sense. But it was not these deficiencies which led to a decline in Bacon's reputation in the seventeenth century: it was the fact that he was not a mathematician. In that century the greatest minds in Europe were concentrated on mathematics. It is true that Pascal deviated into religious controversy and that Descartes had an almost Leonardesque interest in whirlpools. But basically they were mathematicians, and at the close of the century came the purest mathematician of all, Sir Isaac Newton. For universal man a warning gong was sounded: because, although the *Principia* became the sacred book of the next century I cannot believe that, in the great age of the universal man, many had read, still less understood it.

As, towards its close, the earnestness and passionate concentration of the seventeenth century declined the way was open for a new age of synthesis. In many respects it was a throw-back to Renaissance

99

# The Concept of Universal Man

humanism, and it was accompanied by an unbounded admiration for the last Renaissance man, Francis Bacon. Voltaire called him 'le père de la philosophie experimental', and d'Alembert, in his brilliant introduction to the *Encyclopédie*, referred to him as 'le plus grand, le plus universal et le plus éloquent des philosophes'. It may seem an unwise generalisation to call the age of Voltaire and Rousseau optimistic. The author of *Candide* was certainly no blind optimist about his fellow bipeds and, although Rousseau professed to love the human race, he saw anyone who was kind to him as a potential enemy. Yet both were optimistic in that they believed that man could be improved through education. They believed that if men could discover enough about themselves and the world, they would become juster, more reasonable and more humane. The *Dictionnaire Philosophique* is ultimately an optimistic book, and so, of course, are both *Émile* and the *Contrat Sociale*. In this spirit both Voltaire and Rousseau aspired to be universal men, and I think we may say that Voltaire achieved it, for he really did know a prodigious amount about history, human thought and human behaviour, and put his knowledge into practice in organising his little community at Ferney. Unfortunately at that date philosophy extended to natural philosophy, and he felt it his duty to spend many hours in scientific experiments. Many of you will remember two essays on the subject by E.M. Forster. They are high comedy, all the more so because the great mocker took his researches so seriously. As always with the early natural philosophers, geology was the chief stumbling-block. Those marine fossils and sea-shells in mountains! They had baffled Leonardo, who devoted many pages to them, they baffled Mr Jefferson, they even distressed Sir Edmund Gosse's father. They worried Voltaire particularly, because the only reasonable explanation involved admitting that there was some foundation for the legend of the Flood, and this Voltaire's anti-religious fanaticism would not allow him to do. However, as Mr Forster said, all was not lost; 'they can still be accounted for in three ways. Firstly, since so many of them are cockles, they may have been dropped from the hats of Palmers who were going to the shrine of St James at Compostella in the middle ages. Secondly, since so many are edible, they may be the debris of picnic parties. And thirdly, since so many of them are different, they may have come from the collections of dead conchologists.'

# The Concept of Universal Man

I quote this passage, not only because it is comical but because it shows how one of the most intelligent men of all time could make himself ridiculous by attempting to master all knowledge. Voltaire's universalism is more humane than Bacon's, but ignores that wise man's warning that 'we can understand so much and so much only'.

The most complete expression of this desire for universal knowledge was, of course, the *Encyclopédie, ou Dictionnaire Raisonné des Sciences, des Arts et des Métiers.* I give the full title because it shows how the men of the enlightenment, in spite of their lip service to antiquity and their mania for Graeco-Roman sculpture, had an entirely non-aesthetic view of the aims and limits of *human* knowledge. The despised mechanical arts are now the main theme of these twenty-four crowded volumes. The men who pushed through the work were Diderot and d'Alembert, and it must be allowed that their universality gave something to the world. Diderot, in particular, had a range of information and achievement which has seldom been equalled, because in addition to writing well-informed articles on every topic, articles that can still be read with pleasure, he wrote stories as brilliant as *La Religieuse*, and as penetrating as the *Neveu de Rameau.* He was even an art critic. The *Encyclopédie* was not only a source of information. It was, together with the *Dictionnaire de Beyle*, a battering ram to use against the *ancien régime.* It was twice suppressed, and became the subject of passionate struggles in which the Court, the Jesuits and the intellectuals all behaved with equal duplicity. Thus the accumulation of knowledge became not only a source of power over the forces of nature, but a means of defeating tyranny.

This was the intellectual atmosphere in Paris when Benjamin Franklin arrived there as Ambassador in 1775. The fight for the *Encyclopédie* had been won. The last volume was just about to appear, twenty-two years later than the first. The highest minds in France were looking to America, and here, from the new world of liberty, came a universal man. It was over thirty years since the great Buffon had seen the value of Franklin's electrical experiments and caused his essay to be translated into French. It had been accepted by French scientists, rejected by the Royal Society. His electrical kite was one of those images that strike the popular mind. So his reputation as a

natural philosopher, a revolutionary statesman and a sage was already established before he came to France. When he arrived, his character, with its combination of naivety, cunning and apparent meekness, was irresistible. He immediately became one of the most famous men in Europe. In dozens of drawings and engravings his robust frame and large, unromantic countenance appeared rather incongruously floating on clouds of glory. Winged figures of Fame and Virtue flew at his feet. It was said that miniature busts of Franklin outnumbered those of Voltaire and Rousseau; although this is no guarantee of lasting favour, because during 1941 (this is statistically true) there were more Toby jugs sold of Dr Joad than of Mr Churchill. It was certainly the greatest public triumph that any universal man had ever enjoyed. Several factors account for it. Franklin was a man of enquiring mind and of powerful commonsense. If *prudentia* be a virtue, he was virtuous. He made a number of useful inventions, including the glasses I am wearing now, which are much more practical than Mr Jefferson's glasses. A hundred years later he could have been Thomas Edison, the greatest of all 'do-it-yourself' scientists. He also had the diplomatic cunning that one learns in local politics and his famous meekness, which in fact he had assumed with his usual self-discipline, made him a favourite in the competitive society of Paris. But the card which no one else could play was the extreme simplicity of the society from which he had made his way. It is quite hard to believe that there was in the Philadelphia of the 1730s only one printer, till the young Franklin set up in competition, only one set of type, till another arrived from England. The most desirable job was printing for the Post Office, not because of the money it brought in, but because it gave one a chance of knowing about the doings of one's neighbours. Small-town life. Franklin, more than anyone, supports my statement that universal man must have something of Robinson Crusoe. But his resourcefulness extended from the mechanical to the civic arts. His discussion group turned into the Philosophical Society of America; his educational organisation turned into the University of Pennsylvania; his hospital turned into the Pennsylvania Hospital; he first secured the paving of streets; he established the first insurance company. He was not only the first man to see the necessity of all these institutions, but he had the skill and tenacity to see them carried into effect. To the *philosophes* of Paris he seemed to show that reason and benevolence could grow out of

virgin soil as they never could in the over-cultivated fields of Europe. Unwittingly and unwillingly (for he had no high opinion of primitive man) he drew a dividend from Rousseau's *Discourse on the Nature of Inequality* and on Bougainville's *Discoveries*. In spite of an undeniable absurdity, he remains a lovable man. 'I thought myself born to be of advantage to mankind.' These words might have come from his autobiography, and he certainly had more justification for them than Francis Bacon.

'No one can replace him, sir. I am only his successor.' These words were Thomas Jefferson's usual answer to those Parisians who congratulated him on replacing *le grand Franklin* as American Ambassador to Paris. It is true that the two men were remarkably dissimilar. There was nothing of the homespun philosopher about Jefferson. There was not even a feeling of universal benevolence. His famous comments on the French Revolution — 'The tree of liberty must be refreshed from time to time with the blood of patriots and tyrants' — are not those of a humane bourgoise but of a republican aristocrat who really hated government of any kind. Jefferson never adopted the disguise of meekness, and his famous contempt for uniforms and ceremonies was the expression of a heroic pride which has alienated a large section of American opinion till the present day. 'A good guy', 'Just folks', those two terms of praise, which have played so large a part in arousing the love of the great American people, could never have applied to Mr Jefferson, and his instructions to omit from the inscription on his tombstone the fact that he had been President of the Uniited States and made the Louisiana Purchase is surely one of the most magnificent assertions of intellectual pride in history.

But as a universal man he is linked with Franklin in two ways. First, he too was tilling virgin soil. Of course America had come a long way in the thirty years since the small-town simplicity of Franklin. But even so most of Jefferson's investigations were without precedent. When a traveller went West Jefferson could ask him for reports on the terrain, the weather, the fauna and flora, knowing that all this information would be fresh. In agriculture, in botany, in irrigation, in paleontology, in scientific excavation, in the philology of Indian dialects — the list could be extended — he was 'the first', and with his tireless patience, self-discipline and intelligence he arrived in one leap at methods and results that might not have been

# The Concept of Universal Man

discovered for half a century. Like other universal men, he preferred collecting and arranging facts to proposing hypotheses. Jefferson's mind was at its best in questions of fact, at its weakest in questions of theory. In his celebrated — justly celebrated — correspondence with Adams I think that Adams comes out the wiser man. Yet even there, how surprisingly intelligent he could be. That anyone with his intellectual powers and intransigent character could become President of the United States shows what miracles can happen when a nation is still young.

Secondly, he was linked with Franklin, as he was with Alberti, through his involvement with a republic. Universal man does not flourish under a tyranny; Bacon is the exception that proves, somewhat painfully, the rule. The first privilege of universal man is asking questions, and innocent questions about agriculture or irrigation can easily develop into questions about the rights of property. The second privilege of universal man is the use of reason, or at least of common sense; and in the light of reason the pretensions of a tyrant are odious and the divine right of kings looks ridiculous. And thirdly there is the old belief, repeated in the same words by universal men for three hundred years, that man is born to be of use to men, and presumably this hope is more likely to be realised when the *res publica* rather than the tyrant is the final court of appeal. Even Voltaire thought it wise to live on the borders of a republic.

Divine kingship is the oldest form of government, and has been accepted by the majority of mankind for the longest time. Successfully to oppose it requires a rare combination of circumstances and men: a great soldier, a man of absolute probity, a group of able lawyers and a universal man. (I do not include an orator, because oratory is by no means always on the side of reason, and, although an extremely powerful weapon, is one that can ricochet in an incalculable manner.) All these characters were present in the formation of the Florentine Republic in the early fifteenth century. There have seldom been abler and more devoted public servants than the first Florentine chancellors, Salutati and Bruni, both of whom had in fact been trained as lawyers; and their régime produced the first universal man. The same characters appeared in the rise of the Dutch Republic, William the Silent, Grotius and, as universal man, the Huyghens family, who were poets, scientists and indefatigable question-askers as well as public servants. Jefferson fits perfectly into the context. He

104

is, as I had the honour of saying in his own university, almost like a reincarnation of Leon Battista Alberti — the same almost morbid industry, the same belief in a combination of will and commonsense, the same insatiable appetite for information, the same love of nature: even the same recreations — horsemanship and music.

It would seem that a universal man has played an honourable part in growing communities, and especially in republics, and he is also useful in periods of synthesis. But has he, on my definition, relevance to the universal life of the present day? It looks as if the answer will be no, for two reasons. First of all, the questions asked by Leonardo da Vinci, Franklin and Jefferson have turned out to be far more complex than anyone would have realised before the invention of the electron microscope or the radio telescope. The very small and the very large have become so much smaller and larger, and so utterly unpredictable that the answers which satisfied a universal man of the nineteenth century, like Huxley, are no longer acceptable. And then so many of the simplest questions have proved unanswerable. Why does a bird sing? Nobody knows. Why do some moths survive by adopting protective colouring, while others wear the gaudiest dress that nature can provide? Nobody knows. I do not think that Leonardo ever asked these questions, but others that he asked repeatedly, like the age of the earth, the constitution of its inner core, the origin of storms, have remained equally unanswerable. Of course some of his questions, especially those concerned with human anatomy, have been answered with a fair degree of finality; and we certainly know a great deal more about the electric fluid than Franklin did. But these answers have not been arrived at by the intelligence and pertinacity of individuals, but by small armies of field workers and institutions full of men in white overalls. It is the stalest of platitudes that scientific advance is the result of team work.

It is also the result of mathematics. When Lord Snow gave his Rede Lecture, 'The Two Cultures', academic opinion was outraged, and perhaps he made a mistake to use such a provocative word as culture. We should all like to think that historians and physicists can share the same culture, and indeed there are many examples. Lord Kelvin was a fine classical scholar, Lord Adrian was a man of the highest culture; the list could be extended indefinitely. But the traffic is all one way. A physicist can read history after dinner or play Bach on the gramophone. But how many historians can follow even an

elementary proposition? May I be forgiven a fragment of autobiography? When I was Chairman of the Independent Television Authority I was responsible for the erection of transmitting stations, and found myself signing cheques for close on a million pounds. They were made payable to contractors who differed among themselves about the type of equipment required. It seemed incumbent on me to learn just enough about the problem involved to have a view as to which contractor was preferable. I had been interested in science in my youth, and had won (absurdly enough) several prizes in mathematics. I therefore asked our director of engineering how long it would take me to gain a knowledge of electronics sufficient for me to weigh up the often conflicting reports of contractors. He replied, 'Well, if you concentrated on nothing else, and took a sort of crash course, you might do it in three years.' As I had only another three years of my Chairmanship to run I gave up the idea. I may add that one of our contractors (the most famous of them) erected a mast in the Pennines that cast its beam in the direction of Norway instead of Carlisle; so perhaps a universal man could have been some use after all.

There can be no reasonable doubt that the mathematical sciences have transformed Europe, and brought it into its present perilous position. One illustration: our first effective contact with the older and, on the whole, more admirable culture of China was through Jesuit missionaries in the seventeenth century. They were tolerated simply because they knew mathematics. The last great Chinese Emperor, K'ang H'si, said to his successor, 'Have nothing to do with their religion, but keep them and protect them, because of their knowledge of the mathematical sciences'. Well, a universal man might know as much mathematics as a Jesuit priest in China, but he could not learn enough to hold up his head in the most tolerant university. Most of us would regard this as regrettable. The rule of specialists and experts has several drawbacks. They tend to grow rather crazy and attach a quasi-religious importance to their specialised conclusions; and the sanest of them makes mistakes which no one, except a fellow specialist, is equipped to challenge. It sounds ridiculous to say that experts are swayed by fashion, but in all the branches of expertise with which I am even remotely familiar, they are. A universal man should be able to see things in a larger context, both of time and human needs. He should be able to point out the

# The Concept of Universal Man

flaws in an accepted scientific position, as Goethe pointed out the flaws in Newton's theory of colour, and Samuel Butler the flaws in Darwinian biology. This was difficult enough in Samuel Butler's time. He was ridiculed by the whole scientific establishment. Today there is increasing evidence that he was right. Perhaps the capacity to ask specialists awkward questions should be the chief function of universal man today. It may seem rather a limited and negative aim compared to the great ambitions of the *Novum Organum*; but it is one of very great value.

And then the modern universal man, even in his reduced circumstances, can achieve something which, in human terms, is worth preserving. Specialists, owing to the narrow concentration needed for success in their studies, tend to become narrow people. We are told that Chairman Mao was fond of using the term universal man, meaning a man, a complete and harmonious balance of faculties, who can practise both the arts and the sciences, without being a specialist or a mere dilettante.

Finally, there is the proposition that played so great a part in the minds of Alberti and Bacon, Franklin and Jefferson: that man's knowledge should be of a kind that can be of use to man: what one may call the humanist approach to knowledge. This is contrary to the present trend of opinion. We believe that the quest for truth is an absolute which must be honoured even if it leads to our destruction. It is part of the same romanticism which reached an extravagant, but harmless, expression in Villiers de l'Isle Adam's *Axel*. There seems to be something selfishly flat-footed in the adages of classical humanism, by which man's first object should be to benefit himself. I shall not presume to enter this great debate. But I may end by quoting one of the greatest of universal men, Goethe, when he was asked to define the difference between classic and romantic. He replied: 'Classic is health, romantic disease.' Only the author of *Werther* had a right to give such an answer. It affirms that whether or not the idea of universal man is conceivable in contemporary society, his existence is a sign of health.

# EIGHT

## The Work of Bernard Berenson

For almost fifty years Bernard Berenson knew himself to be a legendary figure. His delicate frame, his beautiful eyes, his slightly artificial courtesy and the tone of infallibility which he sustained in the unbroken line of his conversation, made it very difficult to believe that this exquisite little conjuror was not bamboozling us but had made solid additions to our knowledge and understanding of art. I will suggest two or three ways in which he did so.

First of all, by the use of internal evidence he clarified the personalities of the Italian painters of the Renaissance; secondly, he established a scale of values for Italian painting, from Duccio to Paul Veronese, which has proved more or less acceptable for the last seventy years; thirdly, he formulated a number of non-mystical propositions about the nature of our responses to works of art; and finally he was able to apply to the consideration of art history in general a width of experience and power of correlating facts similar to, and perhaps equal, to that of Jacob Burckhardt. Each of these could be made the subject of a separate lecture; but to do so would falsify his achievement, because his value as a critic lies in the interdependence of these four activities.

Berenson was born in Lithuania in 1865; his inheritance was predominantly Jewish, but his appearance always suggested a strong admixture of Slavonic blood. His family moved to the United States when he was seven, and he was brought up in a poor quarter of Boston. The house was standing until quite recently. He was intellectually precocious, and said that his mind functioned more effectively at the age of twelve than it ever did in later life. His favourite author was Goethe, and in later life he confessed that his youthful ambition had been to become a second Goethe. He was never a modest man. As he was also strikingly beautiful, he attracted the attention of various local ladies who helped him to go to Harvard. In 1886 he published articles on Gogol, and, prophetically, on Vernon Lee. In the following year he applied for a travelling fellowship in Europe. The application, which still exists, claims that he excels in

# The Work of Bernard Berenson

the field of Arabic, Assyrian, Hebrew and Sanskrit, and that his chief
aim was to increase the appreciation of Arabic literature. As in
Leonardo da Vinci's letter to Ludovico il Moro, art is mentioned
only incidentally. In fact Berenson says: 'It is there that I feel weakest.
One can study literature after a fashion here (in Harvard), but art not
at all.' It is a shock to recall that when Berenson was a young man
there were practically no pictures by the great Italians in the United
States, a situation which Berenson himself was to do much — we
may sometimes think almost too much — to alter.

He did not get the fellowship owing to the hostility of the great
dictator of all matters connected with the art in Harvard, Charles
Elliot Norton; but in the same year friends who recognised his
brilliance financed a journey to Europe. He was extremely poor.
Often he could not get enough to eat. But he stayed in Europe for the
next 70 years. He went first to Paris, then London, and the pictures in
the Louvre and the National Gallery made a deep impression on him.
He did not immediately abandon his ambition to combine his learn-
ing and his sense of poetry in one compendious philosophy; indeed
one may say that he never abandoned it, and it is this which gives
quality to his latest writing. But in his first year in Europe the visual
arts occupied his mind more and more, and all that was needed for
him to fix his mind entirely on this study was a means of integrating
it with a way of life and an intellectual method. Both of these he
found in Italy. In Italy he found that works of art are not all impris-
oned in galleries, but are, so to say, an extension of the surrounding
life and landscape; and in Italy he found a scholar who had, as he
supposed, elevated the study of art to an intellectual discipline — I
refer, of course, to Giovanni Morelli.

Readers of Berenson's *Sketch for a Self-Portrait* will remember the
moment when his vocation first presented itself to him. Sitting at a
rickety table outside a cafe in the lower town of Bergamo, he
suddenly said to his companion that they should devote their entire
lives to connoisseurship. 'We are the first to have before us no
ambition, no expectation, no thought of reward. We shall give
ourselves up to learning, to distinguishing between the authentic
works of an Italian painter of the fifteenth and sixteenth century, and
those commonly ascribed to him. Here at Bergamo, and in all the
fragrant and romantic valleys that branch out northward, we must
stop till we are sure that every Lotto is a Lotto, every Cariani a

## The Work of Bernard Berenson

Cariani, every Previtali a Previtali.' 'To this,' he adds, 'had vaulting ambition, or at least dazzling hopes, shrunk.'

'No expectations, no thought of reward'. I am sure that was true, because all his letters show that the young Berenson was an idealist. But, ironically enough, the ability to say who painted what picture was to bring him far greater rewards than he would ever have achieved by being a second Goethe.

In the 1880s rich Americans were just beginning to form those great collections of Old Masters which we now take for granted, but which in fact are relatively recent; and before they spent a lot of money on a picture they naturally wanted to have some sort of guarantee that it was authentic. For various reasons they came to believe that Berenson's judgements were infallibly correct, and they reached a point where they wouldn't buy an Italian picture without his certificate of authenticity. One reason was that he had published an article on an exhibition of Old Masters in English collections asserting, somewhat arrogantly, that they were not all what they claimed to be — well, no American collector wanted that kind of deflation. Another reason was that he had formed a collection for a famous Boston hostess, called Mrs Gardner, which, given the circumstances, maintained a very high standard. They are still in her house in Boston which, by the conditions of her will, must be left absolutely unchanged, even down to the bunch of violets beside her favourite Giorgione. It represents perfectly the cultural ambitions of the 1890s — artificial, backward-looking, contemptible to the modern-minded. I find it has great charm, a feeling of its own time just as genuine as if it had been *art nouveau*, and of course a far higher standard of art. How far Mrs Gardner's taste entered into it I don't know — Mr Berenson always said it took a surgical operation to make her buy a good picture.

So the rewards came in, and by 1900 he could afford to rent, and later buy, a pleasant, unpretentious villa near Settignano. He was also able to make a collection for himself. He bought a number of lovable, intimate pictures, and at least two very great ones — a *Madonna and Child* by Domenico Veneziano, which is one of the two most beautiful fifteenth-century pictures in private possession, and Sassetta's *St. Francis*, which is the other. (Is there a greater picture of heavenly inspiration?) His brother-in-law, Logan Pearsall Smith, often said that he (Logan) had discovered it on a cart, being taken to be made

# The Work of Bernard Berenson

into a tabletop. It sounds like a legend — but in fact Sassetta was then completely forgotten, and he isn't even mentioned in the first edition of Berenson's *Central Italian Painters*. Later Mr Berenson wrote a beautiful essay about him, the best thing he wrote during his middle years of money-making expertise.

At this point I suppose one must face the question whether working for dealers influenced Mr Berenson's judgement as an expert; and on the whole the answer must be 'yes, it did'. Not that he ever took bribes, as many of his fellow experts did. But in his first agreements with the dealers he had made the mistake of being paid on a percentage of the price the picture fetched. If he said about a picture 'Yes, it is a Bellini' he got, say, £10,000; if he said 'No, it is a Bisolo' he got £100. So he had a great inducement to treat doubtful pictures optimistically. During these years his judgement did genuinely become more catholic and more inclusive, and this led to a certain number of judgements which make one's heart sink. Another thing — not having worked in a gallery he hadn't seen enough of restorers, and didn't realise what marvellous craftsmen they are. Some of the pictures he authenticated, if they were scrupulously cleaned, would look like a map of Polynesia.

However, his rather overstretched conscience did allow him to achieve one wholly admirable ambition: the formation of a great library on the history of art and of what is sometimes laughingly described as civilisation. This library was the apple of his eye. He spent hours every week looking through booksellers' catalogues. He used to say that he would rather be remembered by it than by anything he had written. It also gave him a lot of pain, because he could never find the book he wanted (and knew was there) and half the morning would be spent in fruitless rages. Then he would say that he had done far better work when he had only a few books and knew where every one of them was — which was true.

Perhaps this is the right place to say something about Mrs Berenson, because she was not only the target for a good many of these rages, but was also largely responsible for the expansion of I Tatti. She had taken a fancy to two young English architects named Geoffrey Scott and Cecil Pinsent, and let them loose on the library and the garden. Mr Berenson never liked all the grand volutes and formal staircases that they imposed on the garden, and said that he much preferred a little path beside a stream at the bottom of the

111

garden, 'out of reach of architectural ambition', and I am sure that he was sincere because that was where he always took his morning walk. Mrs Berenson was a character almost as exceptional as her husband. Her mother had been a religious teacher in Philadelphia and an ardent feminist. She was said to have been a beauty, and Mr Berenson fell in love with her at quite an early age. In fact, although it is not mentioned in the autobiography, she was probably with him in Bergamo when he made his great decision to become an art historian. Photographs suggest that she was never beautiful and by the time I knew her she had become very large and unwieldy. Mr Berenson was small and nimble, and the sight of them walking together in the hills reminded me of a solicitious mahout directing the steps of an elephant. She had an air of bonhomie and Chaucerian commonsense, but this was misleading. There were boiling passions under that Giottoesque exterior. She had a good mind and as long as Mr Berenson stuck to connoisseurship she was a real help to him. She said 'Adam and Eve never had more pleasure in naming the animals than we had in giving names to pictures'. But when he lost interest in naming pictures, she couldn't keep up with him, and later in life she was interested chiefly in her family — children of an earlier marriage, for Mr Berenson had no children.

However, the business of saying who painted what, although it brought Berenson wealth and fame, would not have won him immortality unless the little books containing lists of authentic pictures had not also contained introductory essays on the nature of Italian painting. Two of these — the ones on the Florentines and the Central Italians — are masterpieces. Reading them one can understand for the first time why the young Berenson made such an impression on his contemporaries. For one thing they contain extraordinarily accurate and durable judgements. Our assessment of Old Masters is governed by fashion, like everything else. Posterity is very fickle. But Mr Berenson's evaluations of the painters of the Renaissance have remained practically unchanged for over eighty years. This is because he was not a narrow specialist, but a true aesthete, who would compare the Renaissance painters with the best of his own contemporaries — Degas, Monet, Cézanne. Those names appear in his introductions at a date when they had never been heard of in England.

And then in the introductions he tries to give some reasons why

works of art affect us as they do. He had been a pupil of the American philosopher, William James, who was a pioneer of experimental psychology; and Berenson had determined to find some explanation for our pleasure in works of art which wasn't merely mystical, or magical. He found a departure in his favourite, Goethe, who said that works of art must be what he called life-enhancing. Berenson suggested that one of the ways they achieve this is by making us imagine that we have real physical feelings when we look at works of art. He called these feelings 'ideated sensations', and he identified several of them. The one he valued most he called tactile values. It's the sort of high-sounding phrase that becomes fashionable, and in the '90s intellectual snobs began to use it, as they do psycho-analytical jargon today, without having a very clear notion what it meant. But it has a grain of truth in it. Ultimately our sense of what is real is confirmed by what we can touch; and to stimulate our 'ideated sensations' of touch could well be life-enhancing. I think it is true that one reason why we admire the work of Giotto is that he had, beyond almost anyone, the power of making his figures look solid — as if one could put one's arm round them; and this he achieved not by imitation but by some intense conviction of their solid reality. Berenson didn't confine the idea of tactile values to such obviously massive figures; he extended it to the combinations of outline and modelling that we see in the profile portrait by Pollajuolo — incidentally, the frontispiece and only illustration in his *Florentine Painters* — and I think that is convincing too. One really does feel as if one's fingers were enjoying the taut skin and delicate modelling of this cheek and neck.

Later in the book Berenson identified another source of pleasure; the ideated sensation of movement, which, as he truly said, can be achieved by line far more vividly than by imitation. He called Botticelli the greatest artist of linear design that Europe ever had, and looking at the wind gods in the *Birth of Venus*, one has no difficulty in agreeing with him.

Then in the *Central Italian Painters* he identified another very convincing 'ideated sensation' which he called 'space composition'! 'It is,' he said, 'the art which humanises the void, making it an enclosed Eden, a domed mansion wherein our higher selves can find an abode. In such pictures how freely one breathes, as if a load had just been lifted from one's heart.' Not quite our contemporary idiom, but there is truth in that, too.

# The Work of Bernard Berenson

Obviously these ideated sensations do not provide a complete explanation of why we enjoy pictures. They don't take us all the way, but such progress as we make is on solid ground. They are not simply incantations, as is most writing about aesthetics. And one thing I vouch for, that they represent Mr Berenson's own experience. Looking at pictures with him one could almost see his frail little body reacting physically to the tactile values or the space composition of the works before him. The little books and the 'lists' were written in the 1890s. So was his greatest work of scholarship, and an enormous book entitled *The Florentine Drawings of the Renaissance*: all finished before Mr Berenson moved into his villa. The next thirty years were given up almost entirely to saying who painted what, and during that time he wrote (with the one exception I have mentioned) practically nothing that will stand re-reading. Even his practice of creating artistic personalities on the basis of style alone — which had seemed so exciting in the 1890s — led him astray — and the most famous of these creations, called by the charming name of Amico di Sandro, had to be liquidated. What a waste: and in his old age he realised it. In his autobiography he comes back to it again and again: 'I have never regarded myself as other than a failure. This sense of failure, a guilty sense, makes me squirm when I hear myself spoken of as a successful man.' But these thirty years weren't entirely wasted, because during that time he talked; and through talk he made himself into a work of art — a very complex, sometimes questionable, but infinitely fascinating work of art. What did he talk about? Books, personalities, and, too often for my taste, politics. He was a passionate anti-fascist and, at a time when it was quite dangerous to do so, attacked Mussolini with any terms of abuse at his command; and he could command the eloquence of an Old Testament prophet. He had the advantages as well as the defects of one who saw public affairs from a convenient distance. However, I must confess that I found BB's talk to a group much less interesting than when it was addressed to a single companion, preferably on a walk in the hills. Every day at about 4 o'clock he would take a car up to a point behind his villa and walk down to rejoin it. He went on doing so up to the age of ninety, and was as sure-footed as a mountain goat. How he loved those walks! They all had special names, and he never tired of stopping at certain corners and rhapsodising over the view. His talk was at its best on those walks. At luncheon, when he completely

# The Work of Bernard Berenson

monopolised the conversation, he often spent the whole meal in vituperating a single individual, usually a fellow critic, whose name may have been entirely unknown to the rest of the company.

Although he practically never mentioned the authentication of pictures, he could not have lived without it, and it was the lists of authentic pictures rather than the introductions that made the four little books indispensable.

The prestige of the lists led to the triumph of Connoisseurship, and for almost thirty years this particular branch of scholarship — the giving of names — had a prestige similar to that of textual criticism in classical studies. And just as the greatness of a Bentley or a Housman does not reside in the correctness of their textual emendations, but rather in some combination of elegance of mind and far-reaching scholarship, so the value of Berenson's early lists is not invalidated by the fact that a number of his hypotheses have been proved to be incorrect — often by Berenson himself.

The first lists appeared in 1894, in a small volume called *The Venetian Painters of the Renaissance*, accompanied by a very simple introductory essay on Venetian painting. In the same year the valleys north of Bergamo had seduced him into preparing a full length study of Lorenzo Lotto. It is hard to think of a less suitable subject. Berenson's whole thesis was that an artist's career and work could be reconstructed on internal evidence alone, and Lotto is of all artists stylistically the most unpredictable — the knight on the chess board, as Mr Berenson later called him. Moreover a large number of Lotto's pictures are signed, dated or accounted for by contracts, so the book on Lotto turned into an exercise in the use of documents rather than in the analysis of style. In so far as it attempts stylistic reconstruction it is based on an error. This was the thesis that Alvise Vivarini was a leading influence not only on Lotto, but on Venetian art in general at the close of the *quattrocento*, and it involved attributing to Alvise a number of pictures which were a long way beyond the reach of his modest talent. The magnification of minor painters, as well as allowing for a display of expertise, reflected a kind of nineteenth-century optimism, and was one of the characteristics of Morelli most vigorously adopted by the young Berenson.

The *Lorenzo Lotto* appeared in 1895, and was followed by the *Florentine Painters* in 1896 and the *Central Italian Painters* in 1897. In each the form was the same: one — and only one — illustration, an

115

# The Work of Bernard Berenson

introductory essay, a list of authentic pictures; only in these two volumes the introductions, instead of being a historical summary, were essays in aesthetics. These were in many ways the most important things he ever wrote, and I shall return to them later. It was the lists which made him famous. The student who turns back to them in their original form will have a few surprises. Our astonishment begins with the single illustrations. The frontispiece of the Florentine volume is the now famous profile of a girl in the Poldi Pezzoli Museum. I suppose that most of my audience have never thought of it as anything but a Pollajuolo; in the early lists it is attributed to Verrocchio, and so, to our bewilderment are the *Ginevra dei Benci* in Washington and the Uffizi *Annunciation*, both of which we all now take for granted as early Leonardo. Clearly the science of connoisseurship still had some way to go. The frontispiece to the *Venetian Painters* reveals another weakness of his early connoisseurship, and one which to tell the truth, I don't think Mr Berenson ever entirely conquered. It was the picture of a shepherd at Hampton Court and is one of the works in the lists attributed unquestioningly to Giorgione. One might suppose that anyone with an eye for paint could see even from a photograph, that this picture was much restored. A sight of the original suggests that if it were to be cleaned of all repaint later than the sixteenth century only the faintest shadow would be left. But if there was one thing that bored the young Berenson more than documents it was technique; and although he learnt to be much more careful in these matters, to the end of his days he never had quite enough respect for the skill of restorers. Perhaps nobody who hasn't worked in a gallery can realise how much that one sees exhibited is the work of these gifted and self-effacing craftsmen. The young student from Harvard had never visited a restorer's workshop and had no knowledge of the estate carpenters and handy men who over the centuries, used to 'brisk up' (as it was called) Ducal collections before the great people paid their annual visit. May I add that I was with Mr and Mrs Berenson when they revisited Hampton Court after many years. We stood in front of this picture for a long time in silence. At last Mrs Berenson said 'Bernard, we must have been in love'. Mr Berenson remained silent, but nodded gravely, and we walked on.

Finally, we must admit that the lists suffer from their basic doctrine: that the work of art itself must be the sole basis of connoisseur-

116

ship. In the end there must be some fixed points to which a name is attached, and this name can be provided only by documents and signatures. An example is the group of portraits which Berenson found attributed to Antonello, Holbein and even Memlinc, and transferred to Alvise Vivarini. There is nothing in Alvise's authentic work which justifies the attribution, and in the end Mr Berenson dropped it and lumped the whole group under Giovanni Bellini. Had he been less suspicious of names and documents, he would have found in Michiel's diary the name of Antonello's chief rival in the Veneto, Jacometto, and would no doubt have discovered the link that allows us to assign to him these otherwise unattributable portraits. To ignore such signposts and proceed entirely on internal evidence may sometimes succeed — as it did for example, in the case of Alunno di Domenico, whose name, Bartolommeo di Giovanni, was afterwards discovered; but more often it ends badly as in the outstanding example of Amico di Sandro. This was the most ambitious of all Berenson's 'artistic personalities', and as you will remember he ended by disintegrating Amico di Sandro into Botticelli of the '80s and early Filippino. A similar fate overtook Polidoro Lanziani, and several others. And yet the creation of these Pirandellian figures performed a useful function in criticism; in fact, certain phases of art history, for example the relationship of Filippino to Botticelli, could hardly have been clarified without them. And how often those of us who still privately practise the art of connoisseurship (for there has long ago ceased to be a public demand for it), lament the loss of these convenient cards of identity. To embark on a long inconclusive explanation is far less satisfactory.

This, unfortunately, is what Mr Berenson did in a series of articles, beginning in 1896 and ending in 1926 with a book called *Three Essays in Method*. The curious thing is that in practically all these articles, from that on the Sposalizio at Caen to the Impossible Antonello, the conclusions are questionable, if not positively incorrect; and one has a feeling that he wrote at length only about attributions of which he was himself uncertain, and sometimes lost conviction before the end of the argument. Nevertheless, these books arguing points of authenticity constituted almost his whole output from 1896 to 1936, and only one of them, it seems to me, was worthy of him, the *Drawings of the Florentine Painters*. It was finished in 1897 but did not appear till 1903, owing (as Mr Berenson maintained) to the machina-

tions of Dr Bode, who would not allow the illustrations printed by the German State printing press to be released. I may add in parenthesis that the relations of Berenson and Bode continued for about thirty years to be those of the Pope and the Emperor in the thirteenth century. On the whole the Pope had the best of it and ended by giving the Emperor absolution; but when they met in the 1920s it was not a success.

Berenson always believed that his decision to write the *Florentine Drawings* was the cardinal error in his life. There may be an element of what psychologists call substitution in the tone of regret in which he always referred to that great work; but no doubt he was right, looking back on his life, in seeing this as the moment when he might have followed one of two paths: the path opened up by the introductions to the Florentine and Central Italian volumes, the path, that is to say, of philosophic criticism and appreciation; or the path opened up by the lists. And it is important to notice that Berenson's reason for choosing the latter was not material gain but the feeling that scholarship was a more respectable and serious-looking occupation than criticism. 'I dared not resist the chance offered me of proving that I could toil and plod and pedantise and bore with the best of them.'

I have called the *Florentine Drawings* a 'great work', and it deserves that epithet on many counts: for its sheer bulk, for its originality, for the quantity of penetrating criticism which it contains and for the way in which its judgements have stood up to sixty years of scrutiny. No large systematic study of Old Master drawings had ever been written before, and no one had thought, in the words of the title, of criticising and studying them as 'documents in The History and Appreciation of Tuscan Art'. Consider the mere physical difficulties of coping with this mass of material, and persuading the custodian of the freezing print room of the Uffizi to leave his scaldino and rummage in the dark for another portfolio. Mr Berenson often said that it was those winters in the Gabinetto di Disegni which accounted for the row of shawls and coats which struck every visitor to I Tatti. But through it all his eye never lost its sharpness and when he came to revise it the only judgements which required drastic alteration were those in the section on Michelangelo which, paradoxically enough, contains the best criticism in the book.

It is there that one finds the most ambitious, and, as it turned out,

# The Work of Bernard Berenson

the most durable of all Berenson's style-created personalities, Sebastiano del Piombo. Of course Sebastiano existed and was an admirable draughtsman. But Berenson transferred to him a group of drawings which, had they really been his, would have made him one of the greatest draughtsmen who ever lived: and which, in fact, *are* by the greatest draughtsman that ever lived, by Michelangelo. The origin of this grandiose error (which, by the way, was first suggested by a German scholar named Wickhoff) lay once again in his reluctance to use documents. Berenson must have known the passages in Vasari and other contemporary sources which say categorically that Michelangelo provided the drawings for his friend Sebastiano's pictures. But his preference for works over documents led him to discard this evidence, and to attribute all such drawings to Sebastiano himself. It was an error inherent in his method, and the chief criticism I have to make of it is that he doesn't seem to have realised what a gigantic artist he had created.

By the 1920s Berenson's position as the final arbiter in all questions of authenticity had reached its zenith, and it was inevitable that all those interested in Italian art, dealers, collectors, students, should urge him to revise the lists. I don't see how he could have refused them. It must have been galling for him to see the old ones, with all their mistakes and omissions, quoted as his opinions. Almost every day he would receive corrections which he himself had made twenty years earlier. The revised lists were necessary. But of course, they were much less stimulating than the old ones, because they were not primarily based on quality. No doubt the early lists were too exclusive. They did not allow for an off day; they seemed oblivious to the workshop system by which a great artist would leave the completion of a design to his assistants. Mr Berenson referred to this as dandiacal aestheticism, and it is significant that at the same time that the first lists were published, Mr and Mrs Berenson had printed, in an exquisite volume called the *Golden Urn*, an anthology of what they called 'sacred pictures', which were really the touch-stone on which the lists were based. But it was this response to quality which distinguished Mr Berenson from more industrious colleagues like van Marle, and in abandoning it he lost much of his strength. Then, the new lists suffered from the changed situation which Mr Berenson himself had created. Instead of being a sharp weapon used to assault an inert mass of tradition, they themselves became the mass, the

119

canon, the object of assault. And instead of long delicious drives to country churches, the work had to be done from photographs. Those photographs! They were like a plague of flies which descenced on I Tatti, driving everybody mad. Most of them were those old brown silver prints on very thin paper which curled up at sight. Mrs Berenson stuck them down with paste on to pieces of cardboard, but the paste fermented and the photographs got a disease, which infected all the other photographs, and they had all to be put in the sun to cure them, and then of course, they all curled up again.

When I first stayed at I Tatti in the early 1920s, the revision of the lists was in full swing, and I must say that the atmosphere was very far from the tranquil, frugal, hopeful aestheticism which must have prevailed in Fiesole when the first edition of the *Italian Painters* was being prepared. Young ladies ran hysterically from room to room, and every half hour Mr Berenson would emerge from his study like Jehovah and ask for a photograph which was invariably missing. I was often reminded of Yeats's lines:

> 'I saw a staring virgin stand
> Where holy Dionysus died.'

The lists were done in the end: but, alas, it was too late. By 1932 the prestige of connoisseurship had declined. The new fashion for iconographical studies was already in the ascendent. And although it is a vulgar error to associate the science of connoisseurship with the art market, the fact remains that it derived some of its force, as all forms of art and scholarship do, from the fact that it was needed: needed, I mean, by the big, wicked world.

It is difficult for anyone who was not concerned to imagine the mania for 'attributions' which flourished in the inflationary '20s. It was like the railway mania of the 1840s, or to take a closer parallel, it was like the trade in relics in the fourteenth century. Certificates of attribution were the means of keeping in affluence quite a large proportion of the priesthood of art. In this hierarchy Mr Berenson was, as I have said, the Pope. Like the Holy Father he was himself above suspicion and his pronouncements were accepted as infallible. All this collapsed with the 1930 depression. And by the time rich people were willing to pay high prices for pictures again, their eyes fell on the brighter, more accessible, and by and large, more authen-

tic works of the Impressionists. This meant that by the time the revised lists appeared, everyone had lost just that extra eagerness which we bring to a subject which offers great material rewards. But this does not affect their permanent value. It takes, I think, a little imagination to realise what an extraordinary achievement the small volume of the *Italian Pictures of the Renaissance* is. Open it at random. You will probably find yourself confronted with the name of a painter — let us say Paolo Farinati — which suggests a somewhat vague mental picture. You will find a list of about 100 works in village churches, in galleries, in private collections all over the world. Every one of those works Berenson had seen, and they had formed a clear image of Farinati in his mind, so that he could apply it instantly in going round a collection. Now multiply this by 300, for that is the number of painters listed in the volume, and remember that all these images had to be clear and usable.

These judgements not only involved a feat of memory, but were often a piece of condensed criticism. They meant 'given the character and capacities of this particular artist, this is the kind of picture he might have painted'. All this must be kept in mind when we find ourselves questioning, as we inevitably do, certain of the judgements; or when specialists in one particular artist point to occasional mistakes.

In fact the success of this type of scholarship was almost too complete. A few problems have proved insoluble — very important problems too, Giotto at Assisi, Giorgione and Titian; and short of the discovery of new documents I think they will remain unsolved. But on the whole our knowledge of who painted what in Renaissance art represents a solid, concrete advance, similar to an advance in chemistry or physics. Younger scholars take it for granted — that is one reason why they are no longer interested in it.

As for Mr Berenson, he said the last word in the preface to the 1932 edition — 'What meagre results for the task of a lifetime! Yes, had it been a task. But it had been a way of living. Few are the items in these Lists which do not call up, as my eye glances over them, moments of eager discovery, of happy enjoyment, recollection of enchanting landscapes into which they took me, of interesting personalities they led me to meet. So, neutral enough as they may seem to one who looks them over, for me they are as evocative as the song of the thrush heard by Poor Susan as she walked along the city street.' So

the fragrant valleys won in the end.

In the 1932 edition the essays on Renaissance painting were, for the first time, issued in a volume separate from the lists of authentic pictures. This was obviously a convenience to the student and the tourist, but it diminished and even falsified Berenson's achievement. The point of the first lists was that they were an index of quality, an evaluation: and this was supplemented by the evaluations in the essays. These remain, after sixty-five years, remarkably convincing — and I do not think this means simply that we still agree with them. There are points of disagreement. I think we should all be disposed to rate Uccello and Pietro Lorenzetti higher than he does. But the reasons for his low opinion of these painters are in themselves interesting. He under-rated Uccello because, influenced by Vasarian tradition, he associated him with science and naturalism. To condemn a Renaissance painter in the 1890s for his naturalism is surprising and impressive. And after perceptive praise of the Lorenzetti, he writes that 'Pietro could sink to the rubbish of his Passion scenes at Assisi, when he carries Duccio's themes to the utmost pitch of frantic feeling. Form, movement, composition — even depth and significance — have been sacrificed to the most obvious and easy emotion. A like anarchy has seldom again overtaken an Italian master, even of the Bolognese school. To find its parallel you must go to Spain and to certain Germans.' Well, one may not agree with this judgement (although I think there is some truth in it), but one must admit that to keep one's critical faculties so rebelliously alive in spite of the holy hypnotism of Assisi, was a remarkable feat.

Such sudden shocks of disagreement are rare. In general we find ourselves assenting almost too easily. We take his evaluations for granted until we remember the accepted values of the '90s. For example the unquestioned supremacy of Ghirlandajo — thought to be the Sophoclean climax of the *quattrocento* — an evaluation which you will find not only in Crowe and Cavalcaselle, but in the ordinary encyclopaedia articles right up to 1910. That is firmly put on one side. 'Not a spark of genius'. 'The painter for the superior philistine'. And in contrast, Botticelli, whom Pater had included so diffidently, so apologetically, in the *Renaissance*, Botticelli is rated by Mr Berenson as 'the greatest artist of linear design that Europe has ever had'.

Even more remarkable than his evaluation of Botticelli, who had, after all, been highly praised by Ruskin, was the place he gave to

# The Work of Bernard Berenson

Piero della Francesca, whose work is never mentioned by Ruskin at all. His *name* is mentioned because Ruskin thought he was called after his mother. Piero plays no more than an historical role in Crowe and Cavalcaselle, yet Berenson put him with Giotto and Masaccio as one of the three of four greatest artists of the *quattrocento*, and recognised his affinities with early Greek sculpture and Velasquez.

The comparison suggests one of the ways in which Berenson's approach to the Old Masters differs so markedly from that of his contemporaries, not only Crowe and Cavalcaselle, but Bode, Müntz or Frizzoni. He had far wider terms of reference. He was not confined to the groove of his own period. Already his mind was ranging back to Egyptian art, and dwelling with fascination on the problem which was to absorb his last thirty years, the declining art of Hellenism; and most striking of all when viewed historically, his pages are full of references to contemporary French painting. Signorelli is compared to Daumier, the early drawings of Leonardo, to those of Degas; and in the middle of a passage on Umbrian landscape is this sentence: 'In spite of the exquisite modelling of Cézanne, who gives the sky its tactile values as Michelangelo has given them to the human figure, in spite of Monet's communication of the very pulse beat of the sun's warmth over the fields and trees, we are still waiting for a real art of landscape.' That was written in 1896, and you see that Berenson has recognised, what we have recognised only quite recently, the two decisive figures in late nineteenth-century landscape painting.

The other factor that gives the lists their exceptional authority is, as I have said, that they were accompanied by a fresh and vigorous aesthetic philosophy. Re-reading the introduction to the *Florentine* and *Central Italian Painters* it is surprising how much space is taken up with the statement of aesthetic principles. Most of us remember the pages on tactile values, but forget that there are similar disquisitions on naturalism, on movement, on the visual image, on illustration, on the impersonality of art, on space-composition. Even in the *North Italian Painters*, which sometimes has the weary and distracted tone of an afterthought, there are admirable disquisitions on the influence of the antique, and on prettiness in art. There is no doubt that Berenson attached great importance to these statements of critical principles, and he often lamented, both in his conversation and in the *Sketch for a Self-Portrait*, that he had not carried this sort of criticism

far further. 'I cannot rid myself' he says, 'of the insistent inner voice that keeps whispering and at times hissing "you should not have competed with the learned nor let yourself become that equivocal thing, an *expert*. You should have developed and clarified your notions about the enjoyment of the work of art. These notions were your own. They were exhalations of your vital experience".' How far was this inner voice justified? How valuable were those 'notions', as he calls them, and how fruitfully could they have been applied?

I believe that as they stand in the prefaces, they have great value. Like so much of Berenson's thought they go back to Goethe, to whom I believe the term 'life enhancing' is due; and although he says that they contain no echo of what he had heard or what he had read, I think they must owe something to Hildebrand's *Problem of Form* (1893), which in turn was inspired by the correspondence of Conrad Fiedler and Hans von Marees. But where Berenson was strikingly original was in developing the theory that the life-enhancing effects of works of art is due to what he called 'ideated sensations' experienced through an unconscious self-identification. It was the first, and remains the only de-mysticised aesthetic to command respect. Compared to it the 'plastic sequences' of Roger Fry and the 'significant form' of Clive Bell are pure mysticism — not to say incantation. And even the more respectable aesthetic theories of the past — for example those based on laws of proportion — end up in magic, although we may agree that the magic of numbers is a very ancient and honourable one. In three of its applications, tactile values, movement and space-composition, I find that his aesthetic theory really works, and is a valuable basis for criticism.

Of these, the ideated sensations of movement are the most easily understood and accepted. There is no doubt that a drawing by Signorelli or Pollajuolo does communicate the feeling of movement so vividly that our own sense of vital energy is enhanced. As for the ideated sensation of space-composition, put forward in the Central Italian volume, it is one of several instances where Berenson did not follow through with sufficient vigour a valuable intuition. It is, I think, perfectly true that our enjoyment of a Perugino is enhanced by the feeling of orderly space. One need only compare it with, say, the scenes of Hogarth's 'Election Series' to realise how much our sense of physical well-being is diminished by the claustrophobic muddle of Hogarth and increased by the lucid order of Perugino. But the

# The Work of Bernard Berenson

Renaissance concept of space cannot be considered seriously without some allusions to the mystique of perspective; and from this, as from anything connected with science or mathematics, Mr Berenson's mind shrank in horror.

Of the three ideated sensations the most notorious and the most open to misunderstanding was 'tactile values'. It rests on a familiar and incontravertible fact of human perception, that our guarantee of reality is neither sight, nor sound, nor smell, but touch.

Dr Johnson believed that by kicking a footstool, as opposed to looking at it, he had successfully refuted Bishop Berkeley. All museum curators, and all parents of young children, know how strong is the desire to touch that which gives us pleasure. So Berenson's suggestion that the ideated sensation of touch heightens our sense of reality in a way that ordinary visual sensations cannot do, is based on experience, and the examples he put forward drawn from Masaccio, Botticelli and Cosimo Tura seem to me convincing. Many factors, of course, contribute to our response to these masterpieces; but if one compares them to a Flemish equivalent, one may agree that their vital power is partly due to a type of modelling, as of sculptured relief, which stimulates our ideated sensations of touch. The theory of tactile values does not entirely resist analysis, and when Berenson tried to substantiate it in *Aesthetics and History* the result was confusing. But one thing I can vouch for; that for the author himself ideated sensations were not an abstract speculation, but represented vivid personal experiences. One could almost see his frail little body reacting physically to the tactile values or space-composition of the work before him. We may not have such vivid reactions ourselves. But just as we must believe Wordsworth when he tells us how strongly, in his childhood, he felt the force of nature, so we must believe that Berenson had an altogether exceptional response to certain aspects of painting and sculpture.

He responded also to what he called the element of illustration, but this part of the prefaces is less interesting, and contains some inadequate assessments, as in his slighting references to Brueghel. But this is relatively unimportant, because the illustrative part of art — the interpretation of subjects — can be left to look after itself, especially in England. As Berenson pointed out forty years later, he was writing for 'a public accustomed under the influence of Rio, Ruskin, Lindsay and the Pre-Raphaelites, to see little in painting but illustra-

tion'. His contention that changes of taste are changes of visual imagery, because this reflects the objects of our daily interest or desire, whereas the non-illustrated element in art, being dependent on our bodily responses, is far more stable, and I think acceptable. In 1895 it was revolutionary. Strangely enough it can be applied to the revolutionary art of today which Mr Berenson himself disliked. For example, Mr Henry Moore's statements about sculpture are amplifications of the doctrines of tactile values and space-composition. I don't think Berenson's aesthetic theories take us quite as far as he supposed; but such progress as we make is on solid ground, not in the air. No doubt Berenson was right in thinking that his theories would stretch far further than the application he had given them in the *Florentine* and *Central Italian Painters*.

Should he then have spent his life, as he himself several times suggests, in extending and applying these principles? I think it was a wise instinct which prevented him from doing so. Berenson was not a philosopher in the limited or professional sense of the word. His thoughts were not controlled by logic; his mind, which could accommodate such a multitude of concrete impressions, was hostile to abstractions; and he had a corresponding mistrust of systems. 'Every attempt at a system', he said, 'is made at the expense of facts, fancies, suggestions and ideas that clamour for notice like the denizens of Dante's Inferno. I can never get their cries out of my ears.' So what should he have done to avoid the waste of those thirty years devoted to expertise? Could he have continued with the same kind of critical interpretation of Italian art that is contained in the prefaces? Here the difficulty was, I think, that they had already said too much in too small a space. In a way it is their strength: this is what kept them alive for over half a century. But the price of such concentration was that he could not go back over the same ground. He could not undertake a fuller and more leisurely critical survey of Italian art without feeling that he was repeating himself. It is significant that the best thing he wrote between 1898 and 1938 was his study of Sassetta, whose name does not occur in the early lists of Central Italian painters, although some of his works are mentioned under the rubrics of Giovanni di Paolo and Sano di Pietro.

Sassetta not only had the charm of a fresh discovery; in fact he had already been 'discovered' by a scholar named Langton Douglas who had begun life as a Church of England chaplain in Siena, and ended as

# The Work of Bernard Berenson

a successful art dealer; he was associated with a new critical approach, which had developed out of Mr Berenson's interest in Far Eastern art. So strongly, indeed, did he feel the need of fresh fields of aesthetic experience and scholarly investigation that at one moment he was seriously tempted by a group of sinalogues to abandon Italy, and settled in Indo-China in order to study Far Eastern art on the spot.

Eventually his desire to escape took a less drastic, though hardly less ambitious form. He was determined to write a critical and philosophical survey of the great crisis of European Art history, the transition from antique to early mediaeval art. From about 1910 to 1940 he collected material for this book; his magnificent library, which was the apple of his eye, is far more concerned with this subject than with the Renaissance and to this end he undertook exhausting travels in Syria and North Africa. The reasons for this obsession, like everything else about Mr Berenson, were complex. At certain levels he was a dyed-in-the-wool classicist. On his first arrival in Europe, as a poor student, he had somehow made his way to Greece, and the Greek qualities of clarity, order, proportion and comeliness applied to the human figure, remained in his mind as the summit of human achievement in the visual arts. He liked to be told that he was the successor of Winckelmann. The provisional title of his great work was to be Gibbonian: 'Decline and Recovery in the Figure Arts'. But when he forgot about his notions of a more enlightened humanity and what he called, following Rossetti, the House of Life, in fact about the element of illustration in a work of art, and responded intuitively to his feelings for the plastic elements, he must have been aware that a great part of what has come down to us from classical antiquity is quite the reverse of life-enhancing. Indeed, as we all know, a walk through the Vatican sculpture galleries or the Museo Torlonia is about the most life-diminishing experience that a lover of art can undergo, and, at the end of it, the sight of (say) a Scythian plaque would be as welcome as a cocktail; and this on purely Berensonian principles — because of its life-enhancing qualities of movement and tactile values. Of course, Mr Berenson felt this himself, and I have often seen him in ecstasy before a romanesque bronze door or an early Chinese *hu*. But the experience made him feel rather guilty. To this complex amalgam of love and hate was added the precipitant of pure hate for a scholar named

# The Work of Bernard Berenson

Strzygowski, who was for Mr Berenson the Hitler of art-historical studies, the arch-enemy of humanist culture, who must at all costs be destroyed. The fact that to many of us Strzygowski's name may no longer be familiar proves that even with such an evolved character as Mr Berenson, prejudices must be personalised in order to become dynamic. However, the important thing is, that Berenson's whole thesis of the decline and recovery of the figure arts was to some extent contrary to his own deepest responses, and to his hard-won theories of aesthetics.

This may be one reason why the book was never written. Another was that he lacked completely what might be called the architectonic sense of composition. He thought in sentences which were just long enough to be spoken. This characteristic grew on him with age, fame and the influx of admirers. He became a sort of sublime improvisatore, playing with his vast learning according to the happy chance of the moment. He treated knowledge and ideas as the bards treated legend and poetic imagery, as part of an inexhaustible reservoir to be drawn upon for the delight of his audience; and he had a half-conscious feeling that to fix facts and ideas on a printed page was to deprive them of their life. At most they could be allowed to show themselves in the digressions and asides which illuminate so many pages of *Aesthetics and History* and *Rumour and Reflection*, and are the only things to preserve for posterity some indications of the extraordinary richness of his conversation. Such an exclusively verbal procedure is rare in the modern world; it is hard for us to believe that the *Iliad* or the *Bagavad Gita* was orginally spoken from memory. But in the history of man, this has been the classic form of teaching, especially in those teachings of the East, where Berenson's first interests lay. He differed from Homer and the author of the *Bagavad Gita* in one important respect, and that was his response to his surroundings. The bardic recitals took place on a stage as bare of scenery as that of an antique relief; but Berenson was a child of Rousseau — the Rousseau of the *Rèvéries d'un Promeneur Solitaire*, and his walks, fortunately for many of us, were not solitary. Anyone who has had the privilege of accompanying Mr Berenson on his walks in the garden of I Tatti or in the hills behind Vincigliata, will, I believe, agree that it was then that he was most entirely himself, because it was then that his powers of perception, of memory and of co-ordinating intelligence were all brought into harmony. His mind

was continually enriched by what he saw and not distracted by what he heard.

It is a curious fact that the great scholar and interpreter of the visual image, whose approach to art history has, for the time being, overshadowed that of Berenson — I refer, of course, to Aby Warburg — was also a peripatetic, a talker rather than a writer. Indeed his writings give even less indication of the almost hypnotic power he exercised on those who listened to his words. But, being a German and a natural pedagogue, he had a sense of *apparatus academicus* that Berenson lacked. His historical intuitions could be edited by disciples, and almost engulfed in foot-notes and appendices. Berenson had a horror of academics and of what he called 'institootions'. When American visitors referred to him as 'Professor Berenson' he shuddered visibly. So the works he wrote during the last war that contain his most vitalising ideas and what I may call his historical wisdom remain accessible only to the advanced student who is prepared to read them slowly and sometimes between the lines. I might add that the too numerous articles which he wrote in the '50s show a falling off in power of concentration, and in my opinion should not have been reprinted.

The passages in Berenson's work which are likely to retain their value are few and short. But the pages of Pater's criticism that we care to re-read are not numerous, and with a scholar such as Warburg the actual writings are almost unreadable. The history and criticism of art is a literary form in which quantity and quality are seldom united. What we value in the critic is a general attitude of mind, revealed, it may be, in isolated judgements, which nonetheless imply a new direction of thought, fresh historical intuitions and insights that enlarge our own range of understanding. All these we find in the work of Berenson, explicit in the prefaces, implicit in the lists, half-buried in the historical reflections. We may not agree with them, any more than we agree with Ruskin, but they spring from qualities that are seldom found in combination — learning, intelligence, sensibility and faith in man — and I think that posterity (if I may invoke such a dubious concept) will value them, even though they often seem to us imperfectly expressed.

# NINE

## *Walter Pater*

In spite of his great reputation in the 1880s, especially among the young, very little has been written about Walter Pater. There are two books, one by A.C. Benson, written in 1906, ten years after he died, and one in 1907 by a forgotten and largely illiterate writer called Thomas Wright. Benson's book is inaccurate, pretentious and malicious. He does not, for example, mention the fact that Pater went to Rome when writing *Marius the Epicurean*; and he makes an embarrassing attempt to outwrite Pater in his last chapter, which at least has the merit of increasing one's admiration for Pater's own style. Mr Wright's book is crammed with irrelevancies, but it contains one block of fascinating information about Pater's private life which, although it comes from rather a suspect source, must contain a good deal of truth. There are several good books on Pater in French, including one in two volumes that appeared in 1922.

The reason for this neglect is precisely the quality for which he was once most admired, his style. No one today will take the trouble to extract the meaning which lies buried somewhere in his elaborate paragraphs. He was above all a moralist, and the aim of his best works was to suggest ways of achieving the ideal life. One of the ways was the contemplation of works of art, and so he became labelled as a writer on aesthetics. But the books of his which he rated most highly, the *Imaginary Portraits* and *Plato and Platonism*, are not about works of art but about outstanding human beings (yes, even Plato is seen in that light) whose lives may serve as a guide or a meaning to us. The same is true of *Marius the Epicurean* and *Gaston de la Tour*.

He remains a difficult author. I do not foresee a Pater revival. But I do think we should remember what we owe to this shy, self-effacing, and yet ultimately fearless fellow of Brasenose.

Let me give you a few facts of his life. Walter Horatio Pater was born in 1839, the son of a country doctor. Pater is not an English name, and Walter Horatio liked to think that his family had emigrated here from the low countries. This is possible, but that he was

descended from Watteau's pupil, Jean Baptiste Pater, who figures in one of the *Imaginary Portraits*, is pure fantasy. His father died when he was young, and he was brought up by relations. Like Mr E.M. Forster, he was a man of aunts. He was a quiet, ugly boy, with no boyish characteristics, and the only game he enjoyed was the conduct of make-believe church services. He was sent to King's School, Canterbury, where his dislike of the ordinary conditions of school life was compensated for by his love of the Cathedral and its precincts. These scenes remained vividly in his mind, and are recalled in the beginning of a quasi-autobiographical story called *Emerald Uthwart*. And here I may interpolate that *all* Pater's writings are made up of self-revelation. This man, who revealed so little of himself in conversation, put into his writings all his memories and experiences. In 1858 he became an Exhibitioner at Queens College, Oxford, was considered a scholar of promise and was tutored in Greek by Jowett; but, like Cardinal Newman, he was not awarded a first in his final examinations (known in Oxford as 'Greats'). This did not prevent Brasenose from electing him a fellow, and in 1863 he moved into the inconspicuous rooms in the College which he continued to occupy till his death. His sitting-room was painted a pale yellow and was sparsely furnished; his bedroom could hardly accommodate a small bed. He made a few friends in College, notably C.L. Shadwell, to whom he dedicated *The Renaissance*; and later his two sisters came to live in North Oxford. His passion for physical beauty was made more poignant by his own incurable ugliness. Hoping that it would give his face character his friends persuaded him to grow a heavy military moustache, and he retained this grotesque disguise till the end of his life, looking, said Paul Bourget, like *'un amant de Circe transformé en dogue'*. He always wore a top hat and carried a gold-tipped umbrella, and on his walks he kept his eyes on the ground, so that he should not have to recognise a colleague. George Moore said that he looked as if he were made of lead. Although he had a few friends in the University, including Mark Pattison and his adorable wife, the all-powerful Jowett turned violently against him. For years Jowett had been preaching the doctrine of high-minded worldly success, and one can imagine his feelings when he read the famous words in the Conclusion of *The Renaissance*: 'To burn always with a hard, gemlike flame, to maintain this ecstasy, (that) is success in life.' The University authorities followed Jowett's lead. Sir Edmund

# Walter Pater

Gosse told me that, when he went down to Oxford for the opening of the Shelley Memorial, he lunched with Pater. After luncheon he said to his host 'Well, I suppose we should be making our way to the ceremony'. To which Pater replied, 'I have not been invited'.

In 1877 he made a new friend, Richard C. Jackson. The discovery of this character is the point of Wright's *Biography*: in fact a great part of the second volume consists of Mr Jackson's reminiscences. It is not too much to say that Pater formed an emotional attachment to him. He was undoubtedly the inspiration of *Marius the Epicurean*, although Pater put a lot of himself into Marius. 'My dear Marius' wrote Pater 'I want you to write me a song for my birthday.' Mr Jackson responded with the following lines:

'Your darling soul, I say, is influenced by love for me;
Your very eyes do move. I cry with sympathy;
Your darling feet and hands are blessings ruled by love.'

Mr Jackson, although not in holy orders, became a member of a community called St Austin's in Walworth, founded by an Anglo-Catholic priest named George Nugée. He was rich, Mr Jackson was also rich, and had a house and library in Camberwell which, to judge from photographs, contained a large collection of works of art. Pater spent a great deal of his time there, and did most of his reading in Mr Jackson's library — he himself owned very few books. He wrote 'Oxford slays me. Oh, I can breathe in Walworth!' — the accents of aestheticism, but not the usual sentiments. The preference for Camberwell over Oxford may strike us as rather odd, until we remember the character of Oxford in the '70s, where sentiment and the spiritual life were less important than conventional academic activities and brisk bursarial business. Nevertheless, it is rather sad that a man of Pater's quality should have exiled himself to what, after all, must have been a rather second-rate community. One reason was Mr Jackson; the other the elaborate ritual of M Nugée's services — something, as I have said, that Pater loved since his childhood.

*Marius* was published in 1885, and in that year Pater took a house in London, presumably to be nearer to Camberwell. But ironically enough Mr Jackson had by that time grown rather bored by Pater. I

should mention another sorrow in Pater's life, which has a special interest to Brasenose College, in which this paper was originally read. As many of you will know, there used to stand in the front quad a contemporary replica of Giambologna's *Samson*. As far as can be judged from a photograph it was a good copy, and the only life-size piece of Renaissance sculpture in Oxford. On bump suppers undergraduates used to paint it or otherwise deface it, so the governing body decided to remove it. It was melted down for scrap.

In the '90s Pater seems to have become more reconciled to Oxford. He took a house in North Oxford and lived with his sisters. His lecture on *Plato and Platonism* (1893) was well received by Jowett, and he wrote one of the finest of his imaginary portraits, 'Apollo in Picardy'. He developed a more serious view of Christianity than the love of ritual that tempted him to St Austin's, and gave the best of his mind to an essay on Pascal, which was left unpublished. He died in 1894.

One more aspect of Pater's life remains to be mentioned, his travels abroad. He went to France, Italy, Holland and, to judge from the very precise description in 'Duke Carl Von Rosenwald', to Germany. His travels lasted for two or three months, and he seems to have gone almost everywhere on foot. France was his favourite. This man, whose stooping frame seemed barely capable of carrying him along the High Street, thought nothing of walking from Chartres to Bordeaux. It was on these walks that he developed that close observation of plants and trees that is one of the chief delights of his prose. Marius's walk in the Campagna and Gaston de la Tour's walk to the Chateau de Montaigne are, as usual, autobiographical.

Let me now turn from Pater's life to his work. His earliest considerable piece of writing, published in 1864, bears the rather pretentious title of *Diaphanéité*, meaning, I suppose, the quality of being diaphanous. It suggests, in an indirect and complicated way, the characteristics of an ideal character, neither an artist nor a saint, nor a speculative thinker, still less a man of the world, but an entirely transparent human being, content simply to be himself. The language and thought are already Pater's own, but the sentences are short, and the transitions so abrupt that it is quite hard to follow. It contains some beautiful sentences — one of which must have been put in especially to annoy Jowett — 'This colourless unclassified purity of life can neither be used for its services nor contemplated as

an ideal. . . . The spirit which it forms is the very opposite of that which regards life as a game of skill, and values things and persons as marks or counters — as something to be gained'. But it is not easy to read and I would not recommend *Diaphanéité* to anyone who is not already an *afficionado*. It was followed, in 1866, by one of Pater's finest works, the essay on Winckelmann. The immediate pretext of this essay was Otto Jahn's life of Winckelmann, but it was in fact a quasi-autobiographical record of the emotions that had been aroused in him during his visit to Italy in 1865, and Pater rightly included it as the final essay in *The Renaissance*. The hunger for a golden age, the austere devotion to physical beauty, the feeling of a dedication to art and to the unravelling of its laws, 'the desire', as Pater says, 'to escape from abstract theory to intuitions, to the exercise of sight and touch' — all the characteristics which Winckelmann had united with a burning clarity, Pater recognised as half-smothered fire in his own being. Even those elements in Wincklemann's character which seem more questionable, his formal acceptance of the Catholic faith as the price of a ticket to Rome, and his passionate love letters with young men, corresponded to impulses which Pater felt in his own character and increased his feelings of sympathy.

Half-way through his essay the biographical section ends, and Pater concerns himself less with Winckelmann's character than with his interpretation of Greek art. This is the earliest and was to remain the most sustained of all his writings on aesthetic theory; and it contains many of the conclusions about art and life which were to underlie the other essays in *The Renaissance*. Art is the product of the imaginative intellect; the artist in producing his works 'gradually sinks his intellectual and spiritual ideas in sensuous form', from which it follows that the various arts have each their own domain in which they are most nearly successful. All this he applies to Winckelmann's conception of Greek art, acknowledges its completeness, and then goes on, in some pages of admirable criticism, to show its inadequacy. He does so by treating Winckelmann as the forerunner of Goethe, and showing how Goethe had seen past the bright, compact Greek world of the senses to the dark, chaotic and fateful world of early Greek religion and Aeschylean tragedy, and had fused all these experiences into a single, balanced culture in which the mysterious forces and unsatisfied longings of modern life had their subordinate place.

# Walter Pater

*The Renaissance*, written between 1869 and 1871, although not published till 1873, remains on the whole the most readable of all Pater's works. The essays vary in quality, but two of them, the 'Leonardo da Vinci' and 'The Poetry of Michelangelo', are masterpieces: indeed the description of the Mona Lisa is the one piece of Pater's writing that everyone knows, and in my youth most of us knew by heart. W.B. Yeats, with his usual waywardness, put it as the first entry in his *Oxford Book of English Verse*. But I think it has done harm to Pater's reputation. It has led people who do not know his work to think of him as an exponent of that questionable genre, *prose poetry*, whereas in fact he was not only a perceptive critic but a profound and original thinker on the subject of aesthetics. We tend to forget, so carefully does Pater cover up his tracks, that he was a persistent reader of the German philosophers, and that his writings on aesthetics, although expressed in language very different from that of Kant, Schelling or Hegel, are not mere decoration but are the result of deep thought. The most important of his speculations come in an essay which did not appear in the first edition of *The Renaissance*, and was written the year after its publication; but was included in the third and in all subsequent editions, of which, amazing as it must seem to us today, there have been twenty-three. This is the essay on 'The School of Giorgione'. Its importance does not lie in what Pater says about Giorgione's paintings, where unfortunately he too modestly lets his own fine intuition be over-ruled by the 'science' of Crowe and Cavalcaselle. He was conscious that no final, acceptable corpus of Giorgione's own work could ever be established: this is what he implies in his title, and we may concede that the Giorgionesque is a subject that can be understood at least as well through its reflections, moons and satellites, as through an attempt to determine the fluctuating outline of the central luminary. The importance of Pater's essay, however, does not lie in his descriptions of Giorgionesque painting, perceptive though they often are, but in the four or five pages of criticism with which it opens. Since these contain Pater's most serious attempt to define his thoughts about the nature of art, I will examine them in more detail. He begins with a reassertion of the belief, put forward ten years earlier in the essay on Winckelmann, 'that the sensuous material of each art brings with it a special phase or quality of beauty, untranslateable into the forms of any other. . . . For, as art addresses not pure sense, still less pure

135

intellect, but the "imaginative reason" through the senses, there are differences of kind in aesthetic beauty, corresponding to the difference in kind of the gifts of sense themselves'. This conclusion leads him to reject the venerable adage that painting is a form of poetry, differing only through the artist's skill in making it visible. 'To suppose that all is mere technical acquirement in delineation or touch, working through or addressing itself to the intelligence, on the one side, or a merely poetical, or what may be called literary interest, addressed also to the pure intelligence, on the other: this is the way of most spectators, and of many critics who have never caught sight all the time of that true pictorial quality which lies between, unique pledge, as it is, of the possession of the pictorial gift, that inventive or creative handling of pure line and colour.' This confidence in the value of sensuous impressions Pater carries very far. 'In its primary aspect, a great picture has no more definite message for us than an accidental play of sunlight, and shadow for a few moments on the wall or floor: is itself, in truth, a space of such fallen light, caught as the colours are in an Eastern carpet, but refined upon, and dealt with more subtly and exquisitely than by nature itself.' Already we may feel that Pater has overtaken, in the candour and subtlety of his analysis, all the critics of his time and drawn level with the ideas of our own day. But he has another stride to make. He observes that although 'each art has its own specific order of impressions' yet each may be observed to pass into the condition of some other art, and he concludes with a sentence that he prints in italics: '*All art constantly aspires towards the condition of music*'. For while in all other art it is possible to distinguish the matter from the form, and the understanding can always make this distinctive, yet it is the constant effort of art to obliterate it!

To realise the originality of these ideas, one must recall that the doctrine of painting as a form of visible poetry, justified by a tag from Horace, *ut pictura poesis*, had been undisputed ever since a theory of art had first been formulated in the Renaissance, when it had been allied, somewhat uneasily, with the doctrine of imitation. To suggest that the basic beauty of a picture was like 'a space of fallen light, caught as in the colours of an Eastern carpet', and that its value increased in so far as it aspired towards the condition of music, was to go beyond even the most adventurous critics of the next generation, beyond, for example, the 'ideated sensions' of Berenson, and arrive

at those pure aesthetic sensations which Roger Fry propounded so persuasively in the 1920s. We ask if Pater, with his keen sense of tradition, could really have invented such a revolutionary doctrine; and the answer is, I think, that he did. Other critics, it is true, had admitted that an indefinable sensuous element lay at the root of aesthetic pleasure. But their random statements had always been in the nature of indiscretions, hastily put aside. Ruskin, for example, in *Modern Painters*, had said that we love nature 'instinctively and necessarily as we derive sensual pleasure from the scent of a rose' and later he admits that 'the quality above all which gives me delight in pictures' is simply 'the arrangement of lines, forms and colours so as to produce the best possible effect'. But far from following up this observation, he recoiled from it, and as everyone knows, devoted his life to arguing that the moral and intellectual elements in art are all-important.

Gauthier, who had included the phrase 'art for art's sake' almost accidentally in the impudent pages of his preface to *Mademoiselle de Maupin* (1834) never developed the idea; and his subsequent criticisms of painting are the most purely literary of his time. As for Baudelaire, who is credited with the statement that 'the art of the colourist is akin to music and mathematics', his aesthetic theory always returns to the temperament of the individual artist. None of the critics come to the point which Pater saw so clearly: that what gives our aesthetic experience its unique value is the sensuous or intuitive perception that matter and form are one, and that this unity of perception is most easily achieved in music.

Not only modern aesthetic theory, but modern art itself has followed Pater's prescription. He himself thought to justify his analogy with music by the curious example of Alphonse Legros; to see it accurately fulfilled he would have had to wait for the work of Braque and Picasso, or even Rothko and de Staël. This consummation might have displeased him and it is indeed ironical that *The Renaissance*, which begins and ends with an attack on abstraction, should have first put forward the theoretical justifications of abstract art. He might, however, have been consoled by the influence he had on the theories and the modes of perception of the two greatest aesthetes of the twentieth century, Marcel Proust and Bernard Berenson.

Perhaps it was the study of Winckelmann that led Pater to make a

more intensive study of Greek mythology. At all events in the year immediately following *The Renaissance* he wrote most of the papers subsequently collected under the title of *Greek Studies*, in particular one on Dionysus and another on Demeter and Persephone. They are the most elaborate of all his works, and Pater himself said that the Demeter was the most difficult piece of work he had ever done. They dispose of the statement, frequently repeated by Benson, that he was no scholar. But how far they would stand up to the researches of modern scholarship I am too ignorant to say.

With his mind steeped in the myths and morals of antiquity Pater made his way gradually into the book which is usually regarded as his greatest contribution to literature, *Marius the Epicurean*. I put it thus indirectly because we do not know precisely when the famous work was begun; but we do know that in 1882 he gave up some of his college duties and spent the winter in Rome. I believe that the idea of an imaginary portrait, as a form through which he could personalise the thoughts and emotions of an epoch, had already entered his mind during the composition of *The Renaissance*, and it was in this form that he had originally conceived *Marius the Epicurean*. This is confirmed by a letter he wrote in 1883 to Miss Paget, a young woman already famous as Vernon Lee: 'I have hopes of completing by the end of this vacation one half of my present chief work — an Imaginary Portrait of a peculiar type of mind in the time of Marcus Aurelius. I am wishing to get the whole completed, as I have visions of many smaller pieces of work, the composition of which would actually be pleasanter to me. However, I regard the present matter as a sort of duty. For you know I think there is a sort of religious phase possible for the modern mind, the conditions of which phase it is the main object of my design to convey.' I have quoted this letter at length because it reveals the dual purpose of Marius. It was to be both an imaginary portrait and a philosophic tract. Its subject is a beautiful and earnest young patrician, brought up in a country house near Pisa, who is first persuaded by Cyrenaic philosophy, but after he has made his way to Rome he falls under the influence of the Emperor Marcus Aurelius, and his early philosophy of educated sensation is modified by the Emperor's stoicism. He tastes all that Rome has to offer of thoughtful speculation, but remains deeply dissatisfied. Then, almost by accident, he finds himself at a meeting of early Christians, in the house of a friend, and feels at once that they have achieved a

freshness and a fervour that the worn-out systems of Greco-Roman thought had lost. He returns to Pisa with his heart full of Christian longing, and, while defending a friend from an anti-Christian attack, is fatally wounded. He dies surrounded by Christians, who administer to him the last sacraments. It is a great and serious theme which allowed a full opportunity for Pater's self-knowledge, and I cannot believe that Richard Jackson really had much to do with it. I may add that Marius is worth reading to the end·— or, if you like skipping, till you reach the last four chapters, which concern the early Christians. They are written with more feeling than those that describe the ethos of declining Paganism, and show that Pater, although he passed through a phase of positive atheism, was constantly brooding on the mystery, both doctrinal and historical, of the Christian religion, and at the end of his life became a devout believer.

*Marius* was greatly admired, and produced among the young rather the same mood and rebellious excitement that the poems of Swinburne had done some years earlier. Most of these admirers would, I believe, have said that they did so because of his style. In it Pater had perfected his very personal way of writing, and had sustained it without a break for two volumes. This therefore may be the right point at which to say something about that peculiar instrument which was so much praised in his own day, and which tends to irritate the contemporary reader. As with Carlyle, the other eccentric stylist of the nineteenth century, it is hard to say how it came into existence. We are told that he taught himself the art of writing by translating Flaubert and Sainte-Beuve, but his mature style bears no resemblance to either of them. Pater, who so often insisted on the unity of form and matter, might have maintained that the complexity of his responses to human or aesthetic values could only be conveyed as somewhat elaborate language. But there is more to it than that. Pater's style, like all remarkable styles, echoes a music that was playing in his head, and might without extravagance be called the rhythm of his whole personality. An interesting proof of this was given by his great admirer, whom I have already mentioned, Vernon Lee. Late in life, having achieved an excellent style of her own, she rebelled against Pater's elaboration and analysed one of his most famous passages, the description of the night in the temple in *Marius*. She found it to be full of non sequiturs, meaningless inversions and other errors of style. She then, for she was a dauntless old lady,

re-wrote every sentence as it should have been written, retaining the meaning, but imposing clarity and logic. The result is — nothing. When Pater's inner voice could not be heard the text was no better and no worse than one could read in a dozen ordinary history books. Pater could write in a simple style if the subject warranted it, as in his imaginery portrait of Watteau. He could also write in a straight-forward formal manner, as in the last sentence of his essay on *Style*, which contrasts, and I think was meant to contrast, with the conclusion of *The Renaissance*:

> Given the conditions I have tried to explain as constituting good art — then, if it be devoted further to the increase of men's happiness, to the redemption of the oppressed, or the enlargement of our sympathies with each other, or to such presentment of new or old truth about ourselves and our relation to the world as may ennoble and fortify us in our sojourn here, or immediately, as with Dante, to the glory of God, it will also be great art.

His style had more influence than is commonly allowed — not only on professional aesthetes like Oscar Wilde, who wrote most exquisite Paterese, but on Henry James and Virginia Woolf. There are times when we revolt against the sustained artifice of Pater's style. It is a commonplace of criticism that he loved words. He would fondle them and dandle them till, as Mrs Mark Pattison said, 'they glowed like jewels upon his pages'. He had one or two favourites, which I think he used too often — morsel, quaint, bland, winsome, debonair and, above all, dainty, which, although it occurs in Wycliffe, and is frequent in Chaucer, has fallen on evil days and is now associated only with teas. It is a revealing list. Sometimes his dependent clauses are placed in unexpected places, which sacrifices logic in order to maintain the texture of the whole sentence. But in the end our rejection of Pater's style (if in fact we do reject it) is due to our impatience with his tone of voice. We are told that in conversation he was witty and trenchant, but when he wrote the wit was usually polished away, and in its place came the slow, elaborate sentences that form a sort of tapestry of language, without accents, and sometimes almost without form. As in a tapestry there is a quantity of beautiful, and sometimes surprising detail, but one must look attentively to discover it.

Soon after *Marius* Pater set about writing a sequel. This is seldom a

good plan; but Pater was attracted by the idea of making his second Marius a young Frenchman named Gaston de la Tour living in la Beauce at the time of the wars of religion. Like his predecessor he visits the great writers of his time, Ronsard and Montaigne, which allows Pater to write beautiful appreciations of their work. Personally I think that *Gaston* could have been a better book than *Marius*, simply because Pater liked France much more than Rome, and could write about the countryside more naturally. But for some reason Pater put it aside — perhaps he thought it too much of a repetition, and did not know how to end it, except by having Gaston killed in the wars of religion. But even this was a repetition of *Marius*. I may add that Benson's assertion that in *Gaston* Pater's style becomes less vivid and more narrow is totally false. In many ways it is the most beautifully written of his books.

You will remember that Pater, in his letter to Vernon Lee, spoke of *Marius* as an 'Imaginary Portrait', and added that he had 'visions of many smaller pieces of work which would actually be pleasanter to me'. 'Imaginary Portraits' became henceforth his favourite literary genre. Four of them were published in a book of that name; two others were printed separately. They were, as I have said, among the pieces that Pater preferred, but personally I do not think they are quite as good as the best part of *Marius*, or of *Gaston de la Tour*. The first of them is about Watteau, and purports to be written by a young girl, the sister of Watteau's pupil, Jean Baptiste Pater. It is unique in his work in that it is written extremely simply, and could have been published in *The Lady* without anyone noticing the difference. It is in fact a good deal subtler than it seems. The second of them, 'Denys l'Auxerrois', is on a theme to which Pater returned in his last piece of imaginative writing, 'Apollo in Picardy', the impact of religious feeling on a young pagan. There is an element of violence in both these pieces which shows what a sense of the terrible lay behind Pater's impassive countenance. The third, which I like the best, is about a young Dutchman named 'Sebastian von Storck', who fell under the influence of Spinoza. It allows Pater a beautiful and nostalgic evocation of the Netherlands (and incidentally displays a considerable knowledge of Dutch painting), and then shows the reaction from this amiable 'here and now' to the most extreme and rather *un*amiable form of idealism. The fourth, 'Duke Carl von Rosenwald', I like much less, although critics of Pater seem to prefer it.

# Walter Pater

His last work, published in 1893, was *Plato and Platonism*. He wrote articles about Plato throughout his life, and was finally persuaded to give a series of lectures on the subject. He gave them in a low, even voice, and no one understood a word. But when the lectures were printed the book was recognised as a masterpiece. Jowett, the unassailable Platonist, prized them highly and confessed that he had misjudged Pater. Pater himself thought they were his best work, and I believe that anyone who takes the trouble to read them will agree with him.

So I return to my original contention, that Pater must not be thought of primarily as a stylist or a writer of decorative prose, but as what used to be understood by the word 'philosopher'. To apply this word to him in the age of Wittgenstein, or even in the preceding period of Cooke Wilson and Pritchard, may seem preposterous, and perhaps I am exposing myself to ridicule if I say in Oxford what a philosopher should be. But I do feel fairly certain that he should not be merely a verbal technician. A philosopher, it seems to me, is a man who recommends to us a new train of thought and a good way of life. This Walter Pater did, and if it is a way of life which can be had only by a few, this does not invalidate it as an idea.

# TEN

## *Mandarin English*

Fine writing has fallen into disrepute. Fifty years ago we were encouraged to acquire a prose style. At school, where the difficult, and almost defunct, form of the essay was the only kind of literary composition in the school curriculum, we were advised to read the essays of Addison, Hazlitt, and Matthew Arnold, and take them as our models. With their cadences in our ears, we tried to make our phrases varied, euphonious, and conclusive. Much was expected of us. Here is an example of the kind of advice we were supposed to follow:

> In every properly constructed sentence there should be observed this knot or hitch; so that (however delicately) we are led to foresee, to expect, and then to welcome the successive phrases. The pleasure may be heightened by an element of surprise, as very grossly, in the common figure of the antithesis, or, with much greater subtlety, where an antithesis is first suggested and then deftly evaded. Each phrase, besides, is to be comely in itself; and between the implication and the evolution of the sentence there should be a satisfying equipoise of sound. Nor should the balance be too striking and exact, for the one rule is to be infinitely various; to interest, to disappoint, to surprise, and yet still to gratify.

I remember at school reading this passage, which you will have identified as a quotation from Robert Louis Stevenson's *Art of Writing*, with a certain amount of discouragement, feeling that I should never be capable of such elaborate artifice. I was happier when my old friend Logan Pearsall Smith told me, amongst other things, to collect into notebooks rare and precious words, which I could hoard, as a goldsmith might hoard jewels, until some coincidence of ornament and function justified their use. This was established practice in the nineties. Even Mr Somerset Maughan kept such notebooks, and said that they were lying about in drawers and might be available for 'somebody determined to write nonsense'. I have lost mine.

Very few people, I suppose, think of prose like that today. The very words 'prose style' or 'fine writing' appear in forward-looking

magazines only as terms of derision. Arnold Bennett, in an article in the *Evening Standard*,* described this kind of writing as Mandarin English; and the term is unusually apt, because this was the style of a ruling minority, formed by the study of dead languages, and used in the conduct of public affairs.

Well, Mandarins are not what they were, in China or anywhere else, and it might be worth asking how far their language, a language so far from the usage and impulses of ordinary man, could still be written, or whether it should be considered as no more than a sort of museum exhibit. Although they are bound to overlap, there is a distinction between Mandarin and fine writing. The greatest English prose was written in the seventeenth century by Donne, Jeremy Taylor, Sir Thomas Browne, and Traherne, but even the most ambitious prose writers of my youth did not aspire to write like Sir Thomas Browne. To have done so would have been like trying to build in the style of Nonesuch or Hardwicke. But, if I may continue the analogy, they did feel that they could build in a sort of neo-Palladian. In other words, Mandarin English goes back to the middle of the eighteenth century, and more specifically to Gibbon. In saying Gibbon, I am not forgetting the heavyweights of the first half of the century. But Bolingbroke's subjects have ceased to interest us, so that we do not read his sonorous and eloquent prose; and Shaftesbury is too mannered — a seventeenth-century stylist in eighteenth-century dress. Johnson's powerful and precise antitheses tempt the imitator into feeble parody, and Burke's style is too obviously that of an orator. But Gibbon's style, in spite of its apparent evenness of texture, is remarkably flexible. It can pass imperceptibly from exposition to anecdote; it allows for both eloquence and irony. Of course the language is more pompous than later and less confident Mandarins can afford to be. But the general structure and the control of the rhythms follow, with unequalled skill, the exacting advice given by Stevenson in the paragraph I have just quoted.

I need not remind you of the sustained magnificence of the *Decline and Fall*. But even when Gibbon is writing quite simply, as in the description of his feelings when his great work was finally over,

---

* Dame Rebecca West tells me that Bennett heard these words at dinner with H.G. Wells, who said that they had been invented by Joseph Conrad.

there is a movement and a tone that seem to me the essence of Mandarin. I quote it, familiar though it be, and you will observe from my gestures that one cannot resist conducting it, as though it were a piece of music:

> It was on the day, or rather night, of the 27th June, 1787, between the hours of eleven and twelve, that I wrote the last line of the last page, in a summer house in my garden. After laying down my pen, I took several turns in a 'berceau', or covered walk of acacias, which commands a prospect of the country, the lake and mountains. The air was temperate, the sky was serene, the silver orb of the moon was reflected from the waters, and all nature was silent. I will not dissemble the first emotions of joy on the recovery of my freedom, and perhaps, the establishment of my fame. But my pride was soon humbled, and a sober melancholy was spread over my mind, by the idea that I had taken an everlasting leave of an old and equable companion, and that, whatsoever might be the future fate of my HISTORY, the life of the historian must be short and precarious.

That is Mandarin English at its zenith, and as it was to last for 150 years. In case you think that this is an overstatement, let me quote a passage that used often to be quoted as the summit of late nineteenth-century prose. I don't need to tell you who it's by:

> When that hour came to me among the pines, I wakened thirsty. My tin was standing by me, half-full of water. I emptied it at a draught; and feeling broad awake after this internal cold aspersion, I sat upright to make a cigarette. The stars were clear, coloured, jewel-like, but not frosty. A faint silvery vapour stood for the Milky Way. All around me the black fir points stood upright, and stock still. By the whiteness of the pack saddle I could see Modestine walking round and round at the length of her tether; I could hear her steadily munching at the sward; but there was not another sound, save the indescribable quiet talk of the runnel over the stones.

The rhythm of Gibbon's farewell to the *Decline and Fall* is still effective. If we wonder why Stevenson (for the name of Modestine will have reminded you that this passage comes from *Travels with a Donkey*) admitted those archaisms — 'broad awake' — 'aspersion' — and the sentimental trope of the 'talk of the runnel' we must remember that in his time *Henry Esmond* was considered the greatest

145

novel in the English language.

Now let me give an example of Mandarin in decline — almost, but alas not quite (as many similar passages may show), a parody:

> The Duke's earthly possessions were of a negative character; but it was important that the guardianship of the unwitting child, whose fortunes were now so strangely changing, should be assured to the Duchess. The Duke was just able to understand the document, and to append his signature. Having inquired whether his writing was perfectly clear, he became unconscious, and breathed his last on the following morning.

As you may have recognised, this comes from Lytton Strachey's *Queen Victoria*, which was praised, not only for its really admirable qualities of wit, selection, and economy, but for its style.

If Mandarin seems pompous and empty when written by the most admired prose writer of his day, how much hollower must it sound in those official articles that have to appear on occasions of public mourning, rejoicing, or commemoration. This is not due to any lack of sincerity in the unfortunate writers who churn them out. No doubt they feel most strongly the solemnity of Remembrance Sunday. They are another illustration of the truth that nowhere is there a greater display of sincerity and nowhere less art than in a graveyard. The style, the only acceptable workable style for this particular purpose, has died, and no amount of goodwill can revive it.

Assuming that this kind of writing is no longer acceptable, how can an author escape from the balanced periods and choice language in which he made his first essays? The answer usually put forward is by coming closer to the rhythms of ordinary speech or conversation. This idea has attracted writers at all times. At the height of eighteenth-century formality Sterne tried to stylise the rhythms of speech. He had a perfect ear and a delicate feeling for words, but he could not avoid, in *Tristram Shandy* at any rate, the disease which afflicts nearly all of those who use the spoken word as the basis of style, prolixity. Even a practised speaker, when he tries to speak conversationally, without a text, becomes intolerably prolix, and this fate overcame so great an artist as Henry James. As everyone knows, his late novels were dictated. He adopted this method partly to escape from the forced symmetry of Mandarin. He wanted to achieve a freer rhythm that would follow the movement of his

thought as a situation, with all its inexhaustible possibilities, passed slowly through his mind. He was trying to keep pace with a series of related mental impressions, rather as Claude Monet tried to keep pace with a series of optical impressions by painting on twenty canvases during the same half-hour. Henry James is an exceptional instance, because by all accounts he also spoke like this, so he could reasonably regard his late writing as being in a conversational style.

George Moore also dictated his later novels, and became equally prolix, but he did not speak like this (in fact, his conversation was curiously naïve), so that his later style does not reflect his whole personality, as does that of Henry James. It is the extreme example of that decadence of fine writing which the French call *le style artistique*, and this no doubt is one reason why he is out of favour today. (However, I must digress to say, in fairness, that George Moore's late style was a triumph of self-education. He always said 'I had very little talent, but I worked very hard'. Anyone who cares to compare the first edition of a book like *Evelyn Innes* with the last pages in *The Brook Kerith* will be amazed at what hard work and an artistic conscience can do.)

So the invigorating rhythm and lively syntax of speech are not to be achieved by dictation; and need I add that, although lectures are spoken, they are not in the style of speech. In fact they are usually prime examples of Mandarin. The reason is that, in order to project his idea to the back of a hall and hold the attention of a sleepy audience, a lecturer tends to pull out that old bag of tricks that has been available since Demosthenes, or Cicero; and even if he avoids the blunt instruments of political oratory, he cannot resist working his periods round to a full close, and his audience would feel rather let down if he didn't. It is true that some very unrhetorical pieces have been given as lectures. *Plato and Platonism* was read by Mr Pater in a low, even voice. But among the great Victorians it is usually possible to tell whether a work has started life as a series of lectures. There is, for example, a distinct difference of tone between *The Crown of Wild Olive* and *The Stones of Venice*. Carlyle, who spoke of lecturing with contempt — 'That detestable mixture of prophecy and play actorism' — allowed himself some ejaculations in *Heroes and Hero Worship*, which were less accurately aimed than similar outbursts in *The French Revolution* or *Past and Present*.

But if lectures still prolong, in a modest way, the puffed-up style

of oratory, this is not true of television. The moment that a viewer sees you close to him, he feels that you are talking to him alone. It is a conversation and the slightest flavour of didacticism or pomposity puts him off. The rise and fall of Mandarin rhythm is offensive to him. He feels about it as Queen Victoria felt about Mr Gladstone. If, to save myself trouble, I insert into a television script a phrase or two from a lecture, I always have to remove it in performance. So much is this a psychological matter that I find it difficult to do a good television performance standing up — the posture alone makes me speak in a more pretentious style.

I give these personal experiences because they relate to the question whether the collapse of Mandarin has been effected by television. From the author's point of view I should have thought that the answer was, very little. Fine writing was in disgrace long before the spread of television; and the critics who condemned it most strongly were people who, I am sure, had never watched a television programme in their lives. For that matter, I doubt if they had listened for long to the conversation of the average man, whose language and speech rhythms they thought that the contemporary prose writer should adopt. It is significant that the writer who caught these rhythms most successfully was Mr Eliot in *Sweeney Agonistes*, which is not in prose but in verse; perhaps the formlessness of popular speech, with its threadbare language and meaningless repetitions — 'You know, you know' — would be unreadable unless controlled by metre. The use of alternate lines, as in Attic tragedy, called stichomythia, invented by Eliot and brilliantly dramatised by Becket and Harold Pinter, to my mind one of the chief stylistic discoveries of our time, points to the same conclusion.

So from one point of view the influence of television on style is limited. But if one considers it from the point of view of a reader who is also a viewer, then one can believe that the continuous flow of television language in interviews and advertisements will have some effect, even if it is only of a negative kind. After so much vagueness and inflated benevolence, it must be rather hard to concentrate on Bacon's Essays, or even on Swift; and, since many writers feel conscious of their readers (I am not one of them) I suppose that in the end the written word will suffer.

This brings me to what is often held up as the fundamental objection to Mandarin. That it is the style of a privileged class, and

thus unsuitable to a democratic society. Like all arguments based on the concept of class, this seems to me to have become unreal, because class structure is changing so rapidly. In the past there was a recognisable working-class style. It was not based on the way that the average man spoke, but on a mixture of nonconformist preaching, with half-conscious memories of Bunyan and Tom Paine. This style has long ago dissolved into popular journalism.

Optimists hope that the plain man will express himself in the plain, vigorous, extrovert prose of Cobbett. But in fact uneducated men prefer more ornate and important-looking language. Many of you will remember the story of the old family servant, who was being given a piece of inscribed plate. He expressed his gratitude, but asked one favour: that the word 'given' should be changed to 'presented'. Simple people like fairy-tales, promises, and generalisations, and now that the advertiser has taken the place of the preacher it seems unlikely that democratic prose will become any clearer, or more precise.

Did people ever speak better? We know that Wordsworth thought so, not only because he said that it was his aim to write poetry in a selection of the language used by ordinary men, but from his sublime description of the Leech Gatherer's conversation:

> His words came feebly, from a feeble chest,
> But each in solemn order followed each,
> With something of a lofty utterance drest —
> Choice word and measured phrase, above the reach
> Of ordinary men; a stately speech;
> Such as grave Livers do in Scotland use,
> Religious men, who give to God and man their dues.

I think that Wordsworth is to be believed. I remember Highlanders speaking like this in my youth, and I have heard an echo of it in the General Assembly of the Church of Scotland. Making all allowances for a selective ear, I suppose that the speech of the West of Ireland farmers and fishermen, as reproduced by Synge, also had a fanciful diction and a rhythmic lilt above the reach of ordinary men.

However, these ways of speech, remote in time and place, have no real bearing on the question of a contemporary popular style. One is tempted to ask if such a thing exists in a usable form. Of course it can

be used in fiction, but in the ordinary prose that we have to use in public affairs, speeches, lectures, and leading articles true democratic speech would not only sound very odd, but would be unable to cope with many of the issues involved. And yet, one forgets how radically the language of formal occasions and public debate has been popularized in the last fifty years, probably since Alfred Harmsworth. Think of the elder Pitt's once famous answer to Horace Walpole (of all lightweights to have received so heavy a blow) in the House of Commons in 1740:

> The atrocious crime of being a young man, which the honourable gentleman has with such spirit and decency charged upon me, I shall neither attempt to palliate nor deny, but content myself with wishing that I may be one of those whose follies may cease with their youth, and not of that number who are ignorant in spite of experience.

That is very far away from us (with one obvious exception); and on the whole we may be thankful. Diverting though it may be in a small doses, that style carries with it the implication of a society in which most of us would have felt painfully ill at ease. Only against a background of limitless self-importance is that kind of speech conceivable, and Pitt's expostulation was accompanied (in his maiden speech) by an equally elaborate piece of sycophancy such as one finds in the dedications of practically every eighteenth-century book. This was still the tone of the Quarterlies that attacked Keats, and it was in order to lose this Olympian style that Carlyle went into his long, bleak exile at Craigenputtock. When, after five years, he sent back his first writings in Carlylese, his friends in Edinburgh genuinely thought he had gone mad. Yet all he had done was to stylise the sound of the living voice. He often roared and groaned, and the great tenebrista sometimes laid it on too thick; but he could speak with the accents of human sympathy. Ten years ago, before that unfortunate word had gone into politics, I would have said the accents of compassion: Here is his immortal description of Coleridge:

> The good man, he was now getting old, towards sixty perhaps; and gave you the idea of a life that had been full of sufferings; a life heavy-laden, half-vanquished, still swimming painfully in seas of manifold physical and other bewilderment. Brow and head were round, and of massive weight, but the face was flabby and irresolute. The deep eyes, of a light

hazel, were as full of sorrow as of inspiration; confused pain looked mildly from them, as in a kind of mild astonishment. A heavy-laden, high-aspiring and surely much-suffering man. His voice, naturally soft and good, had contracted itself into a plaintive sniffle and singsong; he spoke as if preaching — you would have said, preaching earnestly and also hopelessly of weightiest things.

It seems perfectly natural, but it is a style compulsive enough to have made Ruskin change his own Byronic eloquence into a modified Carlylese. Here is Ruskin's account of Rural Industry — a mother and daughter making nails:

> So wrought they, the English matron and maid, so was it their duty to labour from morning to evening — seven to seven — by the furnace side — the winds of summer fanning the blast of it. The wages of the matron, I found, were eight shillings a week; her husband, otherwise and variously employed, could make sixteen. Three shillings a week for rent and taxes left, as I count, for the guerdon of their united labour, if constant and its product providently saved, fifty-five pounds a year, on which they had to feed and clothe themselves and their six children; eight souls, in their little Worcestershire ark!

I think one would have guessed that this came from *Past and Present*, rather than *Fors Clavigera*. As Ruskin's imitation makes clear, Carlyle had not created that style for literary reasons, but because he felt it his duty to tell the truth. He saw the shadow of great truths forming themselves just over the horizon of his mind, and he wanted to have a means of struggling towards them. He recognised that the Mandarin style, in which he had grown so proficient, permits, and sometimes almost compels, a writer to avoid or gloss over the truth. Evenness of texture, symmetry, and sonority can be disturbed by an inconvenient fact. This kind of evasion, this sailing over difficulties on the high tide of style, is a major fault of Mandarin. In criticism Matthew Arnold is the chief offender.

In history even Gibbon, whose use of his limited sources is exemplary, sometimes passes too easily over difficult ground. Lytton Strachey has described how Gibbon (like Guicciardini) delayed beginning his great work until he had made several drafts of the first two chapters. He had to be perfectly sure that his style was a vehicle that would carry him through to the end; and occasionally the

stage-coach was too commodious. This is Gibbon's famous description of five hundred years of Byzantine history:

> Many were the paths that led to the summit of royalty; the fabric of rebellion was overthrown by the stroke of conspiracy, or undermined by the silent arts of intrigue; the favourite of the soldiers or people, of the senate or clergy, of the women and eunuchs, were alternately clothed with the purple; the means of their elevation were base, and their end was often contemptible or tragic. A being of the nature of man, endowed with the same faculties, but with a longer measure of existence, would cast down a smile of pity and contempt on the crimes and follies of human ambition, so eager, in a narrow span, to grasp at a precarious and short-lived enjoyment. In a composition of some days, in a perusal of some hours, six hundred years have rolled away and the duration of a life or reign is contracted to a fleeting moment; the grave is ever beside the throne; the success of a criminal is almost instantly followed by the loss of his prize; and our immortal reason survives and disdains the sixty phantoms of kings who have passed before our eyes, and faintly dwell on our remembrance.

Magnificent: but irritating to a serious student of Byzantine history.

If this is true of history, it is truer still of thought. I was walking along Broad Street to Oxford with George Santayana and, passing Messrs Blackwell's bookshop, I asked if I might go in to look for a book. 'It's out of bounds for me', said the philosopher, 'I'll wait outside', and so he did, with his back to the shop window. He did not want to have his mind disturbed by an inconvenient thought; even the title of a book might have set up a train of thought that could have upset him. This is one reason why this writer of flawless sentences (and there can be very few writers of our time who have written more consistently perfect English) has become unreadable (or at least unread). The other reason, not directly connected with my subject, is that, like Emerson, he wrote in sentences and not in paragraphs, so that one becomes exhausted by hopping from one sentence to the others.

Apart from its social and ethical shortcomings, I suppose that Mandarin has also suffered from what might be called a craft reaction. In all the arts styles are attacked when they have been pushed to an extreme. The pendulum swings between elaboration and simplicity, and towards the end of the nineteenth century the English prose

admired by men of taste had become exceedingly mannered and elaborate.

I fancy that this new kind of romantic or sentimental elaboration goes back to De Quincey. He was the originator of the purple patch. Jeremy Taylor, Browne, Gibbon himself sometimes gave their prose a little extra colour, but without any break in tone. De Quincey was, I believe, the first to change gear, from the rather heavy, conventional style in which nine-tenths of his work is written, to those passages that are rightly referred to as prose poetry. 'And her eyes if they were ever seen, would be neither sweet nor subtle; no man could read their story; they would be found filled with perishing dreams and with wrecks of forgotten delirium.' This is presumably what Somerset Maugham meant by 'writing nonsense', and in his path a good deal of it found its way into the periodicals of the aesthetic movement — *The Yellow Book*, *The Savoy*, or *The Venture*. Maugham was himself co-editor of *The Venture*. In the 1880s Ruskin's cloud-capped descriptions of nature, which were believed by all serious critics to be the absolute summit of English prose, had been succeeded by the sweet, sleepy, amoral incantations of Walter Pater. I believe it was Pater, more than anyone else, who gave fine writing a bad name. He has suffered from anthologies; you will remember that no less a person than W.B. Yeats opened his *Oxford Book of Modern Verse* with the Mona Lisa description chopped up into short — very short — lines, thus destroying any quality is may have. Pater has also suffered from imitators. His style was vulgarised by Wilde and thickened, as one thickens a soup with cornflour, by writers like Percy Lubbock. But even without these misfortunes, a reaction, I might also say a revulsion, from Pater was inevitable. Here is a passage that occurs in almost all anthologies; the description of the red hawthorn in *The Child in the House*:

> The perfume of the tree had now and again reached him, in the currents of the wind, over the wall, and he had wondered what might be behind it, and was now allowed to fill his arms with the flowers — flowers enough for all the old blue china pots along the chimney-piece, making fête in the children's room. Was it some periodic moment in the expansion of soul within him, or mere trick of heat in the heavily-laden summer air? But the beauty of the thing struck home to him feverishly; and in dreams all night he loitered along a magic roadway of crimson flowers, which seemed to open ruddily in thick, fresh masses about his feet, and fill softly

all the little hollows in the banks on either side. Always afterwards, summer by summer, as the flowers came on, the blossom of the red hawthorn still seemed to him absolutely the reddest of all things; and the goodly crimson, still alive in the work of old Venetian masters or old Flemish tapestries, called out always from afar the recollection of the flame in those perishing little petals, as it pulsed gradually out of them, kept long in the drawers of an old cabinet.

What is so wrong with this famous passage? Not the subject or the sentiment, for in these respects it could have been one of the most memorable pages of Proust. Not, as is commonly supposed, the epithets. There are a few tiresome archaisms like 'goodly' and 'fair', and the 'perishing little petals', which is an accident that might happen to anybody. (Interesting, by the way, to know when the word 'perishing', which was still so effective in the De Quincey, became a word of popular abuse.) But our embarrassment goes deeper. I am reluctant to use words as imprecise as 'texture' and 'rhythm', but they are the only ones that I can think of to account for the peculiar tone of Pater's purple patches. A curious experiment proved the point. Vernon Lee published in an early number of *Life and Letters*, one of Pater's most famous passages, 'the Night in the Temple', in *Marius the Epicurean*, rewritten in a more workmanlike style. She pointed out, in all seriousness, that Pater had made many mistakes of word order, of chronological sequence, of logic, and of accurate observation. She was an experienced writer, she had been Pater's pupil, and she felt entitled to put these faults right. No one but Vernon Lee, with her relentless fixity of purpose, could have undertaken such an exercise. The resulting translation is defensible at every point, except that it is — nothing. Like it or not, it was Pater's tone of voice that had made one read the original; and it was precisely this tone that seduced the would-be stylist for over fifty years.

I realise that I have passed from Mandarin, as I originally defined it, to its near relation, the *style artistique*. May I dwell a little longer on this curious episode in English prose? For some reason it became *de rigueur* for almost everyone who took writing seriously to try to write in this artificial style. Just as a painter like the Honourable John Collier, who did good, straightforward portraits of Huxley and Darwin, felt bound to spend his life painting ideal figures of ladies in Renaissance costume — green bodices, pearl necklaces, red hair; so

154

gifted writers with sharp ears and hard heads felt bound to attempt the Ruskin-Pater style. A touching example is Somerset Maugham. It is hard to imagine a less Pateresque figure than the young doctor who had published *Liza of Lambeth* and was starting his career as a writer of social comedies. Yet for years he slogged away at the *style artistique*, and was sufficiently satisfied with the result to publish in *A Writer's Notebook* specimens of his apprenticeship:

> The fields were fresh with the tall young grass of Spring, the buttercups flaunted themselves gaily, careless of the pitiless night, and rejoiced in the sunshine, as before they had rejoiced in the enlivening rain. The pleasant raindrops still lingered on the daisies. The feathery ball of a dandelion, carried away by the breeze, floated past, a symbol of the life of man, an aimless thing, yielding to every breath, useless and with no mission but to spread its seed upon the fertile earth, so that things like unto it should spring up in the succeeding summer, and flower, uncared for, and reproduce themselves and die.

Well, it was a triumph to get away from this sort of thing and create that dry, staccato style in which Maugham expressed so accurately his own character.

Let me give you one more example from an author whose gifts are now more highly thought of than those of Maugham:

'There the daffodils were lifting back their heads, and throwing back their yellow curls'. But I shan't go on because it is always a mistake to quote in a negative sense — except to add that later on the daffodils 'show a modest, sweet countenance' and 'lean forward pensively'. No, not Gene Stratton-Porter, but the unassailable idol of all modern criticism, D.H. Lawrence, in *The White Peacock*. One begins to feel that descriptions of nature should be prohibited in English prose; until one remembers Doughty's description of the Arabian desert. As for that other idol, James Joyce, if I were to give you examples of his use of the *style artistique* — Pater without punctuation — *Anna Livia Plurabelle*, I should never end. May I add that Pater had at least one beautiful descendant, the wayward granddaughter of Gaston de la Tour, Virginia Woolf.

Having given some reasons why Mandarin English and the style artistique have been rejected, I will now put forward some arguments in their favour. I have more than once implied an analogy between prose and architecture, so may I quote the opening words of

# Mandarin English

Sir Henry Wotton's *Elements of Architecture*: 'Well building hath three conditions: commodity, firmness, delight'. Apply these to well writing. Commodity is another word for ease; ease of access, ease of movement, ease of communication. Firmness is achieved by the structure of the whole, by logic, and by the precision of detail. Delight, of course, will always remain a more arguable proposition. But let us say that in architecture it is achieved by proportion, ornament, and texture.

Now I think that the writer who sets out to achieve firmness, commodity, and delights without learning the rules and absorbing the movements of Mandarin is making things unnecessarily difficult for himself. The firmness and commodity evolved by English prose writers between, say, 1760 and 1860, the qualities that we find not only in Johnson or Cardinal Newman, but in such secondary writers as Southey and Dean Church, are qualities much more easily achieved if we have at the back of our minds the memory of certain devices by which sentences and paragraphs can be held together. I do not suggest that we apply these devices consciously; but as the notion of what we want to say begins to form itself in our minds, it will, if we have any sense of style, be accompanied by a feeling that our thoughts must conform to certain sequences of shapes. Instinctively we know the tune before we have discovered the words. People often say to one, 'If you know what you want to say, say it'. Yes, and write like — but I cannot think of a suitable example, because even a writer as hostile to the devices of rhetoric as George Orwell had a tune at the back of his mind. Of course, the tune may be anti-Mandarin, as it was with Carlyle, and more recently with Hemingway, and the result may be a gain in vitality. (Although when Hemingway wanted to achieve solemn pathos, as at certain points in *For Whom the Bell Tolls*, he reverted to pure Mandarin.) But on the whole the evolved rhythms of English prose are various and flexible enough to accommodate almost any experience.

Here is a single sentence from Ruskin's *Crown of Wild Olive*, where his control of the classical style is so perfect that he can allow himself great freedom of construction. The ordinary devices of symmetry are left far behind, and yet, in its rise and fall, this is still a piece of Mandarin English:

It made all the difference, in any principle of war, whether one assumed

that a discharge of artillery would merely knead down a certain quantity of once living clay into a level line, as in a brickfield; or whether out of every separately Christian-named portion of the ruinous heap, there went out into the smoke and dead-fallen air of battle, some astonished condition of soul, unwillingly released.

Mandarin helps us to achieve the conditions of commodity and firmness — I mean clarity, ease of transition, and an orderly structure; and although, in its decline, it comes to depend on meaningless abstractions, at its best it is precise. This is true not only of such firm and concise writers as Johnson or Hazlitt, but of the masters of elaboration. Middleton Murry said that 'metaphor is the result of the search for a precise epithet'. This is true of the metaphors of Henry James; and the intricate, motionless style of the much-abused Pater often expresses a desire for precision. Here is an example from his essay on Style:

> The blithe, crisp sentence, decisive as a child's expression of its needs, may alternate with the long-contending, victoriously intricate, sentence; the sentence, born with the integrity of a single word, relieving the sort of sentence in which, if you look closely, you can see much contrivance, much adjustment, to bring a highly qualified matter into compass at one view. For the literary architecture, if it is to be rich and expressive, involves not only foresight of the end in the beginning, but also development or growth of design, in the process of execution, with many irregularities, surprises and after-thoughts; the contingent as well as the necessary being subsumed under the unity of the whole.

This is not the Pater who passed into the anthologies, but it is the style in which he made his most useful contributions to criticism.

There remains the condition of delight. No one would suggest that Mandarin prose can give as much delight as the prose of Jeremy Taylor, Sir Thomas Browne, or the translators of the Authorised Version; but, at their best, they were not writing prose at all, but a kind of poetry without metre. The concluding paragraph of *Hydrotaphia* has the same effect on us as a page of *Paradise Lost*. However, I think that the examples of Mandarin which I have given have shown that balance, proportion, and the perfect control of rhythm, the use of an unexpected but inevitable word, can give that *frisson* of pleasure which we call an aesthetic sensation, and which, whatever

157

Pater may say, is similar in effect, in all the arts.

Of these three conditions, this one has, in the last twenty years, been the least regarded, partly because the most influential critic of that period — powerful above all in provincial universities — has had an austere mistrust of delight. His own style is also deficient in commodity, to such an extent that, although I often agree with his intentions, I find it hard to follow his arguments. One of the engaging things about Dr Leavis is his unpredictability, and, with his admiration for Henry James and Conrad, I do not see why his influence should run counter to a more highly wrought prose style. Our old friend 'the labour of the file' may once more be permitted. But I do not foresee the return of the Gibbonian cadence, which is the hallmark of Mandarin. It has been the parent of too much bad writing, and however well concealed it will strike on our ears as pompous and contrived.

This is how one of the last great masters of Mandarin described his aim:

> That style is therefore the most perfect, not as fools say, which is the most natural, for the most natural is the disjointed babble of the chronicler; but which attains the highest degree of elegant and pregnant implication unobtrusively; or if obtrusively, then with the greatest gain to sense and vigour. Even the derangement of the phrases from their (so-called) natural order is luminous for the mind; and it is by the means of such designed reversal that the elements of a judgement may be most pertinently marshalled, or the stages of a complicated action most perspicuously bound into one.

I agree with everything that Stevenson says, but the Gibbonian rhythm turns me against it.

But the discipline of Mandarin, when it is wholly absorbed and half-forgotten, as in that quotation from Ruskin's *Crown of Wild Olive*, does seem to allow the writer to control quite simple language is such a way as to touch the heart through style alone. Here is one last example — a very familiar one, I am afraid — in which poetic quality is achieved without the use of any rare words, without any change of gear, or obvious rhythmic device. Indeed one has to pass through five quite commonplace subordinate clauses till one word lifts the passage on to a different level.

# Mandarin English

Let us consider, too, how differently young and old are affected by the words of some classic author, such as Homer or Horace. Passages, which to a boy are but rhetorical commonplaces, neither better nor worse than a hundred other which any clever writer might supply, which he gets by heart, and thinks very fine, and imititates, as he thinks, successfully, in his own flowing versification, at length comes home to him, when long years have passed, and he has had experience of life, and pierce him, as if he had never known them, with their sad earnestness and vivid exactness. Then he comes to understand how it is that lines, the birth of some chance morning or evening at an Ionian festival, or among the Sabine hills, have lasted generation after generation, for thousands of years, with a power over the mind, and a charm, which the current literature of his own day, with all its obvious advantages, is utterly unable to rival.

Well, perhaps one has to be like Cardinal Newman in order to write like him, in which case very few people will succeed. But I doubt if anyone could have done so without a long apprenticeship in the technical tradition of classical English prose.

# ELEVEN

# *The Artist Grows Old*

'What is it to grow old?' asked Matthew Arnold, and gave a depressing answer:

> . . . 'Tis not to have our life
> Mellowed and softened as with sunset-glow
> . . . 'Tis not to see the world
> As from a height, with rapt prophetic eyes,
> And heart profoundly stirred.
> . . . It is to spend long days
> And not once feel that we were ever young;
> . . . Deep in our hidden heart
> Festers the dull remembrance of a change,
> But no emotion — none!

Arnold was about forty when he wrote these melancholy lines, and his experience of old age was presumably drawn from his father's friends or his fellow civil servants. He wrote in a reaction against the conventional picture of a golden old age which had been current in antiquity from Sophocles to Cicero's *de Senectute*. Everyone remembers Cephalus, Plato's dear old man at the beginning of the *Republic*: 'Old age has a great sense of peace and freedom. When the passions have lost their hold, you have escaped, as Sophocles says, not only from one mad master, but from many!' Arnold was justified in refuting this classical myth of a golden sunset. But all the same, his diagnosis is not entirely correct. 'No emotion — none!' On the contrary, elderly people feel emotion, and tend to weep more than young ones. But is it the kind of emotion that can be expressed in memorable words? A few minutes' reflection shows that it is not. The number of poets who have written memorable verse over the age of seventy is very small indeed, and to write tolerably over the age of sixty-five is exceptional. This decline in the poetic faculty in old age must be distinguished from the loss of inspiration that may afflict a poet at any age. But the two are obviously connected.

160

# The Artist Grows Old

However desirable it may be, in the conduct of life, to be free from passion, the 'mad masters' have been responsible for at least three-quarters of the great poetry in the world. And old age, although it does not put an end to our emotions, dulls the intensity of all our responses. The romantic poets recognised that this was the cause of declining inspiration; and, as we know from Coleridge, it could happen quite early. He was only thirty-two when he wrote that long and moving letter in verse to Sarah Hutchinson from which he later extracted his *Ode to Dejection*:

> I see them all, so excellently fair,
> I see, not feel, how beautiful they are.

And he went on to define more precisely the feeling that he had lost:

> Joy is the strong voice, joy the luminous cloud.
> We in ourselves rejoice.

This is a much more accurate description of the loss that befalls us in old age than Arnold's 'no emotion — none!' Elderly people do not, and perhaps should not, rejoice in themselves. Coleridge read this letter to the Wordsworths on 21 April 1802. At that time William had not lost the faculty of joy: in fact he was at work on the *Immortality Ode*. He was so shocked by Coleridge's pessimism that he added one (or perhaps two) stanzas to the *Ode* in order to refute it. Alas, a few years later he suffered the same fate. He continued to write poetry; he wrote on high themes, with conscientious skill. 'But no emotion — none!' As most of you will know, there was an exception, and I will quote it to prove, if proof were needed, that our feelings do not die, but are buried so deeply in our memories that only some shock, some unforeseeable Open Sesame, can bring them out of bondage. In 1835 Wordsworth heard of the death of James Hogg, the Ettrick Shepherd. He went into the next room. He thought of Chatterton, that marvellous boy; he thought of his lost friends; and in less than an hour he returned with an extempore effusion:

> Nor has the rolling year twice measured
> From sign to sign its stedfast course,
> Since every mortal power of Coleridge
> Had frozen at its marvellous source.

# The Artist Grows Old

The rapt one, of the Godlike Forehead
The heaven eyed creature sleeps in earth.
And Lamb, the frolic and the gentle,
Has vanished from his lonely hearth.

A parallel instance can be quoted from Tennyson; he had long been deprived of poetic inspiration, and had just finished writing *Romney's Remorse*, which even the most fervent Tennysonians do not defend, when, crossing to the Isle of Wight in October 1889, he was struck by an exceptionally high tide, which seemed for some reason to symbolise his recent recovery from a serious illness. Open Sesame. When he returned to Faringford he went straight to his room and in twenty minutes emerged with a poem:

But such a tide as moving seems asleep,
Too full for sound and foam,
When that which drew from out the boundless deep
Turns again home.

He knew what had happened, and knew that it wouldn't happen again. He gave instructions that *Crossing the Bar* should always be placed last in any collection of his works. Of course, the trouble about these flashes from the depths of an elderly poet's buried life is that they cannot be sustained. To do so requires the kind of concentration that is a physical attribute. 'I can no longer expect to be revisited by the continuous excitement under which I wrote my other book', said A.E. Housman in his preface to *Last Poems*, 'nor indeed could I well sustain it if it came.'

If, for obvious reasons, elderly writers cannot sing with the same fervour as young ones, are there not other branches of literature in which they can excel? One poet, who himself wrote movingly in old age, tried to put a case for his fellow ancients:

And yet, though ours be failing frames,
    Gentlemen,
So were some others' history names
Who trod their track light-limbed and fast
As these youth, and not alien
From enterprise, to their long last,
    Gentlemen.

162

# The Artist Grows Old

Sophocles, Plato, Socrates,
   Gentlemen,
Pythagoras, Thucydides,
Herodotus and Homer — yea,
Clement, Augustin, Origen,
Burnt brightlier towards their setting day,
   Gentlemen.

It is a valiant effort, but I do not find Hardy's roll-call wholly convincing. Sophocles is the classic instance, and we must allow it. But we have no means of knowing whether the late works of Homer and Pythagoras were superior to their early ones. I am ashamed to say that I have not compared the late and early works of Clement and Origen; but I have compared St Augustine's *Confessions* with the *City of God*, and have no hesitation in saying that the *Confessions*, written twenty years earlier, is the more brightly burning of the two. I fear that after the age of seventy, or at most seventy-five, not only is the spring of lyric poetry sealed up in depths which cannot be tapped, but the ordering, or architectonic faculty, which depends on a vigorous use of memory, with its resulting confluence of ideas, is usually in decline. The most ironic instance is that of Bernard Shaw, who believed that man would become wise if he could live to be over ninety and to prove it wrote a diffuse and unreadable play that lacks all the intellectual vigour of his maturity.

Such are the facts that must be faced if we are to consider the old age of writers and artists. But they do not by any means exhaust the subject. I believe that old, even very old, artists, have added something of immense value to the sum of human experience. There is undoubtedly what I may call, translating from the German, an old-age style, a special character common to nearly all their work; and during the rest of the lecture I shall try to discover what it is.

For some reason which is rather hard to analyse, painters and sculptors do not suffer from the same loss of creative power that afflicts writers. Indeed the very greatest artists — Michelangelo, Titian, Rembrandt, Donatello, Turner and Cézanne — seem to us to have produced their most impressive work in the last ten or fifteen years of fairly long lives. I say seem to *us* because this was not formerly the accepted opinion. In the nineteenth century Turner's later paintings were considered the work of a madman, and

# The Artist Grows Old

Rembrandt's *Conspiracy of Claudius Civilis* was called a grotesque masquerade. The lack of polish in Titian's later canvases was excused on the grounds that the painter was over ninety, and John Addington Symonds said of Michelangelo's Capella Paolina, 'the frigidity of old age had fallen on his imagination and faculties — one cannot help regretting that seven years . . . should have been devoted to a work so obviously indicative of decaying faculties'.

That we should now admire these late works so highly, often finding in them some anticipation of the tastes and feelings of the present day, tells us two things about them — that they are pessimistic and that they are not concerned with the imitation of natural appearances. Contrary to the Sophoclean or Ciceronian myth, it is evident that those who have retained their creative powers into old age take a very poor view of human life, and develop as their only defence a kind of transcendental pessimism. We need only think of the eyes that look out on us from the late self-portraits of Rembrandt to realise how deeply this great lover of life became disenchanted by life. Michelangelo's head becomes, in Daniele da Volterra's portrait bust, an emblem of spiritual suffering as poignant as his own Jeremiah; and when he portrayed himself it was as the flayed skin of St Bartholomew in the *Last Judgement*. Mantegna, a name that can be added to the list of aged painters, looks in his bronze bust more indignantly pessimistic than Michelangelo, but he left in the corner of one of his last pictures, the St Sebastian in the Ca' d'Oro, the emblem of his beliefs, a smoking candle, with a scroll on which are written the words *Nihil nisi divinum stabile est, coetera fumus.*

This at least suggests a belief in God, which has been denied to pessimists since the Enlightenment. 'He was without hope', said Ruskin of Turner, one can imagine how reluctantly. By the time that the author of *Modern Painters* had met his hero, Turner had grown almost completely monosyllabic in conversation, but he continued to pour his feelings about human life into the formless, ungrammatical verses of *The Fallacies of Hope*, and celebrated the salvation of mankind after the Flood with these lines (which, incidentally, are the best he ever wrote):

# The Artist Grows Old

The Ark stood firm on Ararat; th' returning Sun
Exhaled earth's humid bubbles, and emulous of light,
Reflected her lost forms, each in prismatic guise
Hope's harbinger, ephemeral as the summer fly
Which rises, flits, expands and dies.

Turner could express his sense of tragedy only through red clouds
and a menacing vortex of sea and sky. His figures, although not
insignificant, are ridiculous. But in the great period of figure painting
the aged artists chose tragic themes, and treated them in such a way
as to bring out their most disturbing possibilities. As far as I know
the first artist to develop what I have called the old-age style was
Donatello. Already in the St Anthony reliefs in Padua he had moved
a long way from the Hadrianic beauty of the David or the Dionysiac
rapture of the dancing putti. The scenes are vehemently dramatic,
but the character of St Anthony prohibits tragedy. By the time he
came to the pulpits of St Lorenzo — he worked on them till his death
at the age of eighty — he was no longer persuaded by the comfort-
ing beliefs of humanism, so beautifully expressed by the arcaded
aisles beneath which the pulpits are placed. The rough, passionate,
hirsute figures who surround Christ in the *Harrowing of Hell* and
seem to menace him with their angular gestures, have no interest in
reason and decorum. They are like a new race of Langobardi; and
Christ himself, as he rises from the tomb in the next panel, is like a
shipwrecked sailor, only just able to drag himself ashore. The means
by which this fierce new world of the aged imagination is made
visible are equally remote from the humanist tradition of decorum.
The scenes are crowded, a reckless perspective is used intermittently
in order to heighten emotional effect, and the actual modelling (or
rather the carving, for almost the whole surface has been cut in the
bronze) is as free and expressive as the stroke of a pen in an impas-
sioned drawing.

As with many works of the old-age style (Titian will provide
another example) the St Lorenzo relief are so far outside the human-
ist norm that an earlier generation of critics questioned their authen-
ticity. And when they were done — in the light-footed youth of
Lorenzo de' Medici — Donatello must have felt completely isolated
from his contemporaries. Old artists are solitary; like all old people
they are bored and irritated by the company of their fellow bipeds,

and yet find their isolation depressing. They are also suspicious of interference. Vasari describes how, late one night, he was sent by Pope Paul III to Michelangelo in order to obtain from him a certain drawing. Michelangelo, recognising his knock, came to the door carrying a lamp, and Vasari just had time to see that he was working on a marble pietà; but when Michelangelo noticed that his visitor was looking at it, he dropped his lantern, and they remained in the dark, till Michelangelo's servant, Urbino, a feeble candle in his hand, returned with the drawing. Then, as if to excuse himself, Michelangelo said, 'I am so old that often death tugs at my sleeve, and soon I shall fall like this lantern and my light will go out'. The reason, says Vasari, why Michelangelo *diletassi della solitudine* was his great love of his art. But it would be a mistake to suppose that great artists escape the pains of old age through the joys of creative labour. On the contrary, all old artists who have left us a written record of their experiences, have described how the act of creation has become for them a torture. Michelangelo is, perhaps, not a good example, because he grumbled about every job he undertook; but when he wrote beneath a late drawing of the pietà 'Dio sa che sangue costa', he was surely thinking of himself as well as of his Redeemer.

At the opposite end of the spectrum of art, Claude Monet, whose skill in rendering a visual experience has never been surpassed, created his own marvellous and unforeseeable late manner, out of infinite pain. He wrote of his water-garden canvases, 'in the night I am constantly haunted by what I am trying to realise. I rise broken with fatigue each morning. The coming of dawn gives me courage, but my anxiety returns as soon as I set foot in my studio. . . . Painting is so difficult and torturing. Last autumn I burned six canvases along with the dead leaves in my garden.' Gone the same way as Christ's torso in the Rondanini Pietà. The aged Degas wrote in almost identical terms.

So the aged artist's pessimism extends from human life to his own creative powers. He can no longer enter sympathetically into what he sees, and he no longer has any confidence in human reason. This, as I have said, is something that we can understand more easily than could our grandfathers. They loved the art of the Renaissance because it was based on naturalism, a love of physical beauty and rational order. Berenson, no less than John Addington Symonds, speaks with real hatred of Michelangelo's *Last Judgement* and (as

far as I know) never even mentions the frescoes in the Capella Paolina. Yet for those who have the good fortune to see them, these two extraordinary works provide an experience as moving as anything in art; as moving as the storm scenes of King Lear, and as rich in layer upon layer of meaning.

As usual Michelangelo had undertaken them reluctantly, 'I cannot refuse anything to Pope Paul; but I am ill-pleased to do them and they will please nobody'. 'The art of fresco', he complained 'was not work for old men.' But, as he said in the same year, 'one paints with the brain and not with the hands', and having once started on the work, his whole mind and spirit were engaged. The subjects selected for him were the Conversion of Saul and the Crucifixion of St Peter, episodes which had a particular theological and doctrinal importance to Paul III. The Conversion of Saul was the supreme example of grace, and in Rome of the 1540s the doctrine of justification by grace was a topic of heart searching and earnest discussion. The most learned and devout of the Cardinals, Contarini, Morone and Pole, who had been the associates of Paul III before his elevation, were deeply impressed by the arguments of Luther, and at the centre of their discussions was Michelangelo's greatest friend, Vittoria Colonna. Thus the Conversion of Saul became for Michelangelo almost a personal experience, and he has made Saul's head an idealised self-portrait. There are many representations in art of ecstasy, of suffering, and of enlightenment; but none that equal this portrayal of the painful transition through blindness to spiritual sight. Saul lies on the ground protected by the encircling arms of one of his companions, an ordinary man. The rest of his troop breaks up in confusion. Their world seems to have exploded, as Christendom had just exploded, touched off by the doctrine of faith. The cause of this explosion, the figure of Christ, swoops down from the sky. With one hand he confirms Saul in his new belief; with the other he points to the world beyond Damascus, in which St Paul will preach His Gospel. Michelangelo has put into this drama some of his greatest formal inventions, many of which would have had a special meaning for his contemporaries. For example, the pose of Saul extended on the ground is clearly reminiscent of Raphael's Heliodorus, the would-be despoiler of the Temple. Paul III would have instantly recognised his allusion. He would have thought of the contrast between the avengers of Heliodorus and the divine apparition that

redirects Saul; and would also have noticed that Michelangelo's old-age enmity with Raphael had at last been reconciled. Another example: Saul's horse, whose panic leap away from us is, so to say, the most massive fragment of the exploded world, is one of the antique horses of the Quirinal, seen from below, as Michelangelo must have seen it almost every day when he made his way to Vittoria Colonna's apartment. Almost every figure has a resonance of this kind.

But marvellous as it is, the 'Conversion of Saul' is a less moving work than the 'Crucifixion of St Peter', and I may add a less complete example of the old-age style. The 'Conversion' is still full of energy and the intervention of the heavenly powers gives us reason for hope. The 'Crucifixion of St Peter' portrays the human lot as hopelessly and monotonously tragic. Instead of an explosion, with its possibility of a new life, the 'Crucifixion of St Peter' is a wheel of life, a *rond des prisonniers*, revolving round the central figure, in and out of the frame. On the left-hand side Roman legionaries, inspired by Trajan's column, move upwards; on the right, conquered and disinherited people move downwards. Their leader, a barbarian giant with head bowed and arms folded in resignation, is one of Michelangelo's noblest inventions, a piece of visionary art that was to inspire Blake's first dated engraving. Two groups are not part of the wheel. One represents the forces of law and order, who have condemned St Peter to death, and have been ordered to see that the sentence is being carried out. They are led by a captain, who is the pitiless embodiment of action, and closely resembles one of those ideal heads which Michelangelo had drawn twenty-five years earlier for presentation to those handsome young men who so troubled his peace of mind. Balancing these active participants is a group of four women, two of them looking at the Martyrdom, one gazing wildly into space, one looking directly at us. They are like a Sophoclean chorus. Incidentally, technicians tell us that this was the last day's work on the wet plaster of the fresco, and so the last piece of painting ever executed by Michelangelo.

Within the circle of life is an inner circle formed by St Peter's arms, and the men who are raising his cross, and it, too, has an appendage — the young man who, with mindless concentration, digs the hole in which the cross will be placed. He is innocent, the air-force pilot who releases the bomb. The saint himself is one of

# The Artist Grows Old

Michelangelo's most formidable embodiments of faith and will. Unlike Saul, who receives his painful enlightment with a kind of gratitude, St Peter is not at all resigned to his fate, and glares at us angrily. He will break through the circle of human bondage if he can. It is no accident that Michelangelo has given his body the same form that we find in his magnificent drawings of Prometheus.

Michelangelo's frescoes in the Pauline Chapel exhibit almost every characteristic of the old-age style: its pessimism, its *saeva indignatio*, its feeling of hermetic isolation; and on the formal side its anti-realism, and its accumulation of symbolic motives. In one respect, however, they do not entirely conform: in the actual technique or facture. The aged artist usually employs a less circumscribed and rougher style. In fact parts of the frescoes are painted with considerable freedom; but as a whole Michelangelo has maintained the firm outlines of every form, either because the medium seemed to demand it, or because he felt that great truths must, in Blake's words, be bounded by the wiry line of rectitude. This clarity of enunciation (even when the statements are themselves obscure) — the old-age style tends to reject. To illustrate this characteristic we must turn to the only artist of equal greatness whose lifespan probably equalled Michelangelo's eighty-nine years — Titian.

Nobody knows when Titian was born. Renaissance artists were in the habit of lying about their birthdays for financial reasons, and the tradition that Titian was born in 1477 is hardly credible. But when he painted the pictures in which he develops his old-age style, he was certainly over eighty. Three of them, the *Martyrdom of St Lawrence* in the Escorial, the *Crowning with Thorns* in Munich and the *Flaying of Marsyas* in Kromeresz, are re-workings of pictures that Titian had painted earlier, and it is remarkable that he chose to repeat three of the most violent and tragic subjects in the whole of his oeuvre. In the later versions of all three the sense of tragedy and its universal application to human life is enhanced by purely pictorial means. The earlier *Crowning with Thorns* is a superb academic exercise, but visitors to the Louvre do not look at it for long. We have all grown too suspicious of rhetoric, and Christ's anguished movement has a chilling effect. Translated into the old-age style it is subordinated to a single passionate cry made through the medium of colour and design. The central theme is no longer the expression of Christ's head, but the cruel geometry of the soldiers' sticks. A powerful

diagonal leads up to a basket full of flames, and we suddenly realise how great a part fire and flame play in Titian's later work. It became an obsession similar to the ageing Leonardo's obsession with destruction by water; and we find it again in the Escorial *St Lawrence*, where the fire that lights up the evil faces of his executioners is, for the saint, a source of ecstasy. I am reminded of some lines by one of the rare poets who continued to write great poetry in advanced age, W.B. Yeats:

> *Saeva indignatio* and the labourer's hire
> The strength that gives our blood and state
>    magnanimity of its own desire
> Everything that is not God consumed with
>    intellectual fire.

Throughout his life, Titian had been the supreme master of fruitfulness. He had used his skill in the cuisine of painting to render the smooth, full pressure of flesh on skin, or pulp on rind. In the work of his old age these sensual and vegetable images are replaced by fire, flame and smoke. Titian did not, like Turner, put his thoughts into words, but even his earlier paintings leave us in no doubt that he had a powerful and well-stored mind; and in his last pictures he becomes a profound philosopher. The most complete expression of his philosophy is to be found, after considerable search, in the Moravian town of Kromeresz. It represents one of the cruellest myths of antiquity, the Flaying of Marsyas. As with the *St Lawrence*, we know that he had painted a version of the subject in his maturity, but the picture at Kromeresz is one of those left in his studio on his death, and sold by his great-nephew, Tizianello, to the Earl of Arundel. In case the story of Marsyas is not fresh in your minds, let me remind you that he was a satyr who excelled in playing the flute. The flute was out of favour on Olympus because the goddess Athena, having invented it, found that it distorted her features and threw it away. It was picked up by Marsyas, who learned to play the instrument so skilfully that he was emboldened to challenge Apollo to a musical contest. The judge was King Midas, who, as King of Phrygia, decided in favour of Marsyas; but the Muses reversed his decision, and ordered that as a punishment for his insolence, Marsyas should

be flayed. It is one of those offsprings of the Greek imagination in which the forces of divine order assert themselves by an act of cruelty and we are left horrified by the price that it seemed worth paying for Olympian harmony and reason. The antique world does not seem to have questioned it, and two groups of statuary, one of them by Myron, were amongst the most frequently copied sculptures of the ancient world. The hanging Marsyas from one of these groups was, in fact, known to Michelangelo and provided a model for those late drawings of a Crucifixion which are amongst his most moving examples of old-age style. Titian saw the myth in less simple terms. To begin with his Marsyas is hung up by the feet, like a dead animal in a butcher's shop — or like St Peter who would not be crucified in the same position as his Saviour. All the other protagonists crowd round him in a circle, giving the design that uninterrupted fullness which is a mark of the old-age style. Titian understands that this sacrifice is questionable. Midas sits beside the central figure, sunk in reverie, and behind him a satyr who has come to help his tortured sovereign, starts back with pity and astonishment. The flaying goes on as a ritual act, accompanied by the music of Apollo's cythera. He plays as if in ecstasy, and vibrations of sound seem to fill the whole canvas. We are ravished, and yet we feel that beauty achieved at the expense of life is outrageous. This is a kind of crucifixion, a sacrifice of pure instinct to reason, and if all that reason can achieve is the hideous shedding of blood, why not leave the Dionysiac impulses to follow their own course? An answer is given by another masterpiece of the old-age style, the *Bacchae* of Euripides. The triumph of the irrational produces its own kind of catastrophe, as cruel as the triumph of reason.

This bare description of Titian's imagery suggests a wealth of visual metaphor almost as great as is to be found in Michelangelo's Pauline frescoes. But what I cannot convey in words is the extraordinary freedom with which it is painted. Every stroke of the brush is itself a metamorphosis, in its first dictionary sense, 'the action of changing in form or substance, especially by magic'. Paint is no longer a solid sticky substance, but precious, volatile and alive.

The transformation of paint into an endless series of direct messages from the painter's imagination appears in another great masterpiece of the old-age style, Rembrandt's *Conspiracy of Claudius Civilis*. As with Titian, this is the reworking of an earlier invention,

# The Artist Grows Old

only in this instance Rembrandt has painted over a fragment of the original canvas which, for some unexplained reason, had been rejected by his patrons, the City Fathers of Amsterdam. He has felt free to please himself and in the Cyclopean hero and his grotesque attendants has produced a world so bizarre that one cannot but admire the courage of the seventeenth-century connoisseurs who saved the picture from destruction. But these strange figures have the inevitability of Macbeth's porter or Hamlet's gravedigger. And the freedom with which every form is translated in the colour holds us spellbound in a way that the subject alone would not achieve. Titian's subject is horrifying, Rembrandt's grotesque, yet both arouse in me a similar emotion. For a second I feel that I have had a glimpse of some irrational and absolute truth, that could be revealed only be a great artist in his old age.

> Clouds of affection from our younger eyes
> Conceal the emptiness which age descries.
> The soul's dark cottage, battered and decayed
> Lets in new light through chinks that time hath made.

The Rembrandtesque image of Edmund Waller is irresistible. But it is only partly accurate, because the light that entrances us in these old-age pictures is not the result of exhaustion or decay, but is communicated to us by the indestructible vitality of the painter's hand. Nearly all the painters who have grown greater in old age have retained an astonishing vitality of touch. As their handling has grown freer, so have strokes of the brush developed an independent life. Cézanne, who in middle life painted with the delicacy of a water-colourist, and was almost afraid, as he said, to sully the white-ness of a canvas, ended by attacking it with heavy and passionate strokes. The increased vitality of an aged hand is hard to explain. Does it mean that a long assimilation of life has so filled the painter with a sense of natural energy that it communicates itself involuntar-ily through his touch? Such would seem to be the implication of the famous words of Hokusai in the preface to his Hundred Views of Fuji:

All I have produced before the age of seventy is not worth taking into

172

account. At seventy-three I have learned a little about the real structure of nature, of animals, plants, trees, birds, fishes and insects. In consequence when I am eighty, I shall have made still more progress. At ninety I shall penetrate the mystery of things; at a hundred I shall certainly have reached a marvellous stage; and when I am a hundred and ten, everything I do, be it a dot or a line, will be alive. I beg those who live as long as I to see if I do not keep my word. Written at the age of seventy-five by me, once Hokusai, today Gwakio Rojin, the old man mad about drawing.

'Everything I do, be it but a dot or a line, will be alive.' Rembrandt could have said the same, and so, before his loss of manual skill, could Leonardo. There is nothing more mysterious than the power of an aged artist to give life to a blot or a scribble; it is as inexplicable as the power of a young poet to give life to a word.

Another reason for the reckless freedom of facture in the old-age style is the feeling of imminent departure. 'I haven't long to wait. I shall say what I like, how I like, and as forcefully as possible.' Maer Grafe put it more vividly in his description of Van Gogh's style: 'He paints as one whose house is beset by burglars, and pushes his furniture and everything he can lay his hands on against the door.' Van Gogh was in his thirties. Cézanne and Monet did not arrive at this state of desperation till their last years. Then they began their furious battle with time, not staining, but scarring the white canvas of eternity. But in contrast to this grandiose impatience is an ultimate feeling of resignation and total understanding. In Rembrandt's *Prodigal Son* in the Hermitage we feel that the whole of humanity has been enfolded in an act of forgiveness, beyond good and evil.

Titian, the sensualist, courtier and libertine, reveals himself in his latest pictures, the master of resignation. In the first version of his *Crowning with Thorns*, Christ's head is twisted in agony, like Laocoon; in the later version he sits motionless with downcast eyes. His last great pietà in the Venice Academy unites both the elements of the 'old-age style'; Mary Magdalene steps forward from the platform, passionate, enraged, like an actress who can no longer endure her role, but must break out of the scene and appeal to the audience; but the Virgin and St Jerome are resigned.

Incidentally, we may suppose that this sublime work was originally in the same style as the Marsyas, and perhaps for that reason was refused by the monks of the Frari. Palma Giovane, who finished

it with skill and understanding, added an inscription, saying that it had been *inchoatum*. We cannot blame him, but if it had come down to us as Titian left it, I think it would have been one of the greatest pictures in the world.

Writers on Titian have long accepted that St Jerome who kneels before the Virgin is an idealised self-portrait, and, as I have said, the Midas in the *Flaying of Marsyas* is almost identical. Twenty years earlier Michelangelo has included his idealised self-portrait, as Nicodemus, in the marble pietà now in the cathedral of Florence. It may have been the piece which Michelangelo was carving when Vasari paid his nocturnal call, and shortly afterwards Michelangelo broke it up; just as Rembrandt cut up his canvases, and Monet burned his. Later Michelangelo was persuaded to sell the pieces to a friend named Bandini, and it was restored by the sculptor Calcagni. It was really *inchoatum* and Calcagni was more ambitious and less sensitive than Palma Giovane. But fortunately he died before completing his work. The figure of Nicodemus remains unrestored, and as one looks at his noble head from different angles and in different lights one finds a whole range of human emotion beginning with unutterable grief, passing through practical solicitude (specially praised by Vasari), and ending with calm and an almost beatific resignation. I do not think that Titian was inspired by this precedent, and indeed it is most unlikely that he had seen the group. Nor do I think that the desire of an aged artist to include himself in his last great work was a piece of egotism. Rather, I would suppose that he had come to think of the great tragic myths of the human imagination as almost his private property. He sees them with a mixture of heartfelt participation and detachment that requires his actual presence in the drama.

Now let me try to summarise the characteristics of the old-age style as they appear, with remarkable consistency, in the work of the greatest painters and sculptors. A sense of isolation, a feeling of holy rage, developing into what I have called transcendental pessimism; a mistrust of reason, a belief in instinct. And in a few rare instances the old-age myth of classical antiquity — the feeling that the crimes and follies of mankind must be accepted with resignation. All this is revealed by the imagery of old men's pictures, and to some extent by the treatment. If we consider old-age art from a more narrowly stylistic point of view, we find a retreat from realism, an impatience

174

with established technique and a craving for complete unity of treatment, as if the picture were an organism in which every member shared in the life of the whole.

I have mentioned a few of the artists in whose late work these characteristics can be found. I could have extended it to almost every great painter who has lived beyond the age of 65 or 70. Indeed I can think of only one exception, Piero della Francesca; and there a physical cause, cataract or partial blindness, prevented him in his old age from painting at all. Turning back to writers of equal stature, one cannot but be struck by the difference between the two arts.

One of the finest critical essays in English begins with the words, 'It is a mistake of much popular criticism to regard poetry, music and painting — all the various products of art — as but translations into different languages of one and the same fixed quantity of imaginative thought, supplemented by certain technical qualities'. Pater's warning is always in my mind. Nevertheless the elderly great do seem to have a good deal in common, and it is worth speculating on the reasons why they can express themselves so much more movingly in painting and sculpture than in poetry. Perhaps a clue is given by Coleridge's words, 'we in ourselves rejoice' together with the word vitality. The painter is dealing with something outside himself, and is positively drawing strength from what he sees. The act of painting is a physical act, and retains some element of physical satisfaction. No writer enjoys the movement of his pen, still less the click of his typewriter. But in the actual laying on of a touch of colour, or in the stroke of a mallet on a chisel, there is a moment of self-forgetfulness. Harassed public servants — presidents, statesmen and generals — take up painting; they do not (with the exception of Lord Wavell) write poetry. It may seem ridiculous to compare the therapeutic activities of these amateurs to the struggles of Titian or Rembrandt; but I think that they do indicate a fundamental difference between the two arts. A visual experience is vitalising. Although it may almost immediately become a spiritual experience (with all the pain which that involves), it provides a kind of nourishment. Whereas to write great poetry, to draw continuously on one's inner life, is not merely exhausting, it is to keep alight a consuming fire. What in old age feeds this fire? Memories of past emotions; only very occasionally fresh experiences which, if they are strong enough to generate poetry cannot, as Housman said, be

endured for any length of time.

Before trying to discover instances of the old-age style in literature and music, I ought perhaps to consider the question of what, in a creative artist, is meant by 'old'. Painters and sculptors tend to live much longer than writers or musicians, and their work shows no sign of old age till their last years. Mr Henry Moore is seventy-three, but neither in himself nor in his carving is there the slightest sign of old age. Matisse became bedridden, but his art remained as fresh as a daisy. Conversely, Beethoven was under fifty when he entered what critics agree to call his last period, and the quartets, written when he was fifty-five, are classic examples of the old-age style in their freedom from established forms and their mixture of remoteness and urgent personal appeal. Like the last works of Michelangelo and Titian, they seem to go beyond our reach, and yet there is an ultimate reconciliation. One should, I suppose, add that Beethoven's isolation may have been increased by his deafness.

But there are other examples of an old-age style in a great artist under fifty for which there is no such simple explanation. How do we explain Shakespeare's last four plays? Critics tend to write of them as if they were the work of an old man, although Shakespeare was in his middle forties when he wrote them. *Pericles, Cymbeline* and *The Winter's Tale* do indeed show some of the negative characteristics of the old-age style — the impatience, the recklessness and the bitterness. But these seem to me symptoms of exhaustion rather than of a new direction. Lytton Strachey's notorious judgement that 'Shakespeare in his last years was half enchanted by visions of beauty and half bored to death', although it has been rejected with horror by most scholars of Shakespeare, seems to me substantially true. No man has ever burnt himself up more gloriously. But *The Tempest* does seem to show some characteristics that only an artist who has lived his life could give. Far more than the earlier plays it creates a private world of the imagination. Shakespeare, who had in the past written so immediately for his actors and his audiences, now seems to be writing only for himself. And Prospero's last speech could surely not have been written by a young man, even the young Shakespeare.

I have hesitated to quote the example of Shakespeare in *The Artist Grows Old*; and I would definitely exclude Racine, for, in spite of the enormous change that took place in his life during the twelve years'

silence between *Phèdre* and *Esther*, and the considerable difference of style of his last two plays, they do not seem to reflect the liberation of old age. But I have no such hesitation in including a third — I might say the third — great European dramatist: Ibsen. His last plays, from *The Master Builder* to *When We Dead Awaken*, are perhaps the most complete illustration in literature of the characteristics of the old-age style, as we have seen them more consistently revealed in the visual arts.

First, isolation. In the 1890s Ibsen was the most famous writer in Europe, but after his return to Norway he lived in a solitude of his own making. He was as lonely as Michelangelo and if anything rather grumpier. Then the flight from realism. Viewed as a realistic drama *The Master Builder* is unconvincing, and in *When We Dead Awaken* all pretence of naturalism is abandoned. Both plays are still based on marvellous and embarrassing psychological insights: but in form they are allegories of guilt and redemption. They are full, perhaps too full, of symbols; and as usual with the old-age style, these symbols can be interpreted differently and leave us with an uneasy feeling that we can decipher only half the message. They are intensely personal; in fact it can be argued that the hero-villain of each play is Ibsen himself, the man who sacrificed life to art and came to believe that life is the more important. Michelangelo, when asked to design the reverse side of his portrait medal by Leone Leoni, chose as his emblem an old blind pilgrim, led by a mongrel dog, trotting along confidently with tail erect. Ibsen would have agreed. But solitude and physical inaction do not imply a lack of vitality, and during the years in which his last play was being written, Ibsen was constantly falling in love with young girls. Hilde Wangel and Irene were real experiences and few things gave him more satisfaction than to read about the aged Goethe's love affair with Mariana von Wilmer. Only instead of his young ladies inspiring him to write poems to the rising moon, as Goethe did, whether effectively or not it is hard to say, Ibsen saw them as a new kind of Eumenides, playing on his sense of guilt and driving him on to self-destruction.

On the name of Goethe, I must confess that the greatest and most prolific of septuagenarian poets does not illustrate the characteristics of an old-age style, which seems to me so evident in the work of painters and sculptors. It is true that the second part of *Faust* ends with symbolic utterances as mysterious as the last speeches in *When*

# The Artist Grows Old

*We Dead Awaken*. But Goethe's respect for conformity (what is usually referred to as his wisdom) led to a tone of vague optimism, which his fellow ancients have not usually shared. It is remarkable that Thomas Hardy does not include Goethe in his list. Perhaps he could not bring himself to say (and we sympathise with him) that the second part of *Faust* burned brightlier than the first. The numerous lyrics that Goethe wrote in his last years at the drop of a hat may be better than Longfellow. I cannot tell. What is certain is that they might have been written by any middle-aged poet conscious of his powers, and of his responsibilities to a rather conventional notion of poetry.

In the present century, as opposed to the last, poets have tended to gain in power as they grew older, and a number of them have written movingly in the old-age style — Yeats, Rilke, Thomas Hardy himself. Yeats and Rilke used the freedom of address and the almost impenetrable symbolism of aged painters. Thomas Hardy in such a poem as *Aftermath* spoke more simply, but with a feeling of isolation and imminent departure. But with no disrespect to these fine poets, I think one must allow that they are in a different category to Michelangelo, Titian and Rembrandt. Can we name an aged poet of this stature? Although he arouses no enthusiasm among modern critics, I hope I may be allowed to pronounce the name of Milton. *Samson Agonistes* is, so to say, a double distilled example of old-age writing, because it is undisguisedly modelled on the *Oedipus at Colonus* which Sophocles is supposed to have written after the age of 87. Like the other examples I have quoted, it is deeply personal. Milton was himself blind; his hopes had been shattered, his cause betrayed, and although his relations with the opposite sex were certainly not as simple as those of Samson and Delilah, he felt that his love of women was in some way connected with his failure. *Samson Agonistes* is almost as autobiographical as the last plays by Ibsen. But it differs from them in that Samson discovers a humility that Ibsen's guilt-ridden characters cannot achieve, and so unlike the questionable victories of Solness and Rubeck, he ends his career with an apotheosis which is also the highest victory of old age.

*Samson Agonistes*, like *Paradise Regained*, also ends on a note of resignation; and in its actual diction it introduces one more aspect of the old-age style — a stoic austerity which denies any appeal to the emotions made through the sensuous quality of the medium.

# The Artist Grows Old

Michelangelo, Titian, Rembrandt, Donatello, Cézanne, all continued to use their media with an added sense of its material possibilities. But at least two great artists of the seventeenth century voluntarily rejected that charm of colour, light and joy in the use of paint which captivates us in their early work. These are Poussin and Claude. Poussin had equalled the great Venetians in his richness of colour and had sought for subjects that might allow him such sensuous delights. But by the time he had còme to paint his second series of the Seven Sacraments, he had come to feel, as did Milton in *Paradise Regained*, that to display any pleasure in sensation would be to deprive the subject of its high seriousness. Poussin by the intellectual power of his invention seems to me to have justified his puritanical renunciation. But a poem, which has to hold our attention and keep our faculties warm for a longer time than a picture, may suffer more severely from the exclusion of ornament and graphic invention. The old-age style of Claude was less calculated. In his last landscape he did not deliberately exclude the enchantments of light and distance; but he retreated into a remote world of his own creation, where colour is subdued to a near monochrome and events take place in a sort of trance. This gentle, dreamlike departure from reality is very different from the fiery pessimism of Michelangelo and Titian, and is perhaps the least painful expression of growing old.

The fact is that Arnold was not far wrong. The outstanding poet of our own day, Mr T.S. Eliot, has amplified his statement with more subtlety and even greater bitterness:

> Let me disclose the gifts reserved for age
> To set a crown upon your lifetime's effort.
> First, the cold friction of expiring sense
> Without enchantment, offering no promise
> But bitter tastelessness of shadow fruit
> As body and soul begin to fall asunder.
> Second, the conscious impotence of rage
> At human folly, and the laceration
> Of laughter at what ceases to amuse.
> And last, the rending pain of re-enactment
> Of all that you have done, and been; the shame
> Of motives late revealed, and the awareness

# The Artist Grows Old

Of things ill done and done to others' harm
Which once you took for exercise of virtue.

Any elderly person can vouch for the accuracy of those lines. They record the common lot of *homo sapiens*. And the miraculous fact, which I have tried to describe in this lecture, is that many artists and some writers have, with infinite pain, created great works of art out of these miserable conditions. Their rage at human folly has not been impotent, their re-enactment of things done has been a means of re-creating them as part of a life-preserving myth, and they have arrested the moment when the body and soul fall asunder, caught enough of the body to make the moment comprehensible, and seen how its disintegration reveals the soul.

# Acknowledgements

These chapters are revised and adjusted from lectures delivered on the following occasions:

*Moments of Vision*: The Romanes Lecture, Oxford, 1954
*Provincialism*: The Presidential Address to the English Association, 1962
*The Concept of Universal Man*: Ditchley Foundation Lecture, 1972
*Walter Pater*: The Brasenose Lecture, Oxford, 1977
*Mandarin English*: The Giff Edmonds Memorial Lecture, 1970
*The Artist Grows Old*: The Rede Lecture, Cambridge, 1972

# Index

# Index

183

# Index

# Index

# Index

Horace, *ut pictura poesis*, 1, 136
Housman, A.E., preface to *Last Poems*, 162, 175–6
humanism, 97, 100, 107, 165
humanitarianism, 71, 76–7
Humphrey, Ozias, on Stubbs, 54
Hunt, Holman, *Hireling Shepherd*, 59
Huyghens family, 104

Ibsen, Henrik, last plays in old age, 177, 178; love affairs, 177
iconoclastic movement, loss to art, 40–1; alleged survival in *Virgin Hodegetrias*, 41, 42; philosophic influences, 45
iconography, 1; Christian, 27, 34–5, 76; and illiterate man, 42; expresses abtruse theology, 42; confused with veneration of relics, 43; scientific symbolic shapes, 49; acceptance in healthy society, 68; influence on religious belief and dogmas, 68–9; and non-religious systems, 69
iconophobia (image hating), in history of art, 31; motivation, 31, 33, 43–4, 45; destructive episodes, 43, 44; social and stylistic causes, 45–6; religio-theological and aesthetic nature of hostility, 46, 47; link with contemporary art, 47–9
images, reveal a sense of design, 63; creation on behalf of a minority (élite), 63–4; and systems of belief, 64, 66; exploitation of emotionalism, 64; and exposition of dogma, 68; debasement in art criticism, 87
imagination, common source of art, science and aesthetic values, 24, 46, 78; and hypotheses, 96
Impressionists, 58, 121; Berenson on, 123
India, 45, 61; Ajanta, 64; illustrated MSS, 65; ornament, 65; Taj Mahal, 74
Indonesia, 61; Borabadur, 64, 66; Mayayana Buddhism, 64
Ingres, Jean Auguste, 46, 53
Ireland, 38–9, 65
Islam, Kaaba, 31, 36; the Qur'an, 36–7; the Hadith, 37; Judaic origin, 37; Mahomet and puritanism, 37, 39–40; Caliphate, 37, 38
Islamic art and architecture, iconophobic, 31, 36–7; influence of

Persia, 38; Cufic lettering, 38, 39; aniconic, 46; Damascus Mosque, 37; Dome of the Rock, 38–9
Italy, mannerist art, 20; fourth-century Christian art, 35; metropolitan artists, 53; current criticism, 86

Jackson, Richard, C., and Pater, 132, 139
Jacometto, 117
Jahn, Otto, life of Winckelmann, 134
James, Henry, 140, 157, 158; prolixity, 146–7
James, William, and Berenson, 89, 113
Japan, 61; T'ang bronzes, 38; illustrated scrolls, 65
Jefferson, Thomas, 100; universal man, 91, 92, 94, 97, 103, 104–5, 107; likened to Alberti, 94, 105; and architecture, 94, 95; compared with Franklin, 103–4
John, Augustus, 77
Josephus, iconophobia, 34; palace of Herod Antipas, 34
Johnson, Samuel, 144, 156, 157
journalism, pseudo scientific terms, 86–7; working class style, 149
Jowett, Benjamin, 131, 133, 142
Joyce, James, *style artistique*, 155
Jung, Carl Gustav, 28
Judaic culture, iconophobia, 31, 32–3, 35; written history, 31; pre-history tribalism, 32–3; scarcity of recorded images, 32, 33; exit from Egypt, 32–3; puritanism, 140; Ark of the Covenant, 31; Temple of Jerusalem, 33

K'ang H'si, Emperor, 106
Kandinsky, Vasily, 24, 46, 78; and pure abstraction, 48; *The Spiritual in Art*, 47
Keats, John, 9, 11–12, 57, 150; *Eve of St Agnes*, 3, 10
Klee, Paul, 'micropolitan' art, 61
Kromeresz, Titian's works, 169, 170

language, 86, 140; development from mass needs, 65; stylization of ordinary speech or conversation, 146, 148; prolixity, 146–7; rhetoric, 147; lecturers, 147–8; of television, 148; stichomythia, 148; contemporary style, 149–50; *Mandarin English*, 144 and n; distinguished from fine writing, 144; eighteenth-century origins,

# Index

# Index

abstraction, 48; moral rectitude, 49;
*General Principles of Plastic Equivalence,*
47

Monet, Claude, 112, 123, 147; painting in
old age, 166, 173, 174

Moore George, style, *Evelyn Innes*; *The
Brook Kerith,* 147

Moore, Henry, 126: in old age, 176

Morelli, Giovanni, Berenson and, 109,
115

Morris, William, and the machine, 74

Mortimer, John Hamilton, drawings, 56

Moslems, 65; *see also* Islam

Murry, John Middleton, 157

music, 50, 136, 137; old age style, 176

Nahum ben Sinai, Rabbi, 34

naturalism, 47, 53, 69, 122

Netherlands, 20; and Mondrian, 48–9;
Dutch Republic, 104

Newman, John Henry, Cardinal, 26, 59,
131, 156, 158–9; last day in the
University, 2–3, 13

Newton, Sir Isaac, 107; *Principia,* 99

Norsemen, decorative motifs, 39

Norton, Charles Elliot, 109

Nugée, George, St Austin's community,
132

ornament, a visual appreciation, 63;
derivative from élite style, 65; an
assertion of status, 65–6; majority
acceptance, 74; role of the machine, 74;
Scythian, 65; women's dress, 74

Orwell, George, 156

Pacino de Bonaguida, 65

painting, 1, 4; precipitation of sleeping
memories, 9; visible expressions,
13–14; and imitation, 25; tachiste, 28;
non-representational, 31; nineteenth
century failure over Christian
subjects, 46; desire for purity, 47; and
pure abstraction, 47–9; English artists,
51–2; mannerism, 54; Pater's aesthetic,
135; a physical act, 175

Palma, Giovane, and Titian's *Pietà,*
173–4

Palmer, Samuel, 59; visions, 8, 14;
isolationism, 56–7, 61; 'micropolitan',
57; colour print of Nebuchadnezzar,
56

Pascal, Blaise, 99

Pater, Walter, 129; writings on art, 82,
84, 134, 135; biographers, 130; style of
writing, 130, 139–40, 153–4; life and
personality, 130–3, 134, 138; author's
evaluation, 135–42; and Christianity,
139; influence on other writers, 140;
reaction against, 153; *Appreciations,* on
Coleridge, 11 and n; *The Child in the
House,* 153–4; *Diaphanéité,* 133–4;
*Emerald Uthwart,* 131; *Gaston de la
Tour,* 130, 133, 141; *Greek Studies,* 138;
*Imaginary Portraits,* 130, 131, 133, 141;
*Marius the* Epicurean, 130, 132, 133,
138–40, 154; *Plato and Platonism,* 130,
133, 142, 147; *Renaissance,* 89, 122, 131,
134–5, 175; 'Leonardo da Vinci',
evocation of *Mona Lisa,* 85–6, 135,
153; 'Winckelmann', 134–5, 137–8;
essay on *Style,* 157

Pattison, Mr and Mrs Mark, 131, 140

Paul III, Pope, 166, 167

Persia, Shiite deviationists, 38;
decorative art, 38–9, 65

perspective, 5, 22, 125, 165

Perugino, Pietro Vannucci, 124

philosophy, 21–2, 142; depiction of the
Absolute, 33; and European
iconophobia, 45; and art/society
relations, 63; and nature of art, 64, 72,
89

photography and portraiture, 75

Picasso, Pablo, 47, 61, 137

Piero della Francesca, 27, 122–3; in old
age, 175

Pitt, William, the Elder, 150

Plato, 8–9, 64; ideal magnanimous man,
92; Pater and, 130, 142; old age, 160;
*Republic,* 92, 160; neo-platonism, 27,
41

poetry, the poet, 4; source of visionary
art, 9, 13, 57; use of visual experience,
17; and lyricism, 55; decline in
inspiration in old age, 160–1, 175

Pollajuolo, Antonio, 113, 116, 124

posters, 74–5, 75n, 76

Poussin, Nicolas, 21, 84; in old age, 179;
*Seven Sacraments,* 179

Pre-Raphaelites, 3, 7, 125; provincial art,
58, 59

Proust, Marcel, 137, 154

provincialism, in visual arts, 60–1;

# Index

recognition and definition, 50, 61–2; contrasted with metropolitan, 50–1; relevance to music and literature, 50; conflict with dominant style, 51–2; concepts, 52; depiction of the concrete, 53; characteristics, 58, 60, 62

psychology, influence on the artist, 27–8

Pythagoras, 19, 94

Quakers, 34, 44, 45

Raphael, classicism, 52, 53; Heliodorus, 167; Stanze, 64

Racine, Jean, 176–7

Reformation, 40, 43, 44, 46

Rembrandt, 6, 30, 67, 163; self-portraits, 164; old age style, 171–2, 178, 179; *Conspiracy of Claudius Civilis*, 164, 171–2; *Prodigal Son*, 173

Renaissance, 54, 136; use of perspective and anatomy, 22; nineteenth-century copies, 23, 78; support for the artist, 24, 66; and Greek aesthetics, 25; illustrations of neo-Platonism, 27; invention of universal man, 92–3; concept of space, 125; and naturalism, 166

Reynolds, Sir Joshua, 82; *Discourses*, 9

Richardson, Jonathan, 1; *Theory of Painting*, 1

Rilke, Rainer Maria, 178

Romano, Giulio, 72

Romanticism, 107; and science, 22, 107; theory of art, 25; iconography, 69

Rome, 54, 70; Christian art, 35; Baroque, 50, 51; mannerism, 55; Palazzo Farnese, 66

Rossetti, Dante Gabriel, 3, 127

Rothko, Mark, 137; abstract expressionism, 48, 49

Rousseau, Jean-Jacques, 100; *volonté générale*, 64; *Contrat Social*, 100 *Emile*, 100; *Nature of Inequality*, 103

Rubens, Sir Peter Paul, 30, 90

Ruskin, John, 1, 5, 9, 29, 59, 125; fireflies of Fonte Branda, 12, 16; writings on art, 39–41, 66, 67, 74, 82, 84, 87, 88, 90, 122–3; eulogy on Bewick, 59; poetic morality, 63; style of writing, 87, 151, 153, 156; on Turner, 90, 164; *Crown of Wild Olives*, 147, 156–7, 158; *Fors Clavigera*, 151; *Modern Painters*, 137,

164; *Praeterita*, 12; *Queen of the Air*, 84; *The Stones of Venice*, 147; *Two Paths*, 21, 39

Russell, Bertrand, 30

Russia, 48; philosophic time-lag, 26; art as a political influence, 26

Ryder, Albert Pinkham, US poet, 57

St Augustine, 42, 93; *Confessions/City of God* comparison, 163

St Basil, classic text, 41

St Bernard of Clairvaux, objection to images, 42, 43, 45

St Luke, *Virgin Hodegetrias*, 41, 42

Sainte-Beuve, Charles Augustin, 82

Sano di Pietro, 126

Santayana, George, stylist reputation, 152

Sassetta, Stefano di Giovanni, 110–11, 126

science, 22–3, twentieth-century achievements, 23, 24, 77; search for unity, 24, 78; popular support, 24, 78–9; and functions of art, 25, 29; disregard for ultimate truths, 29; deflection of creative energy away from art, 23–4, 25, 26, 29, 77; new accuracy of measurement, 71, 76; and hypotheses, 96

Scott, Geoffrey and Pinsent, Cecil, and I Tatti, 111–12

Sebastiano del Piombo, 119

Shadwell, C.L., 131

Shakespeare, William, last four plays, 176

Shaw, George Bernard, decline in old age, 163

Shelley, Percy Bysshe, 22, 69

Signorelli, Luca, 123, 124

Silchester, grave reliefs, 50

Smith, Logan Pearsall, 110–11, 143

Snow, Charles Percy, Baron, 'The Two Cultures', 105

society, art and, historical relationship, 63–71; importance of its vitality to health, 66–7; impact of materialism, 71–3, 80; role of ornament, 74; decline in confidence, 75

Souillac church, *trumeau*, 42

Sophocles, golden myth of old age, 160, 163, 164; *Oedipus at Colonus*, 178

Spencer, Stanley, 59, 60

189

# Index

# Index

William the Silent, 104
Winckelmann, Johann Joachim, 82, 127; Pater's essay on, 134, 137–8
Wolfflin, H., analysis of Baroque architecture, 87
woodcuts, *images d'Epinal,* 64–5
Woolf, Virginia, 140, 155; *Lives of the Obscure,* 60
Wordsworth, William, 5; and Coleridge, 2; moments of vision, 4, 5, 13, 15, 57; and nature, 125; in decline, 161; and Coleridge's pessimism, 161; Chatterton sonnet, 161–2; *Immortality ode,* 161; 'The Leech Gatherer', 149; Prelude, 4
Wotton, Sir Henry, *Elements of Architecture,* 156
Wren, Sir Christopher, 95

Xenophon, and illiberal arts, 90, 94

Yeats, W.B., 3; *Oxford Book of English Verse,* 86, 135, 153; poetry in old age, 170, 173

Zwingli, Huldreich, 43